Startup London

Startup London
First Edition

Copyright © Hoxton Mini Press 2018
All rights reserved

All text by Christina Hopkinson except 'Tips and Advice' by Rebecca Burn-Callander

All photographs © Rick Pushinsky

Design and sequence by Matthew Young and Hoxton Mini Press

Copyediting by Liz Marvin

With thanks to Ruth Brooks and Faith McAllister

Dedicated to the best ever startup: Olive Usborne

A CIP catalogue record for this book is available from the British Library

ISBN 978-1-910566-30-5

First published in the United Kingdom in 2018 by Hoxton Mini Press.

No part of this publication may be reproduced, stored in a retrieval system, or transmitted in any form or by any means, electronic, mechanical, photocopying, recording or otherwise, without the prior written permission of the copyright owner.

Printed and bound by
Livonia Print, Latvia

To order books, collector's editions and signed prints please go to:
www.hoxtonminipress.com

Startup London

INSPIRATIONAL STORIES FROM CREATIVE ENTREPRENEURS

Written by Christina Hopkinson
Photography by Rick Pushinsky

Contributors

Christina Hopkinson
Writer

Christina Hopkinson is a novelist and journalist specialising in examining contemporary issues through both fiction and non-fiction. Her articles have appeared in a range of UK publications including the *Guardian*, *The Times*, *The Sunday Times*, *Grazia* and *Red*. Her five novels have been translated into more than 12 languages and have been praised in the national press as 'witty, absorbing with a darker edge' and 'sharp, funny and deliciously rude'. She lives in Islington and describes the creation of this book 'as bicycling round great bits of London meeting inspiring people'.

Rick Pushinsky
Photographer

Rick Pushinsky is a British photographer based in East London, with a background in fine art and architecture. He shoots portraits internationally and his work has been featured in *Vogue*, *The Telegraph* and the *Financial Times*. A book of Rick's personal work was published by Sternthal in 2016 and in 2017 he released a set of recipe cards made in collaboration with his family. Rick continues to work on his own projects alongside editorial and commercial commissions.

Contents

9	Welcome
11	Introduction
19	**Mark + Fold** Modern handmade stationery
27	**Beeline** Smart compass for bikes
35	**Blackhorse Lane Ateliers** Raw and selvedge jeans
43	**Eporta** Online platform for interiors professionals
51	**Blenheim Forge** Hand-forged knives
59	**Birdsong** Ethical fashion empowering women
63	**Automata** Affordable robotic arms
71	**The Castle Cinema** Historic cinema revival
79	**Borough 22** Gluten-and-dairy-free doughnuts
87	**Butternut Box** Freshly cooked dog food
91	**Seenit** Crowd-sourced video app & platform
99	**Cubitts** Affordable, stylish spectacles
109	**OLIO** Food-sharing app
113	**East London Liquor Company** Distillery, bar and restaurant
123	**Riposte** Smart magazine for women
131	**Tribe** Sports nutrition products
137	**The Goodlife Centre** Workshops in making & mending
145	**Ugly Drinks** Sugar-and-sweetener-free carbonated cans
151	**London Terrariums** Gardening under glass
161	**Piccolo** Organic baby food
167	**Pressure Drop** Brewery and taproom
173	**Quill London** Calligraphy and stationery
181	**ROLI** Musical instruments of the future
187	**Pip & Nut** Nut butters and milks
195	**Fitzcarraldo Editions** Independent book publisher
201	**Secret Smokehouse** Fish curers and smokers
207	**EJ Ryder** Design and construction
215	**Petalon** Flowers delivered by bicycle
223	**Yardarm** Deli and wine shop
229	**Second Home** Workspace and cultural venues

Welcome

As a small publisher based in Hackney that started just four years ago by raising funds on Kickstarter, the subject 'startups in London' is close to our hearts. We are all too familiar with the pleasures (and pains) of bootstrapping into existence and having to fix the printer and the balance sheet on the same morning. Looking back, I would say that passion and naivety were our most powerful motors. Had we known how much work was involved I'm not sure we would have jumped in so quickly.

I'm conscious that I'm now sounding clichéd. The idea that all you need is a laptop and a whole lot of passion is too predictable. Real business, as we all know, is not so simple. You'll need to understand cash flow, have some marketing nous, you'll need contacts and, most importantly, you'll have to know what your potential customers want to spend money on.

And yet, and yet . . . despite all the tools required (and we have a small booklet dedicated to the must-have info to start your own business in the front pocket of this book), ultimately it *does* come down to *you*. It's not your degree, it's not your wealth, it's your raw drive. How much do you want this business to happen? Are you willing to go through the risk and effort? Because, if you are, the stress of making it happen will sharpen your business skills more effectively than any course or manual.

This book is, therefore, an inspirational guide rather than a how-to. It is about the people and their stories more than it is about their balance sheets and business plans (although we do touch on the finances, of course). It is also, unashamedly, geared towards our own interests: to the smaller, more visually creative enterprises rather than the bigger, more abstract tech companies.

We hope that in reading this book you will feel motivated to take a step closer to realising your entrepreneurial dream. Oh, and by the way, you don't need self-belief. We doubt ourselves almost every morning. Don't wait for certainty. Go out and learn as you do.

Start up!

Martin and Ann
Founders of Hoxton Mini Press

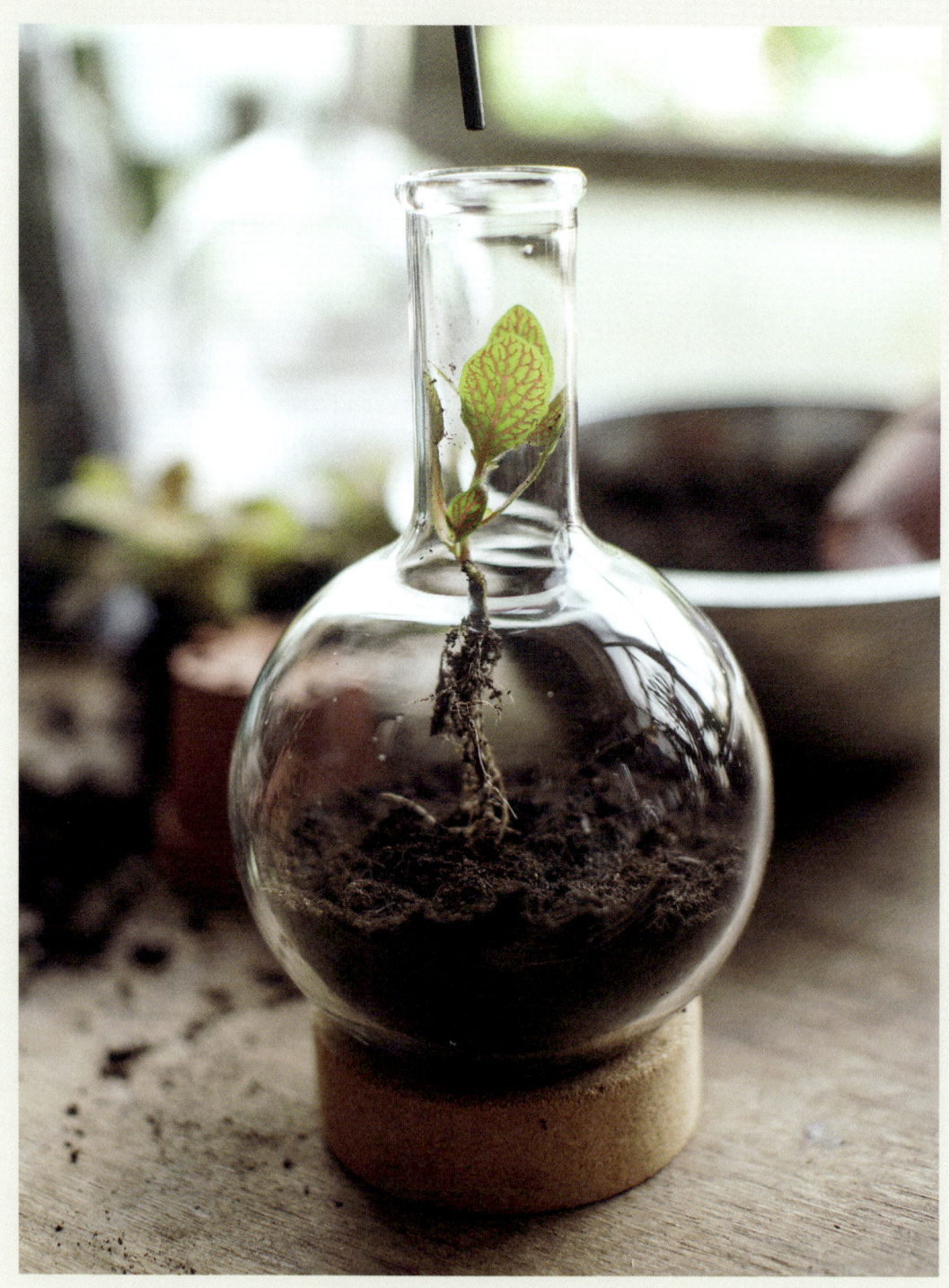

Introduction

The world's most innovative people are choosing London to make their startup dreams a reality, with nearly 200,000 new businesses founded in the capital every year. It's not hard to see why – the city has the entertainment industry of Los Angeles, the technical hub of San Francisco and the financial and creative services of New York rolled into one thriving mass. In London's living rooms and kitchens, under railway arches, in industrial parks and converted warehouses, people are dreaming up, planning, starting or actually running their own businesses.

Startups are by definition fresh, imaginative and original, fuelled by optimism and dynamism. These are young businesses, less than five years old, that are working to find solutions to problems, be they personal, political or environmental. Entrepreneurs don't look at what's available and wonder why, but see things that aren't on the market and ask themselves 'Why not?'

In the following pages, we have taken this broad definition of a startup and asked 30 very different London entrepreneurs to explain what inspired them to step outside of the 9-to-5, as well as asking how they did it. Photographed in their workspaces, they share the challenges they faced and some of the hard-won wisdom they have acquired along the way.

We've included tech companies with big ambitions, but also smaller, creative businesses that don't want to transform the world, but do want to make it kinder, smarter or just a little bit more beautiful. They have been chosen because they are inspired – offering ways of making our lives better – but also inspiring, as the stories behind them show that so much is possible with some creativity and hard work.

Choosing so few out of so many hasn't been easy, but we've sought out companies that are passionate, creative and diverse to present a snapshot of the exciting world of startups and of London's innovators in particular. Some aim at nothing less than world domination in their chosen fields. For others, their primary motivation is to build a sustainable business that allows them to do what they love, or the flexibility to spend time with their families.

The ways in which these startups raised their funding, and the amount needed, are as diverse as they are, demonstrating that there

are many ways to get something off the ground when you have the courage and imagination. One company featured here raised $50 million from venture capital firms and angel investors; another began with just £200. Many have harnessed the power of crowdfunding, not just to get the capital to launch a new product, but to connect to a ready-made and often highly engaged customer base. Some discovered that forming strategic partnerships with suppliers or manufacturers brought down costs and made ambitious ideas achievable. Others made use of mentoring schemes, courses, or other types of support increasingly available to potential startups, while some took out a second mortgage and ploughed straight in.

The founders' reasons for starting a business are myriad. For some, such as London Terrariums' Emma Sibley, it was a hobby that grew too big to be juggled with a day job. A timely redundancy gave Borough 22 founder Ryan Panchoo the jolt he needed to devote himself to his vegan doughnut business full time. These are almost accidental entrepreneurs, while others were inspired by the goal of entrepreneurship as much as the product they've created. Mark Jenner and Tom Putnam of Beeline, the smart compass for bikes, were learning all that they needed to know about business working as consultants at McKinsey & Company, waiting for the right idea onto which to apply their know-how.

Some of those in the book are awe-inspiringly young, but as Rohan Silva of co-working hub Second Home says, 'Entrepreneurship isn't just for kids in their early twenties in skinny jeans.' The *Financial Times* announced in 2017 that 'over 50s are the new startup generation'. After all, there's no age discrimination when you're your own boss.

What they share, however, is an ability to get on and just do it. As a group, they are exceptionally engaging, optimistic and dynamic – they have a vital capacity to throw aside doubts in order to forge their business, one step at a time, without over-analysing the potential pitfalls. Many of them modestly protest naivety, claiming that had they known all the hurdles to be overcome they'd never have had the chutzpah to go for it. But most admit that they felt the natural fears and anxieties that we'd all have on starting something new, and yet they persevered undaunted. Yes, some of them have been lucky, but most of them have made their own luck with business acumen, vision, an understanding of their market and a lot of hard work.

Hard work is, of course, key. While many of us dream of being our own boss, the reality is that it's not for everyone. One entrepreneur

admitted that she felt she'd swapped the 9-to-5 for the 5am to 9pm. Weekends and evenings are no longer their own but the company's, and many of the entrepreneurs here acknowledge that there have been times when friendships and relationships felt the strain. Starting their own business may have given them more control over their time, but rarely does it actually give them more time.

Globally, it's estimated that twice as many men as women become entrepreneurs. This imbalance is particularly noticeable in venture-capital backed startups, where TechCrunch's research arm, Crunchbase, has found that as few as 17 per cent of founders are female. However, when you adopt a broader understanding of startups to include any innovative new business, as we have done here, then the balance between men and women founders looks a lot healthier. New businesses are often born from times of life changes, such as graduation, redundancy or retirement, and some of the women in this book reflect this, having begun their businesses while on maternity leave.

London continues to be a place that stimulates innovation. Few of the entrepreneurs featured here were born here, but many credit the city's atmosphere of innovation and creativity as a factor in their success. It's no secret that rents can be sky high, but, with a little ingenuity, unexpected and unlikely locations have become home to workshops, food outlets and even a blacksmith's forge. And you wouldn't necessarily expect to find an unashamedly intellectual publisher in a borrowed office in the shadow of Harrods in Knightsbridge or two ex-Goldman Sachs trainees thriving in a windswept industrial estate in Park Royal.

Even in this forward-looking city, you still can't get away from the past, and many of the startups included here have been inspired by London's history. Businesses like Secret Smokehouse and Blackhorse Lane Ateliers are reviving the dormant but once thriving fish-smoking and garment-making industries. Cubitts' glasses frames are named after the surrounding streets of King's Cross, where a number of spectacles workshops were situated in the early twentieth century.

And then there's what Mostafa ElSayed of Automata Technologies describes as London's 'startup eco system'. Organisations such as Fab Lab London, Bethnal Green Ventures and Bathtub 2 Boardroom offer workspaces, advice, mentoring and a supportive community to budding entrepreneurs.

The clustering of new firms and support groups is crucial to London's startup success, from official groups such as ones to support

female entrepreneurs to more casual WhatsApp groups. In contrast with the cutthroat reputation of an older generation of business people, the founders interviewed recognise that it's not a zero-sum game, but that the more they share, the more they get back. 'There's a support network in London among food brands as a small business,' says Pippa Murray, founder of health food enterprise Pip & Nut, 'who you can email if you've got a problem with a factory.'

Alison Winfield-Chislett of The Goodlife Centre sees this spirit of cooperation as something that has developed since she began her professional career in the 1970s. 'It's so different today, and this collaboration is so exciting as it allows younger people to stand on the shoulders of giants to build something bigger.'

Another factor that contributes to London's place as a centre for business innovation, is that UK bureaucracy around starting a company is relatively minimal. More than one entrepreneur explained to me that it takes just half an hour to go online to register a company and become incorporated – all you need is a name, address, at least one director, a shareholder and £40.

London as a bridge between Europe and the rest of the world is well established, but is now threatened by Brexit. Entrepreneurs tend to be outward-looking and global, as well as valuing both the freedom of movement and goods that EU membership offers. Many of the founders themselves hail from outside the UK, both from countries within the EU and beyond. So, unsurprisingly, if the referendum vote was mentioned in our conversations, it was invariably viewed negatively (as one interviewee dubbed it, 'this Brexit shambles'), but it is striking that so few were allowing its uncertainties to occupy any headspace. Pippa Murray is thinking of increasing her exports in order to balance the increased cost of her imports as the pound weakens. Automata's Mostafa mused as to whether London can retain its position as centre of the design world. French national Jacques Testard of publisher Fitzcarraldo Editions isn't allowing himself to get bullied into the expensive and time-consuming process of getting himself British citizenship: 'I'm stubborn,' he said, 'and I almost like the idea that they might try to get rid of me – let them try.'

On the whole, though, they are determinedly getting on with their work and have no intention of relocating. London isn't just a good place to do business, it's their home. That Brexit will have an effect is undoubted, but as we can't know what that effect will be, most are choosing to concentrate on what they do know about: their own ideas. Will MacNamara of ROLI told me he'd felt heartened by

the fact that those he knew who were planning to start businesses seemed so undeterred by the uncertainties and potential disadvantages that Brexit brings.

There are mutterings of an increasingly hostile environment for new businesses – on top of Brexit, the Treasury appears to be targeting the self-employed (who on average pay less taxes), and there's a suggestion that the government is planning to limit tax breaks on investment. Meanwhile rents and property prices remain too high for many entrepreneurs.

But, despite this, the rate of startups in London shows no sign of abating. Just like the entrepreneurs themselves, this scene is adaptable and resourceful. If investors are becoming wary, turn to crowdfunding. If rents are too high in Shoreditch and Dalston, there are new clusters of innovation emerging, with Croydon and Tottenham becoming hot spots.

Those included on these pages exemplify the spirit of London's entrepreneurship. They are both extraordinary and yet ordinary – they don't necessarily have huge investment, a bulging book of contacts, MBAs or the perfect idea. What they do have, and what we can try to emulate, is determination, vision and persistence. Interviewing and photographing them has been exhilarating; we hope that they inspire readers as much as they have us.

Christina Hopkinson
London, 2018

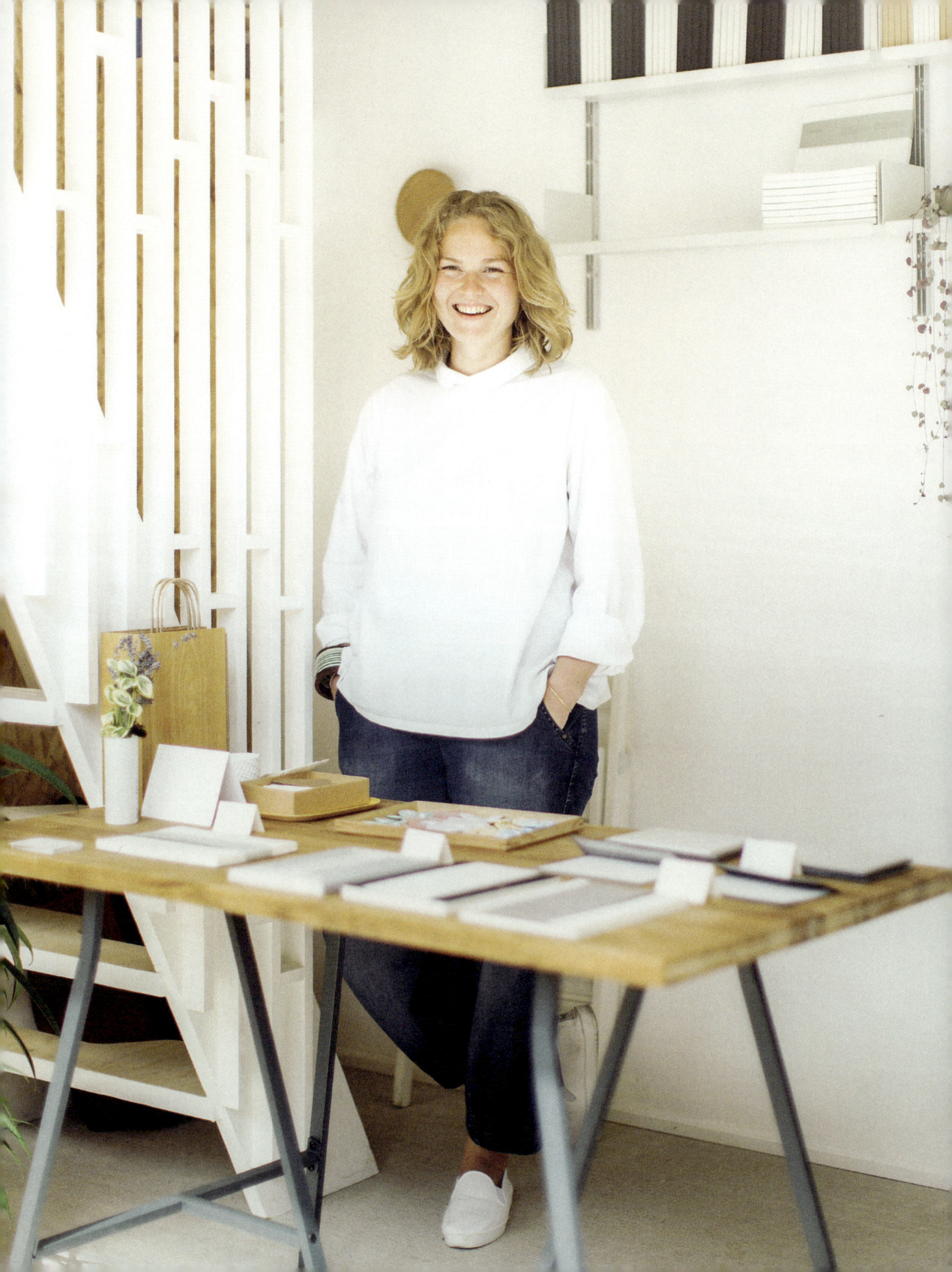

Mark + Fold

How to make timeless stationery for the modern age

Who
Amy Cooper-Wright

What
Modern handmade stationery

Website
markandfold.com

Follow
@markandfold

Startups are often born at moments of transition – graduation from university, retirement or on having children. Amy Cooper-Wright's Mark + Fold, for which she designs and binds stationery made of materials sourced from the world's finest paper mills, is an example of this, created as it was while she was on maternity leave and her daughter was only four months old. Taking her newborn with her, Amy visited factories, mills and printers to find the perfect paper and materials to bind into individually numbered limited edition notebooks, diaries and exercise books using traditional techniques.

But don't use that horrible neologism 'mumtrepreneur' to describe her. 'Rightly or wrongly,' Amy says, 'some people have this idea of, "Oh she's a mum, she's doing a little business in her living room". I want people to respect the brand and not to know or care that I'm a mum.'

While it took the break prompted by having a baby to start the business, its gestation had taken place over decades. 'I've always been obsessed with stationery, from growing up in Camden and taking the bus down to the big Paperchase on Tottenham Court Road where I'd spend all my money on notebooks.'

Studying French and Philosophy at Oxford seems like a detour, but still today she brings a sense of academic inquiry into the power of the stationery: 'Why is it that we all get excited by the blank page? A new notebook and the white surface represents the potential and optimism of starting a project or going travelling. It's like that first day at school.'

After her degree she worked as a project manager for design agencies, including Pentagram, where she developed business expertise, such as the ability to cost jobs and to deal with clients and

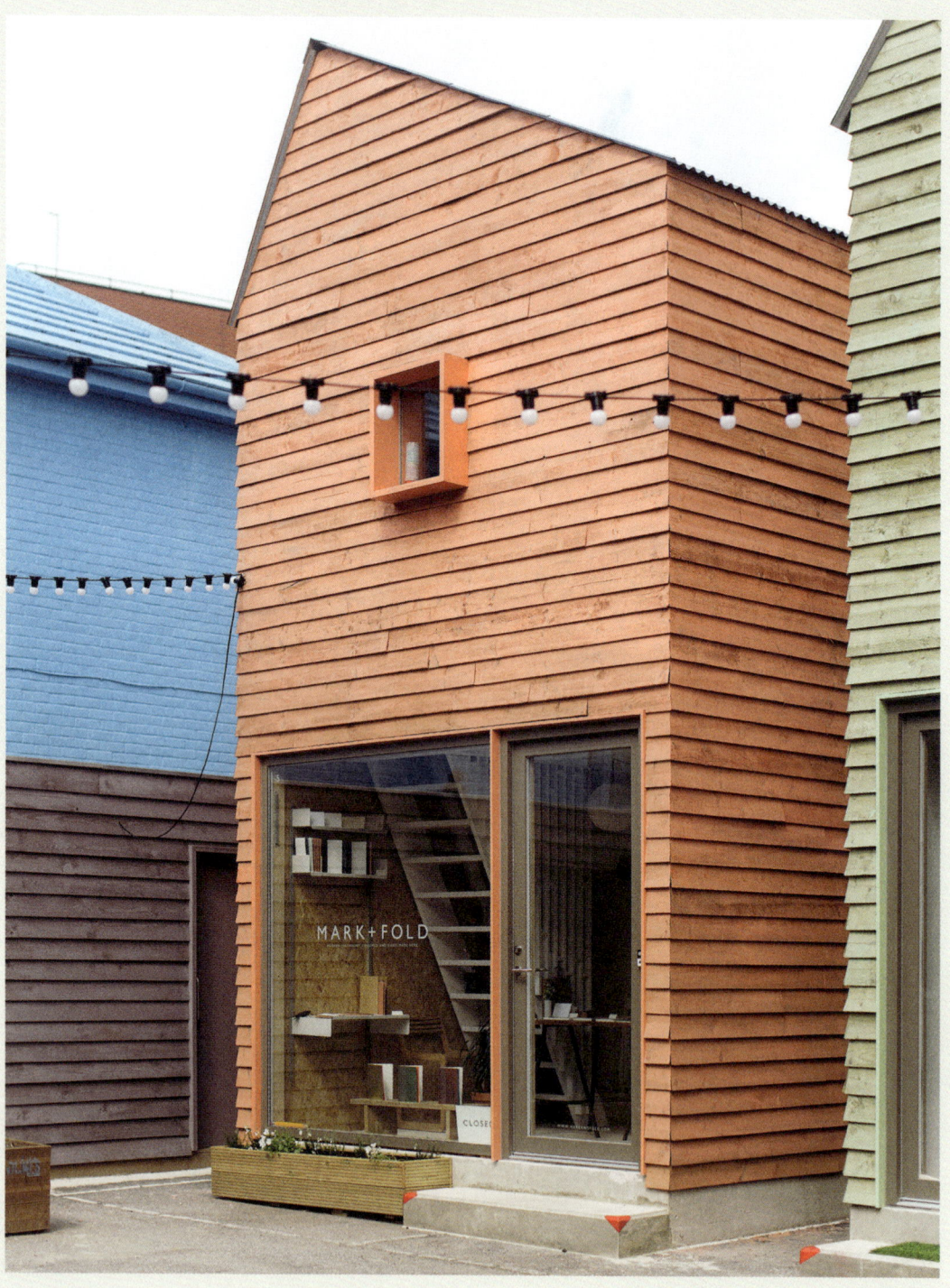

The temporary 'worksheds' at Blue House Yard, a Haringey council redevelopment of a disused car park, provide an ideal space for Mark + Fold to make and sell.

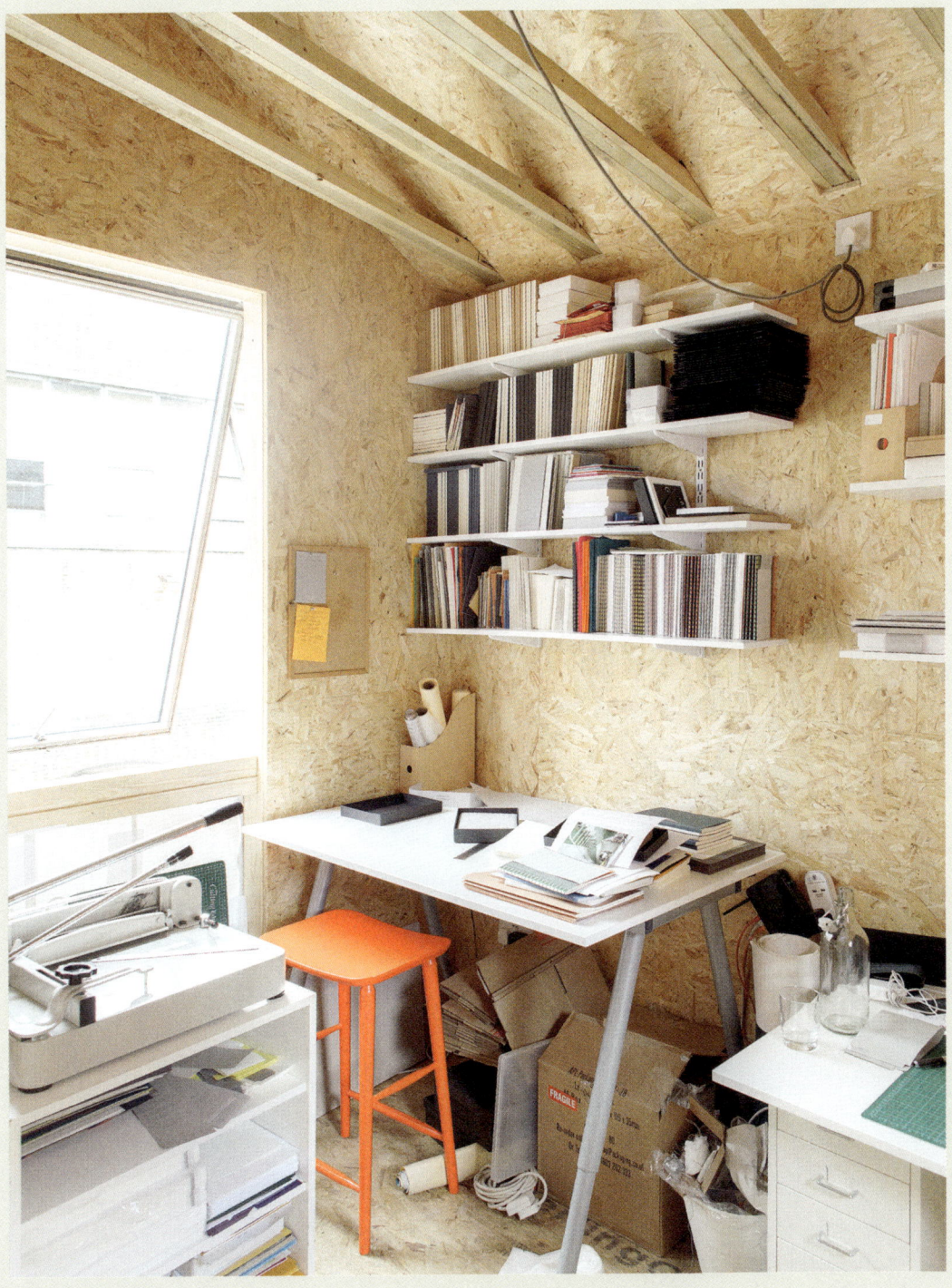

Amy cuts and creates her notebooks and stationery upstairs, while downstairs is open to the public as a shop.

Every range of products is made on a small scale and individually numbered by Amy.

production processes, something which she believes has been invaluable in establishing a business that's been lean and profitable from the start.

You might expect the self-confessed paper-obsessive to be depressed by the fact that most of us use our phones in place of diaries or notebooks, but she welcomes the reduction in waste and the way the digital age elevates paper into something you choose consciously. Less paper means, Amy believes, higher quality – something that is reflected in her careful sourcing, from a Japanese paper mill that uses wool in its products to a family-run printer in Aberdeen.

Amy came up with the name for the business, registered the website and started with an Instagram page before she even had any products. 'This meant that we were an entity before we really were – people took it to be a thing, and it was a way of saying, "This is my idea, come see it".' It was also low-cost and, so far, Amy has been able to run the business funded by savings and sales.

Having tested the market by displaying samples of her stationery on Instagram, she launched with handmade notebooks a few months later in November 2015 and, by the following Christmas, the business was so well established that there was a seasonal rush of customers from across the world ordering from her.

In addition to selling directly, she also sells wholesale through shops that match her aesthetic, such as Oliver Spencer and SCP. It was a buyer from the former who gave her some sterling advice, useful to anyone in retail: 'Whatever you do, it's quiet in February. Until the sun comes out, nobody wants to spend money so don't beat yourself up.'

Opening a shop was always a dream but it has come earlier than Amy had planned or expected. An old council car park near her house in Haringey is to be redeveloped as part of Crossrail, but for five years will be managed by an organisation called Meanwhile Space, who encourage creative businesses to use temporary spaces and boost the local economy. Mark + Fold was a perfect match for one of their beach hut-like units, which is both a workspace and shop front.

Now stationery aficionados and curious passers-by alike can pop into her shop and buy a handmade exercise book, clothbound journal or bespoke planner. From the local browser, buying in an Oliver Spencer shop, to the mathematician in Oklahoma who has a subscription to receive regular notebooks, Amy is building up a group of fans who share her belief in the power of turning over a new leaf.

Standout Advice

'Don't be afraid to make a big statement of your intentions – don't do yourself down or be apologetic, because if you say you're just a little thing, then that's what people will think of you.'

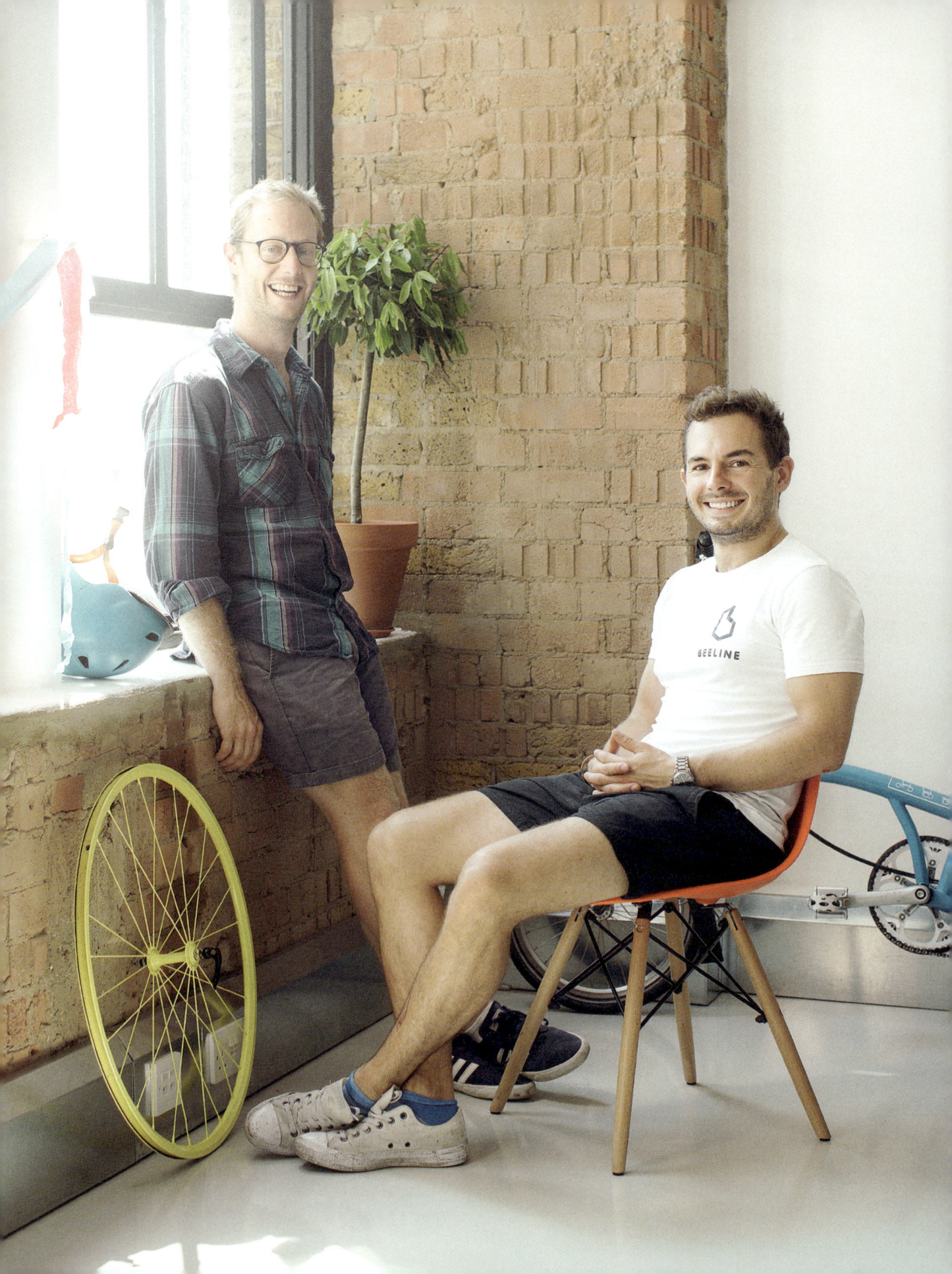

Beeline
How to develop a digital bike compass and not get lost in the world of investment

Who
Mark Jenner and Tom Putnam

What
Smart compass for bikes

Website
beeline.co

Follow
@ridebeeline

Many of the businesses featured in this book begin with an idea and the entrepreneurship follows, but the story of Beeline is very much two would-be entrepreneurs in search of an idea. And ironically they found their way to it when Mark got lost cycling to meet Tom in the pub.

The pair had met when they joined the management consultancy firm McKinsey & Company on a graduate scheme. There they'd talk about 'out-there projects' and how they dreamt of building something new, exciting and worthwhile. They shared a sense that while they were learning lots from the corporate world, it wasn't one they wanted to inhabit forever. They also knew that their similar philosophies but different personalities would make them an ideal team: 'We often joke,' says Tom, 'that I'm the overexcitable, gung-ho one and he's the sensible one . . . the balance seems to land in just about the right place.'

'I'm a keen cyclist,' says Mark, 'but I hate getting lost, having to stop every five minutes to unlock my phone and check the route instead of enjoying the journey. And we got talking about whether there was a cool design for a bike compass and, if not, maybe we should make one.'

Though neither of them had a tech or design background, they were confident that they'd be able to build a prototype in an amateur way. Mark took a sabbatical in early 2015 and used it to teach himself how to build an app using basic

Cyclists input their destination into the Beeline app and the bike compass points towards it with a countdown of how far they've still to ride.

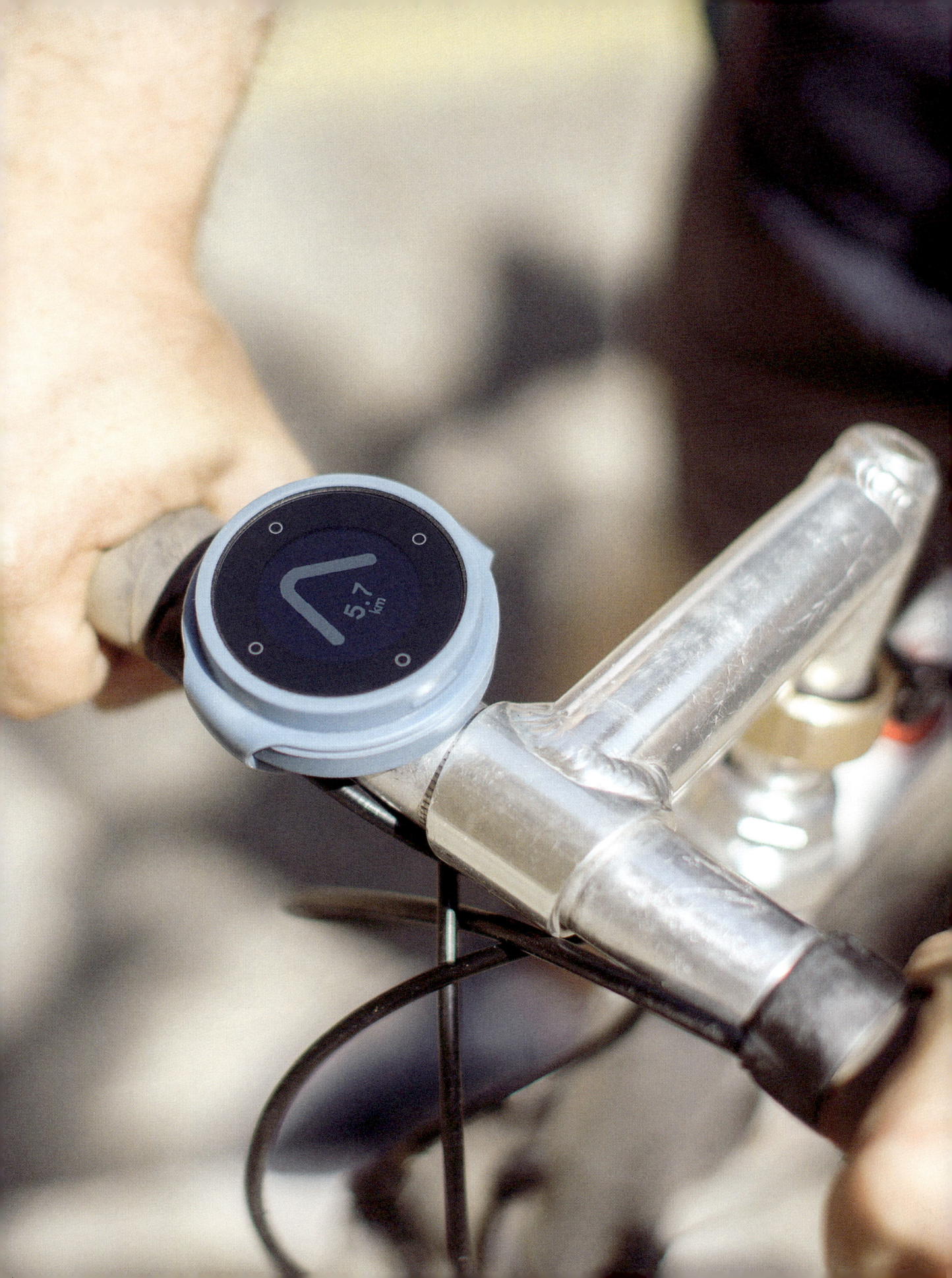

'The community we got through Kickstarter is super strong. If we need to test, they're always willing.'

technology such as the Raspberry Pi, a tiny computer that allows beginners to learn programming.

Building an actual product, as opposed to an app or software, brings with it many challenges – not least a greatly increased cost. First, there's getting the design right to start with. It was here that one of their key pieces of advice comes in: 'partner good people'. They were recommended the agency Map, industrial designers who specialise in making things that make a difference. Map's designers, keen cyclists all, loved the idea and agreed to work for free in return for shares in the company.

A large part of the appeal of Beeline is its tactile simplicity, but there were many tricky design elements to get right. 'The manufacturing has to be very precise to make sure it doesn't budge when it's attached to your bike, that it's watertight, that it can be removed for charging.

It's complicated to make something so simple,' says Mark.

What started out as a basic compass expanded to include additional features such as a distance countdown and a clock. The user inputs their destination onto the phone app, which is paired with the Beeline strapped to their bike. Then the device's arrow points the rider to the end goal, while allowing them to make their own decisions as to the route. It means you feel as though you're always headed in the right direction without having to stress about the exact path.

Once Tom and Mark had a working prototype they could crowdfund on Kickstarter, which had three benefits – firstly to raise money, secondly to check if there was a market for the product and lastly to raise awareness. It did all these things and more. 'The community we got through Kickstarter is super strong, 18 months after the campaign. If we need to

test, they're always willing.'

While Kickstarter proved useful, it by no means provided them with the funding they needed: 'If you're going to do something with both software and hardware, you're going to need a lot more money.'

The initial £500,000 required to go into full production came from a mixture of private investment from small seed investors, strategic partnerships such as with their 'brilliant' Chinese manufacturer Victor, and some institutional investors. But it wasn't easy, recalls Mark: 'When you go to typical investors, they're looking for a software platform that can launch and reach customers quickly; a risky product you have to manufacture is out of their comfort zone. We talked to a lot of people where it was apparent from the off that they wouldn't invest . . . we had a lot of bad dates!'

But in January 2017, their faithful Kickstarter community got their compasses and full-scale production began. They've now expanded into their Bermondsey offices with a team of six. Within nine months of launching, they'd sold 8,000 devices and been awarded the Best Consumer Product by Design Week and nominated by the Design Museum for the Design Week Designs of the Year award, although an attempt to win funding from BBC's *Dragons' Den* proved fruitless.

In the immediate future they'll be focusing on increasing what their compass can do, and then introducing a scaled-down, cheaper version. After that they want to develop further products: 'Anything that makes the journey better.'

Standout Advice

'Recognise that you can't do everything and partner up with good people as early as you can – giving away equity to our design partner and to our manufacturers has been one of our best decisions.'

Blackhorse Lane Ateliers

How to slow down fast fashion with handmade jeans

Who
Bilgehan 'Han' Ates

What
Raw and selvedge jeans

Website
blackhorselane.com

Follow
@blackhorselane

In 2009, Han realised that he had become disgusted with the fast, throwaway fashion industry that he'd been working in for over 20 years: 'From China to India to the Philippines, I had seen the worst part of fashion . . . its high carbon footprint and the poor conditions of workers.'

Han left the industry and travelled with his family for nine months and on his return to London decided to open a restaurant near his home in Stoke Newington. 'Food was a chance for me to connect with my community and I liked the way that ingredients and where they came from is so important.'

For three years, the restaurant, Homa, thrived but Han watched his chefs with envy. 'I owned the restaurant but I wasn't in the creative seat and I missed that. I looked back at my life and realised I'd been most happy in the workshop, touching, feeling, deciding, working with the product every day. I needed to go back to making stuff.'

It was a revelation that would lead to the foundation of Blackhorse Lane Ateliers, makers of selvedge and organic raw denim jeans, at the end of 2012. He closed his restaurant but took away from it a conviction that ingredients and

> 'I wanted to give something back to London's heritage. Thirty years ago, we had 2,000 or so factories within three square miles and now that's lost.'

honouring customers' trust was crucial. Han asked himself, 'Why can't fashion be like that?'

He wasn't sure what aspect of fashion would fulfil these ambitions until he bought three pairs of jeans in Regent Street and was shocked at both the low quality and their carbon footprint. It was then that he decided he would make jeans that were high quality and locally manufactured – as good or even better than the 'very best makers from Japan'.

Han brings out a pile of jeans from the shelves and shows me the different stitches and techniques that distinguish the good from the truly great – tiny, almost imperceptible details, like how the stitching ends and the look of the leather label.

But why London, an expensive city where manufacturing is all but extinct and there hasn't been a jeans factory in over 40 years? 'I wanted to give something back to London's heritage,' says Han. 'Thirty years ago, we had 2,000 or so factories within three square miles and now that's lost. I wanted to revive the garment-making heritage. London has a special energy of people wanting to do things differently.' Blackhorse's jeans are even named after postcodes to reflect their style – the E8 being considerably skinnier than the well-heeled NW3.

Han was fortunate that he owned a high-ceilinged factory in Walthamstow, having bought it over 20 years previously, when, as he puts it, 'All the lovely loft-style apartments in Dalston were shitholes full of rats and Shoreditch was unsafe.' But even with this advantage, additional funds had to come from somewhere and in his case it was by re-mortgaging his house three times and

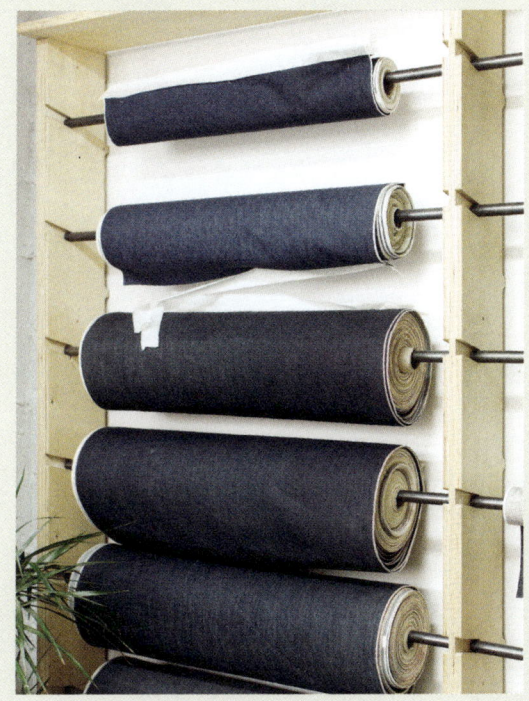
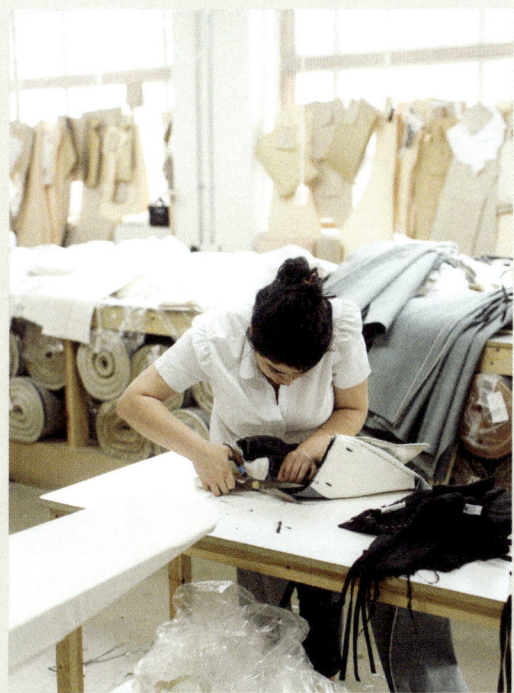
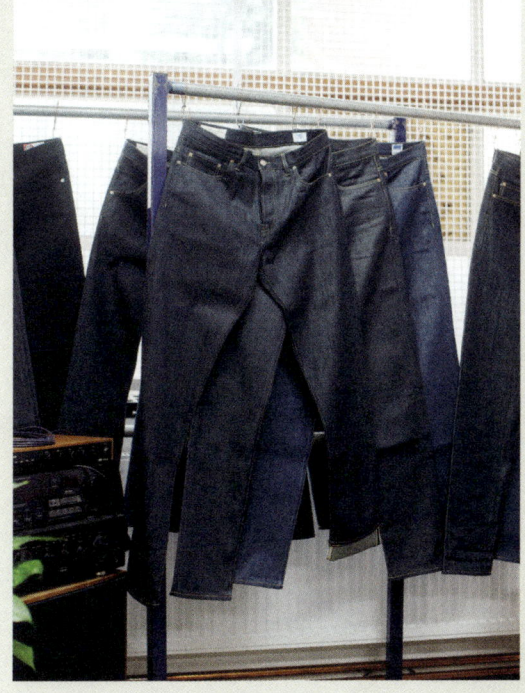

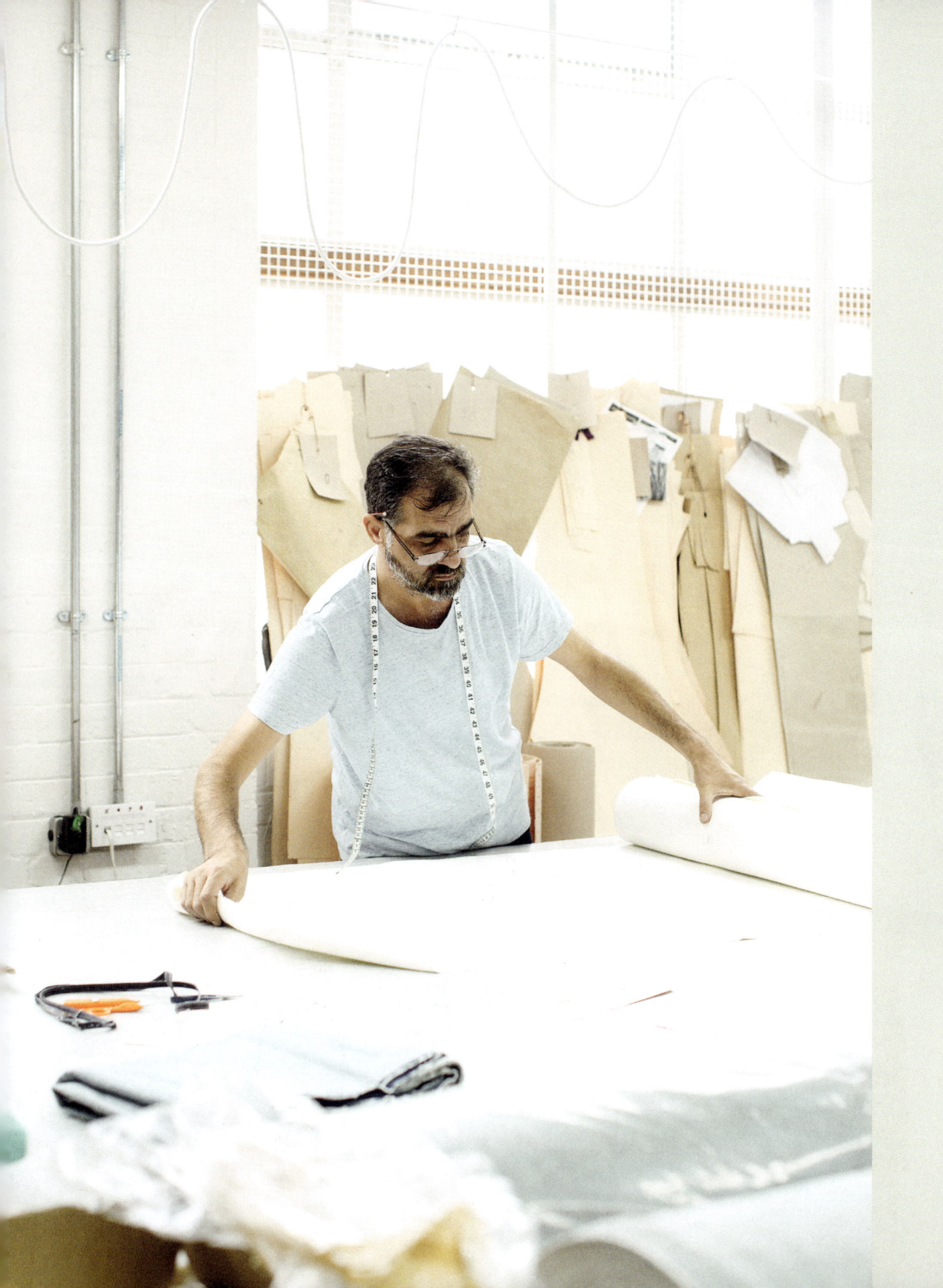

taking out bank loans. 'My credit score is rubbish,' he admits.

One of Han's biggest challenges was finding skilled machinists, a group that he reveres. 'My mum and dad were machinists and weren't respected enough. I'm the facilitator but they're the real makers and it's important that we talk about them with the respect they deserve, more like we do chefs.'

All the workers at Blackhorse are paid the London Living Wage and are given the opportunity to become shareholders in the company.

The second challenge was finding the necessary knowledge to make premium jeans. The construction is complicated, especially with no one in London who could share the expertise. 'Even the smallest details took us two weeks to work out how they were done – we had to teach ourselves by unpicking them.'

His philosophical ambitions are huge: Blackhorse is to be a movement rather than a fashion brand. 'We want people to understand that they need to buy intelligently because everything has a carbon footprint.' It's their aim that every customer who buys a pair of jeans takes the philosophy of thoughtful consumerism and applies it to all aspects of their lives. 'I don't want them to be zombie customers but to question everything that they buy.'

This is put into practice at the factory where they eat food grown on their own allotment and share workshop space with an art restorer and weaver.

Blackhorse's business ambitions are rather smaller. 'The aim isn't a £3-million turnover and we only want to go from our current nine employees to 18 or so. If there is demand in Tokyo or Denmark, we wouldn't export but instead find local partners. Community and connecting to local people is paramount.'

Standout Advice

'Get good financial advisers right from the start – I should have put more money in at the beginning rather than later, and a good adviser would have helped me with this.'

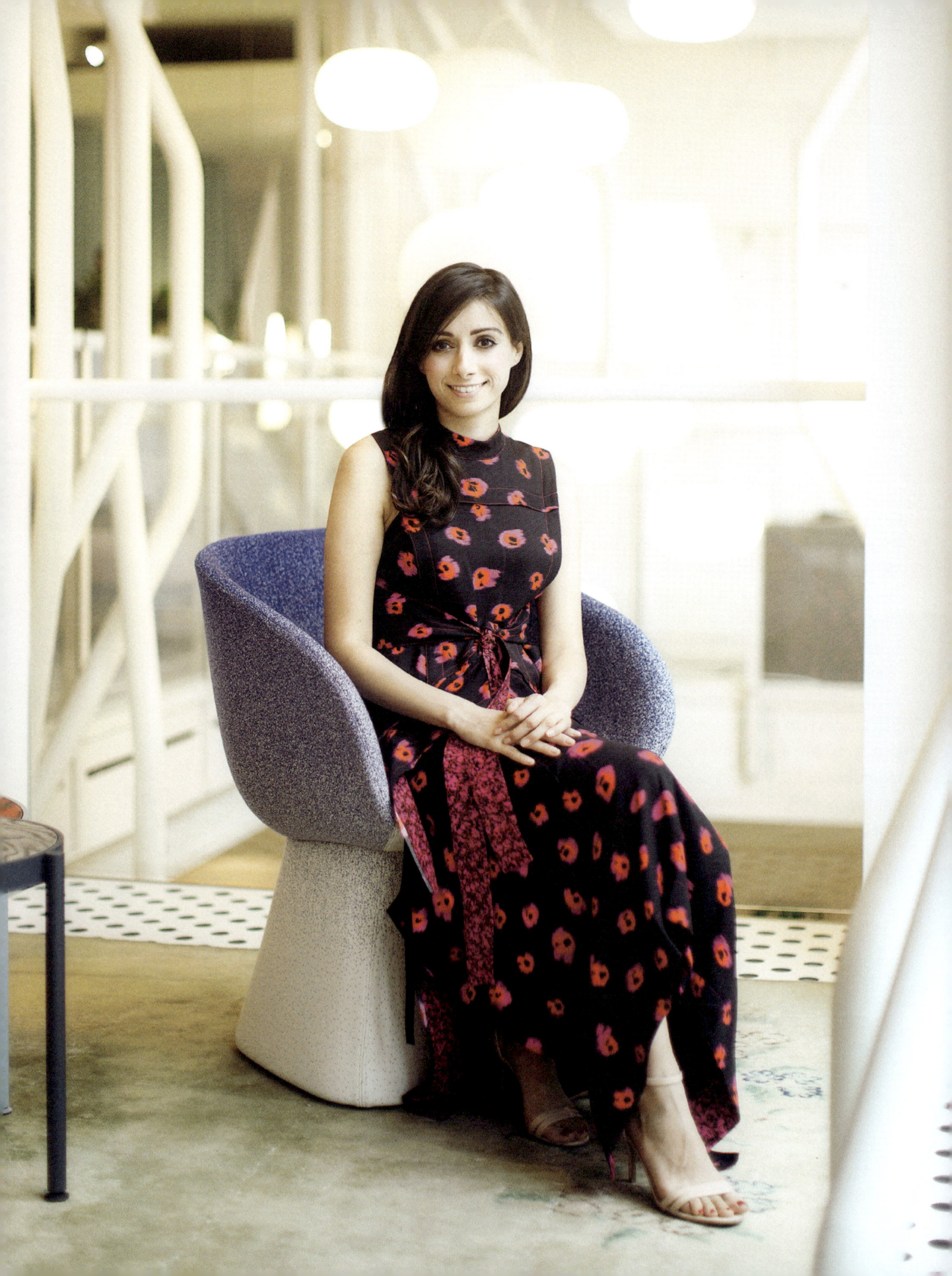

Eporta

How to fill a gap in the interiors world with smart technology and business instincts

Who
Aneeqa Khan

What
Online platform for interiors professionals

Website
eporta.com

Follow
@eporta

Aneeqa was a child entrepreneur, selling sweets to her friends at school from a young age and always on the lookout for opportunities.

'I was always going to start something,' she says today. 'Both my parents have their own businesses and I was packing boxes in my dad's factory from the age of ten.'

Her parents had what she calls 'real-world' businesses and she was determined that whatever she started would be a long-haul, sustainable company, rather than a get-rich-quick scheme. 'I'm not thinking, "Grow this business, flip it", like many of my generation.'

After leaving Oxford University, Aneeqa worked in private equity and then as head of strategy for the property search site Zoopla. It was when buying her own flat in Brixton and trying to fill it with interesting furniture and objects that the idea for Eporta came about.

Although she had originally decided to build a website aggregating manufacturers to sell directly to consumers, she soon realised that the real bottleneck was on the trade side. Working with other businesses has the additional benefit that professionals tend to make their decisions more efficiently than homemakers, who prevaricate. 'I always joke

Terrariums made by Eporta's team on display at the Clerkenwell offices.

The online platform offers easy access to furniture and interiors objects, such as this Tropicalia Chair by Patricia Urquoila for Moroso.

> 'We said that if in six months it's not going anywhere, we kill it.'

that London people spend half an hour looking at a property before putting in an offer, but six months to buy a coffee table to put in it.'

She was astonished to find that there wasn't an easily navigable website to allow the trade to buy directly from manufacturers. 'There had to be need for whatever I founded, it had to be useful,' she stresses. 'Nobody needs another useless technology company.'

By putting all the manufacturers onto one searchable website, as well as streamlining the invoicing process, she has made it easier for architects, builders and designers to both find and buy what she calls 'gorgeous gems' from companies as renowned as Tom Dixon to little known as the Portuguese footstool and chair maker Duistt.

The manufacturers get a platform to reach new customers in return for a small commission to Eporta, which is 'much cheaper than going through a dealer or an agent or setting up a trade show'.

Aneeqa shared her idea for the platform with her old friend, Simon Shillaker, who became her technical co-founder. They gave themselves half a year to make a go of the idea. She believes that it would have been impossible to have got it off the ground while still working in a day job, but at the same time was disciplined about a time limit. 'We said that if in six months it's not going anywhere, we kill it. This meant we worked night and day for that time and it wouldn't have worked with juggling other work.'

Initially they survived on their savings but towards the end of the year they had enough of a working product to go out for funding. Aneeqa's successful career at Zoopla led to them being the first investors. 'Our first raise was basically people we'd worked with before – not friends and family, but companies I'd worked at.'

So far so smooth, but the tricky bit came when trying to get the first manufacturers and customers to commit to the site when it was merely an idea rather than a thriving market; especially in interiors, which Aneeqa sees as 'sleepy' in comparison to an industry like fashion that has embraced online shopping. 'It's so hard convincing people of a vision of something that's new . . . lots of people think you're bonkers and you get kickbacks.'

The flipside of this model is that once a few customers and manufacturers have been acquired then growth tends to be exponential, and the website featured over 1,000 suppliers only a few months after its launch in September 2016.

As well as growing the users of the site, the company itself has been expanding at a rapid rate, meaning Aneeqa has had to relinquish areas of control to 'senior people who are used to managing teams and can do their jobs better than I can'.

Careful delegation gives her the opportunity to grow Eporta outside the UK, which had always been a central aspiration for Aneeqa, reflecting her own very international heritage (she's part Yemeni, Iranian, East African and, she says, all Mancunian). 'We're in 80 countries already, but in the US we need people on the ground there. And there's the Middle East – it's a great but unique market where we'll also need local staff.'

These are all grand plans for the future, but in the short term there are bakes to be eaten. 'We have cake every day,' she says. 'It's super important that people love coming to the office. It makes me so happy when I see people laughing and having a good time here.'

Standout Advice

'Listen to your own mind – if you have conviction in your idea, don't listen to the naysayers. But if you're quivering in your own head, then maybe you need to be honest with yourself and rethink.'

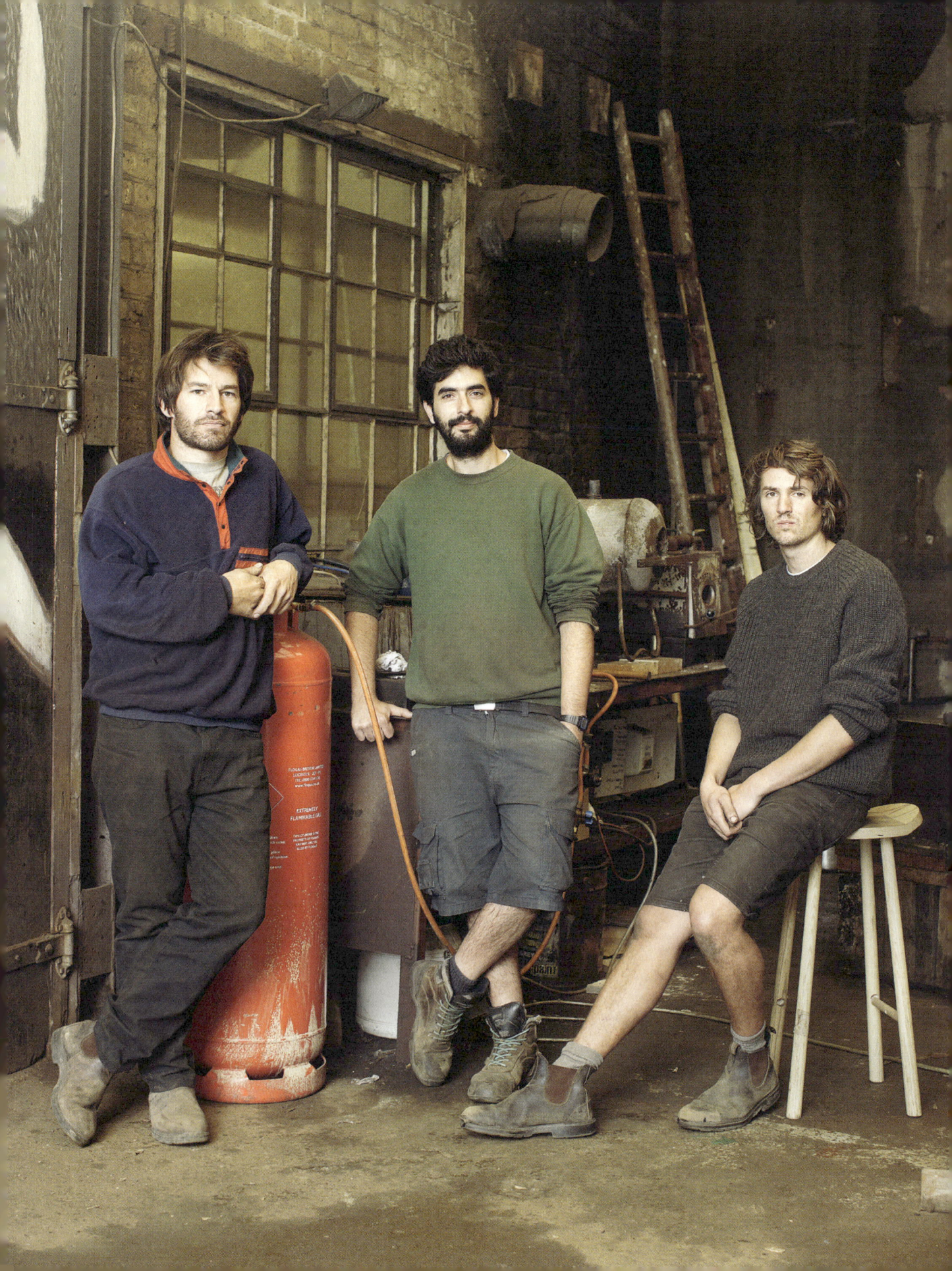

Blenheim Forge

How to cut through the business minefield with a passion for making knives

Who
Richard Warner, Jon Warshawsky and James Ross-Harris

What
Hand-forged knives

Website
blenheimforge.co.uk

Follow
@blenheimforge

The trio behind specialist knife-makers Blenheim Forge have little interest in business plans, marketing concepts, Excel spreadsheets, scalable projects and seed capital. They just want to get on with making their knives amid the sparks, hammers, anvils and angle-grinders that assault your eyes and ears on arriving at their forge under the arches at Peckham Rye station.

These aren't 'just' knives though. Their blades are created by using the Damascus process, where layer upon layer of steel are welded together. This method is both time consuming and error prone. 'In 2014 we were making only one or two a week, now it's more like 30,' says Richard. At first, as many as three out of every four wouldn't make the final cut, so to speak. 'Now it's only about 10 per cent going wrong.'

The result is a blade with a rippling, mottled effect paired with a handle made from locally sourced wood. Although they're necessarily pricey (from £150 to over £600), they've found fans in both professional and amateur kitchens.

'There are more amateur chefs out there, especially ones with a bit of money,' says James, 'but if you ask any chef in London who we are, they'll know.'

Their knives have sliced some of London's finest food, in kitchens from Brunswick House in Vauxhall to St. John

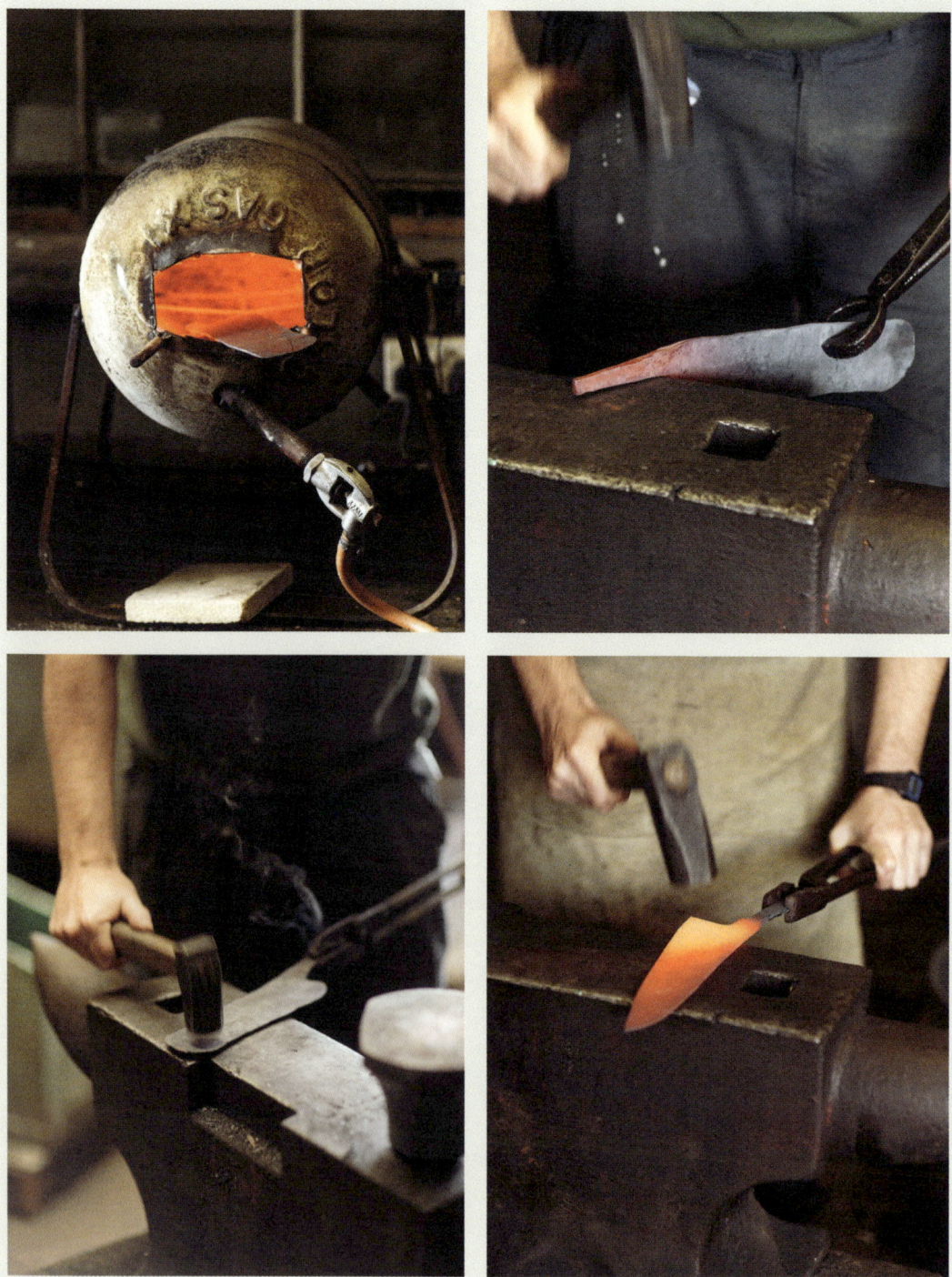

The final stages of the forging process (clockwise from top left): preheating the blade in a homemade gas forge; forging the knife's tang (the steel that lies beneath the wooden handle); forging the blade itself; refining the final profile of an almost-finished knife.

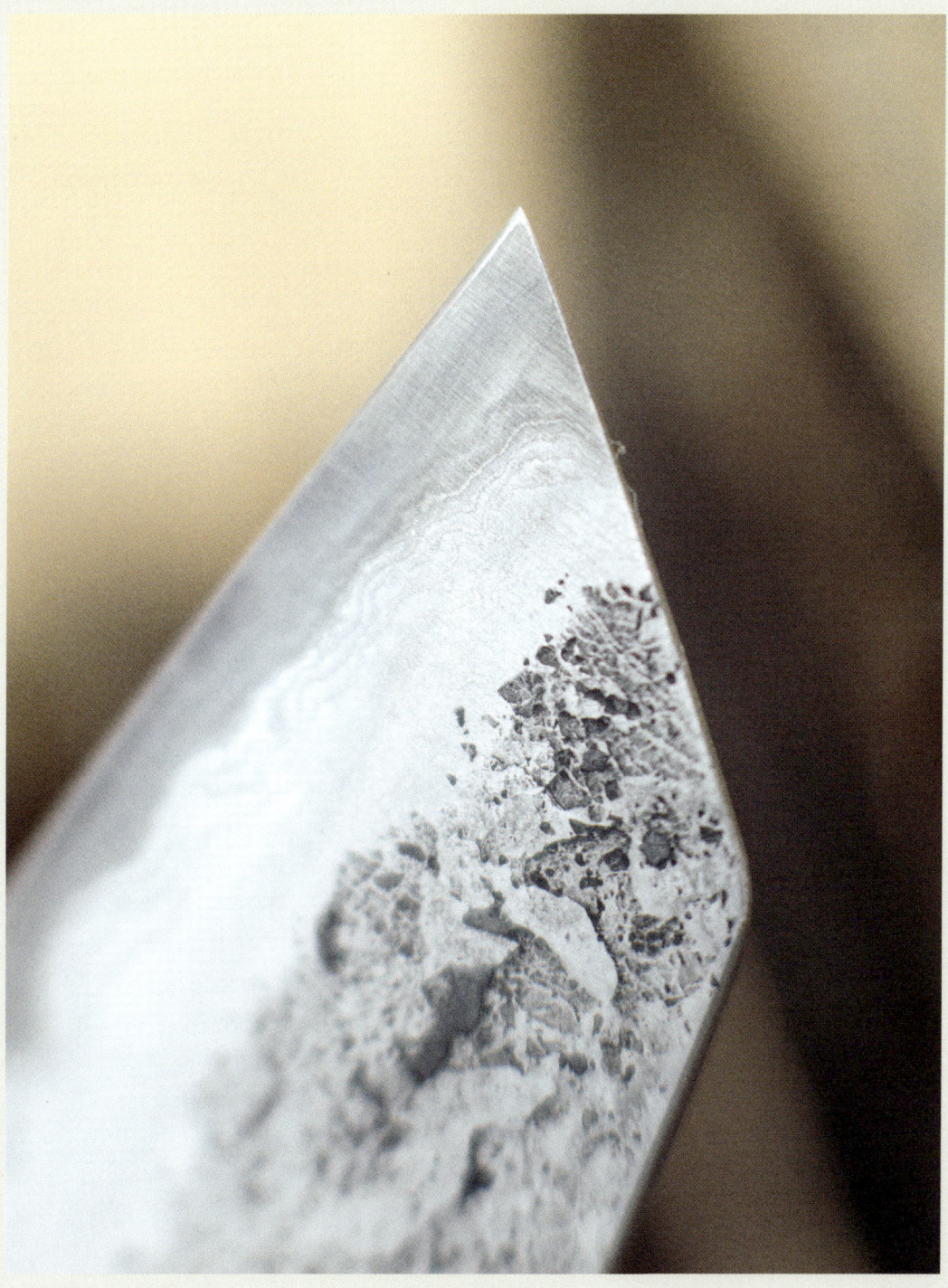

The knives are forged using the Damascus process, where layer upon layer of steel are welded together, to create their distinctive rippled appearance.

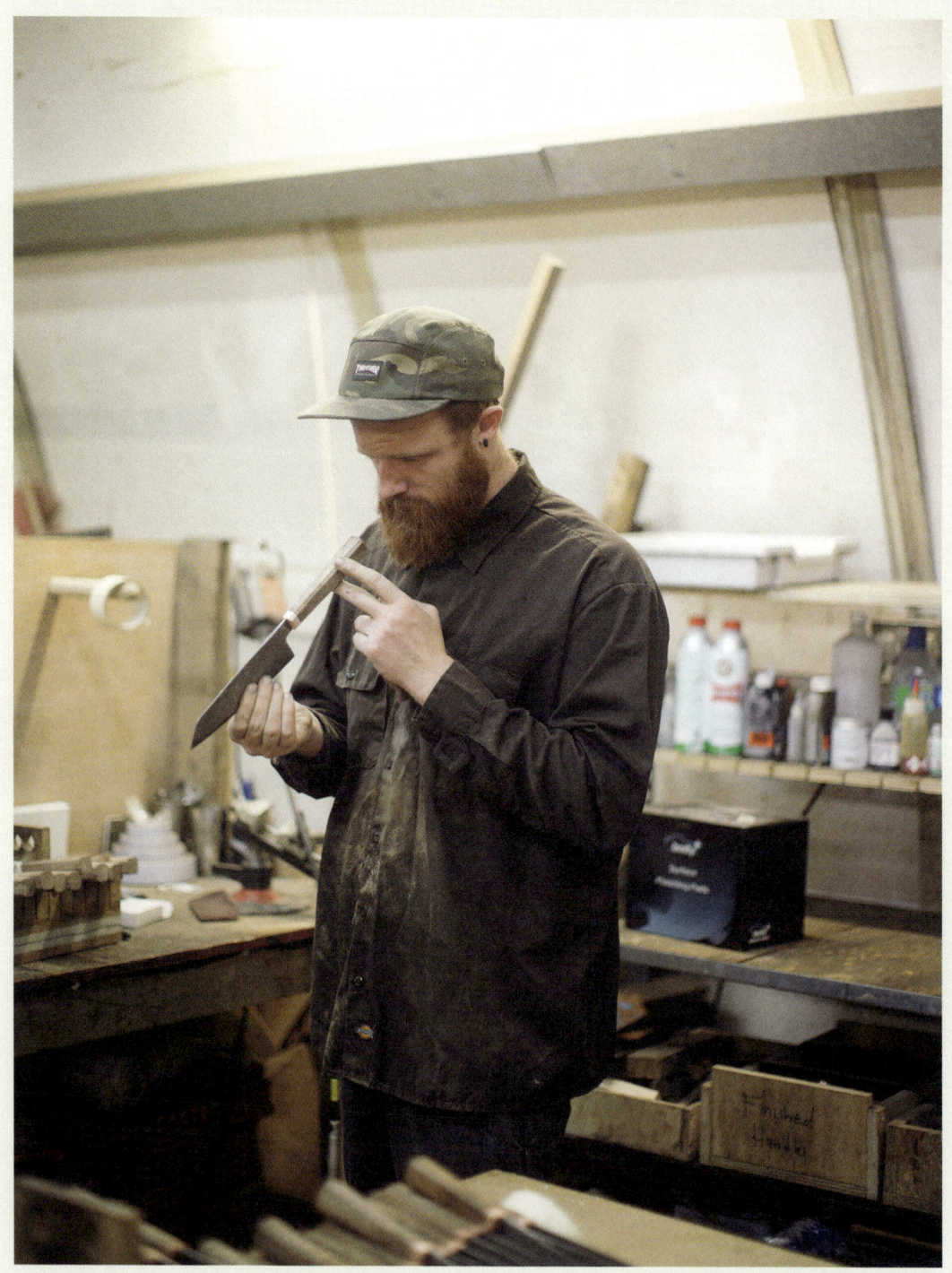

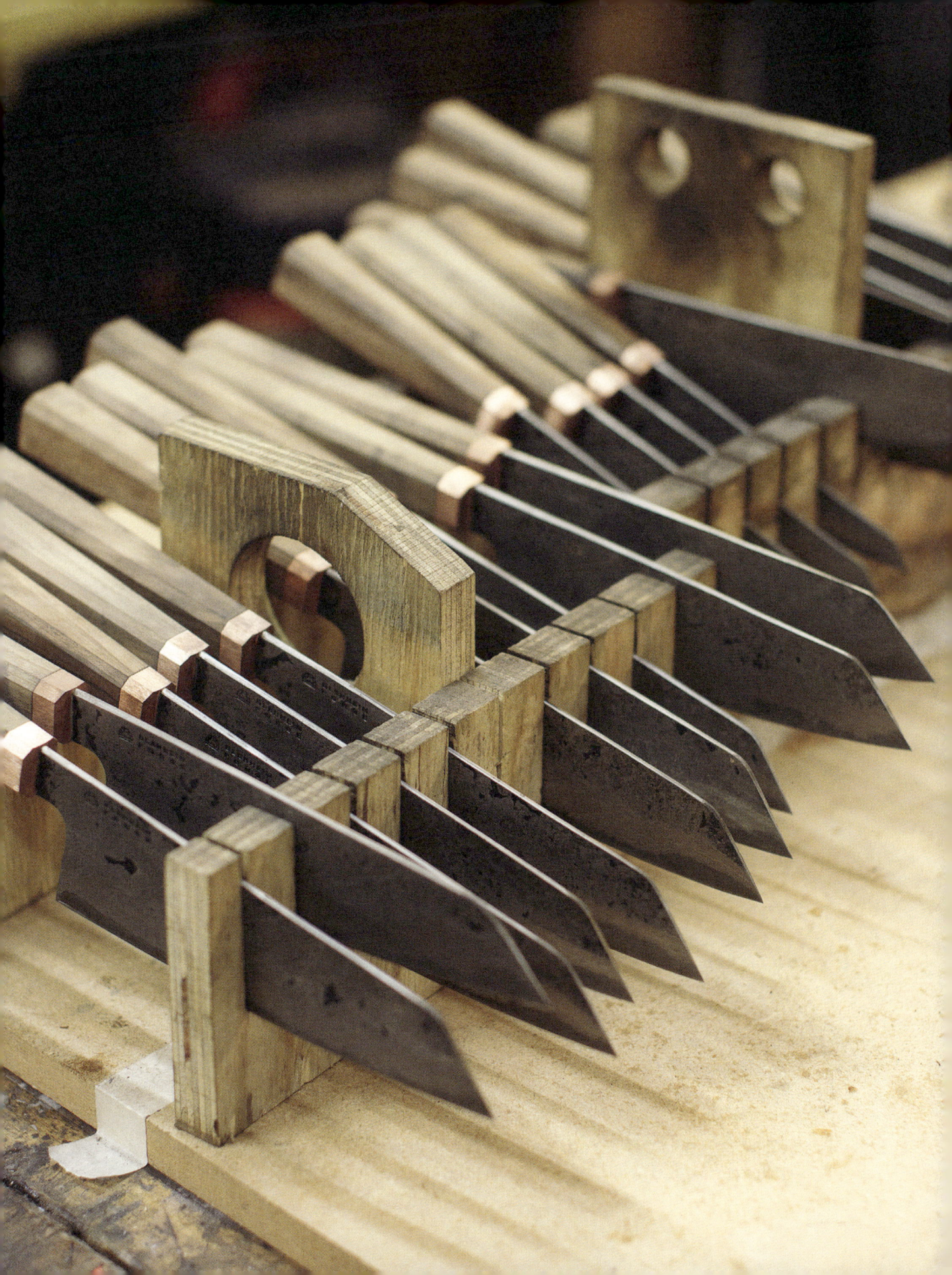

in Clerkenwell, and they sit in the kitchens of restaurant critic Jay Rayner and TV chef Hugh Fearnley-Whittingstall.

The business started back in 2013 almost accidentally. Jon and James were living together in a house around the corner from the forge and were 'messing around with knives' in their garden. James was working as a blacksmith and furniture maker in the premises that would eventually house Blenheim Forge, so had the knowledge, while Jon was completing his PhD in philosophy, aching to ditch abstraction for construction.

After a few months of making knives to give to their families, James' bosses decided to move out of the Peckham workshop and the opportunity arose for them to take it over. 'It's a perfect space for making knives,' he says, 'as it has outside and inside space, plus this is a good area for starting in as there are lots of restaurants around.'

Their friend Richard, who'd been working in a lucrative job building roads in Australia, soon joined them. Some of the previous occupants' equipment was left in the forge and the rest they made themselves. 'We didn't need to put in more than a couple of hundred quid to start,' recalls James. 'The forge was made from a load of scrap metal.'

Its location, in Blenheim Grove, gave the business its name. 'Though it turns out it's slightly confusing when you leave Peckham because everyone thinks you're working out of Blenheim Palace.'

The incongruity of a blacksmiths in Peckham also generated all the press interest they needed, right from the start, 'and the fact that we're covered in dirt' adds James. They've never needed to market or publicise their knives and although they're toying with the idea of adding some sort of 'how did you find us?' button on their website, they're unsure how effective any targeting of customers would be.

As inadvertent entrepreneurs, they cheerfully admit to having no interest in the administrative tasks of running a small business. 'To start with we'd spend all our time making knives,' remembers Richard, 'and it wasn't a very good way of making money.'

In fact, it took them over two years to start to pay themselves salaries big enough to live on. Even now, they concentrate their efforts on buying new tools and refining the process of knife-making rather than the HR, accounts and email-answering that's an inevitable, if unenviable, part of business. 'At the moment, there's three of us reading the same email and no one necessarily answering it so it makes sense for us to employ a manager to do the paperwork,' says James.

They now have even less time to concern themselves with financial planning, having taken out a lease on outbuildings on a farm in Hampshire where they work for two days a week to give themselves more space in which to carry out projects too noisy for the heart of the city.

It's no surprise that they've no fixed plans for the future. 'We've got an annual cycle,' says James, 'where we get bored at about this time of year and start thinking of new ways to change and improve the process. We'll probably be making completely different knives by next year.'

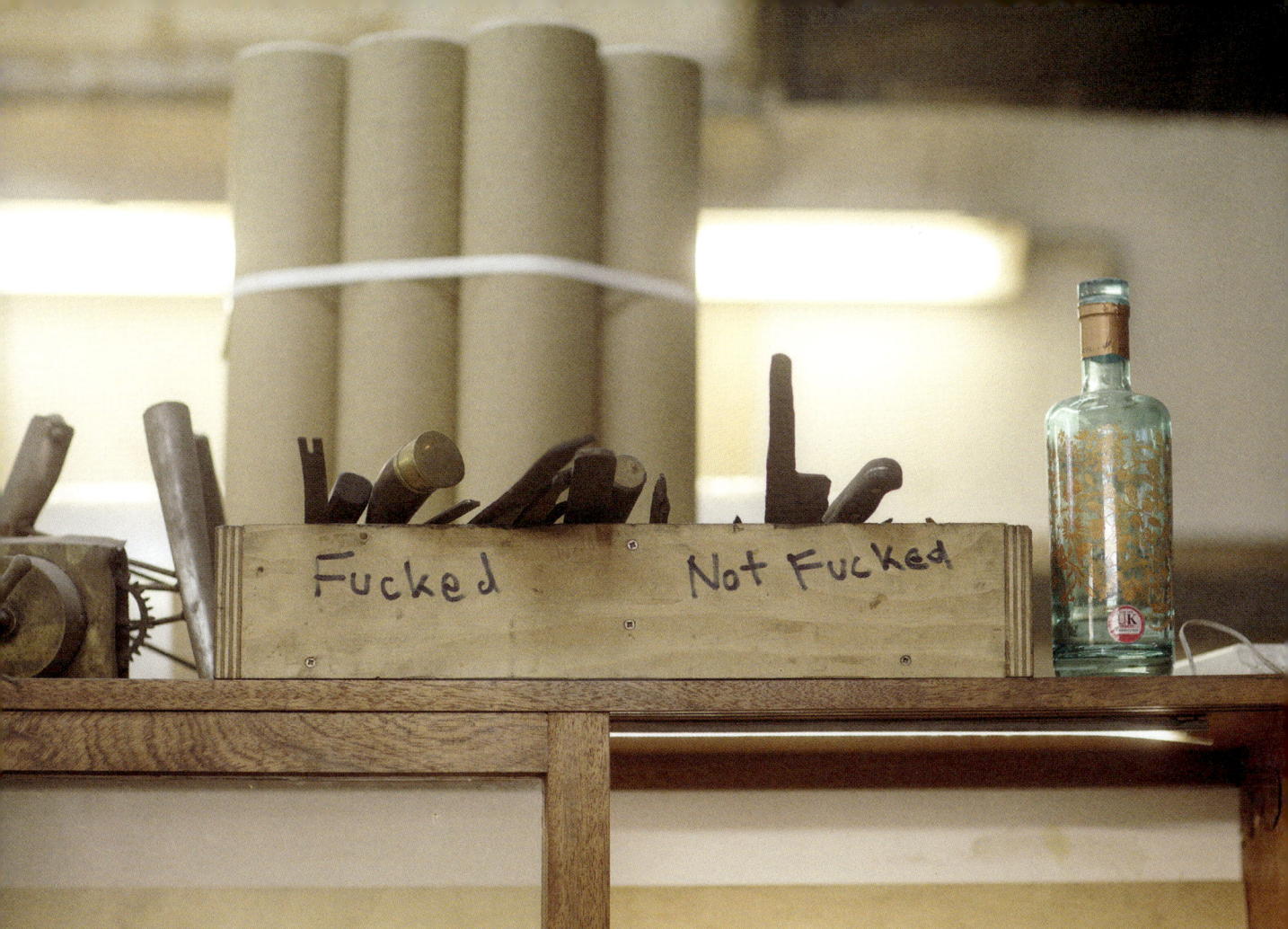

At the beginning, as many as three out of every four knives would be thrown in the 'fucked' side for those not deemed good enough. Now, around 90% make it to the hallowed 'not fucked' box.

Standout Advice

'If you want to start a business quickly, get all the kit right away. Going to a bank and getting a loan would have sped things up for us.'

Birdsong

How to sell clothes that both look good and do good

Who
Sophie Slater, Susanna Wen and Sarah Beckett

What
Ethical fashion empowering women

Website
birdsong.london

Follow
@birdsonglondon

Birdsong is a sort of small-scale, community-focused Net-a-Porter that connects the worker to wearer by selling products made by charities supporting women. Original founders Sophie and Sarah saw that there were women's groups crafting beautiful clothes yet struggling to find a market and that, if they could sell their wares online for them, they could help to solve this issue. Thus the e-tailer was born in 2015 with the promise 'no sweatshops, no Photoshop'.

Sophie and Sarah had met earlier that year on a postgraduate programme called Year Here, which Sophie describes as, 'A crash course in the social sector with six months' placement in a charity and a few months with a local council.'

Through Year Here, Sarah had a placement with Age UK which first gave them the idea for Birdsong. 'They had a knitting group called Knit and Natter that had been meeting for 15 years, who made wonderful hand-knitted jumpers but were selling them for £5 at bring-and-buy sales.'

Sophie and Sarah had a lightbulb moment when they realised if they could sell these products online for prices that reflected their quality and craft then they could help small groups to self-finance. Initially they paid their partners a commission based on sales, although subsequently they've moved towards paying the women a London Living Wage for the hours they work on the products.

The founders were only 23 and 24 at the time of Birdsong's inception and their relevant experience was limited to a short stint at a digital marketing agency and a job as a shop assistant at American Apparel – what on earth made them think they could do it? Partly, they concede, naivety, but Sarah also recognises the huge benefit of Year Here. 'They forced us to have confidence by organising a live

crowdfunding event, which meant that we couldn't just talk about starting a business, we had to get on with it.'

The event raised £8,000 and they were on their way. Next they approached Bethnal Green Ventures, which invests in and supports tech companies aiming to make positive changes as well as profits. BGV provided investment and their current office, in the middle of a 1920s housing block in Somers Town, a socially and economically mixed area near Euston station. They also provided constant advice. 'We didn't know what we were doing,' admits Sophie, 'I didn't even know what a shareholder was or what incorporated meant. Now I wonder whether we'd have done it had we known all the paperwork that was involved.'

In the summer of 2016, they raised more funding on the crowdfunding platform Crowdcube – they targeted £75,000 and got £86,000 within a month.

Along the way, they've discovered that London is a peculiarly fertile place to set up a business. Says Sarah, 'We sell a lot of our stuff in Berlin and talking to people there makes me realise how much easier it is to set up in the UK than elsewhere, in terms of bureaucracy. Here, £40 and half an hour is all it takes to register your own company. There's so much help for start-ups – we've been on both free and paid-for programmes.'

One of Birdsong's challenges has been how to balance supporting their partner charities but at the same time selling products that are as stylish as they are ethical. With this goal they hired designer Susanna Wen so that now half the products on the site will be made up from her designs, with the rest of the clothes and accessories sourced directly from the women's groups. In other words, Birdsong is becoming a brand as much as a platform.

The future plans for Birdsong are fluid. They've had a sell-out popup store in Old Street and aspire to a permanent retail space. Recently, Birdsong has evolved from a straightforward e-commerce site into the go-to company for the crossover of fashion and ethics, manufacturing t-shirts for charities and social enterprises as well as designing and producing a uniform for the workers at Mazí Mas, a Dalston-based catering company that trains refugee women.

It all happened at such breakneck speed that I wonder if there are things they wish they'd done differently. 'Oh, so much,' laughs Sarah. 'And in six months from now, there will be loads more that we'll look back on and wish we'd done differently. But it's great to be able to do that and see how much we've learnt along the way.'

Standout Advice

'Don't wait until everything is perfect before starting – go out there and test stuff immediately so that you fail in small ways rather than thinking about everything for a year and failing in a massive way.'

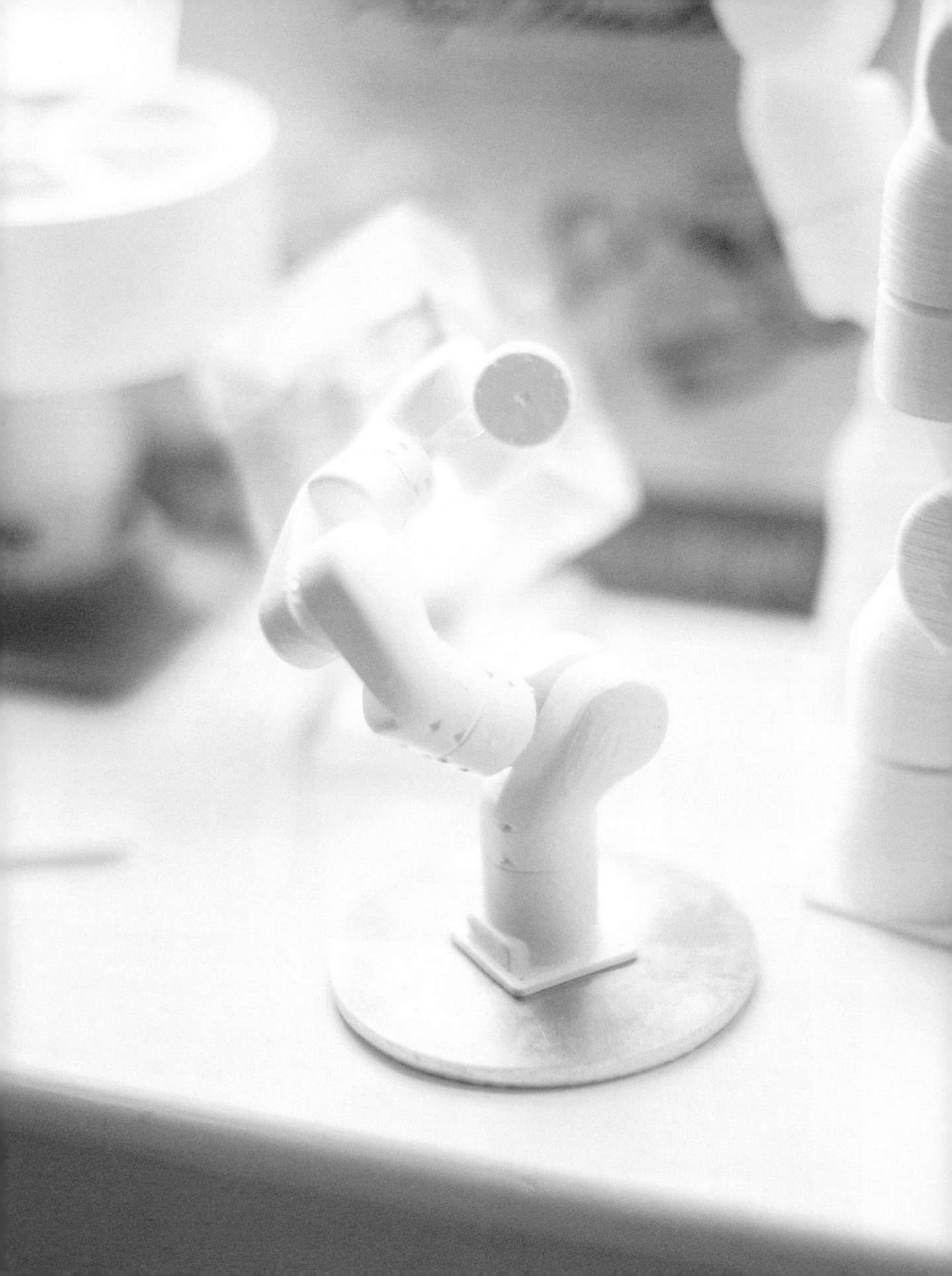

Automata Technologies
How to democratise robotics with the help of an industrial arm called Eva

Who
Mostafa ElSayed and
Suryansh Chandra

What
Affordable robotic arms

Website
automata.tech

Follow
@automata_tech

Suryansh is the sort of person who sees the lull in the office over Christmas not as an opportunity to slack off, but to investigate a cutting-edge project.

One such Christmas, while working in research and development at the offices of Zaha Hadid Architects (most famous in this country for the London 2012 Olympics' Aquatics Centre), he explored why the experience of using robotics in the workplace remained so poor.

Ten days proved not enough time to solve this particular conundrum, but his interest was piqued and he shared what he had learnt with his colleague, Mostafa, who he'd known since they studied together at the Architectural Association School of Architecture. They had both been feeling dissatisfied since the professional high in being involved in the creation of Zaha Hadid's construction for the Venice Biennale in 2012. 'You experience that feeling of immense satisfaction at work,' recalls Mostafa, 'and you're seeking a way of replicating it.'

For the next few months, they'd snatch conversations in the lunchtime queue at the Waitrose opposite their

> Despite having no robotics experience, ex-architects Mostafa and Suryansh were determined to improve what they'd found in the market.

office, wondering whether they were cursed by having done such amazing work so early in their careers. It was then that they decided to commit six months to developing a robotic industrial arm. They felt that there must be a robot between a kids' one costing a few hundred pounds and the £25,000 models used in factories. Suryansh wrote a blog, in which he'd given away the knowledge he'd developed so far. The increasing volume of traffic to it bolstered their resolve: 'There were people from Amazon Robotics and Google coming to it, which gave us the confidence to think we were onto something.'

They were cushioned by the offers of PhD places at Massachusetts Institute of Technology and ETH Zurich. They were, by their own admission, further insulated from reality by their lack of robotics experience. 'If we'd known how complicated making robots would be,' admits Suryansh, 'we'd have done something else.'

It was a decision that shocked their colleagues. Designers and architects, they believe, can see themselves as the closest thing to God and their calling as 'a more noble pursuit', while technology is seen as grubbier, less stylish. But Mostafa had begun to feel envious of what he saw as the 'cultural and political agency' that those working in technology had in comparison to designers.

As well as no robotics knowledge, they had zero business experience, but registering a company is a straightforward process in comparison to coding a robot. They attended a startup course, which gave them invaluable advice on how to turn a hobby project into a business. They lived off savings for this six months as well as a loan from Mostafa's family. Then came investment from accelerator Entrepreneur First.

At this point two angel investors came in – robotics isn't cheap especially in the latter stages of refining a product. 'It took three months and £10,000 to get to a prototype and now we've spent a further £600,000–£700,000 to get to a point where it's ready for market testing,' says Mostafa.

In the early stages, they were driven more by an academic interest in robotics

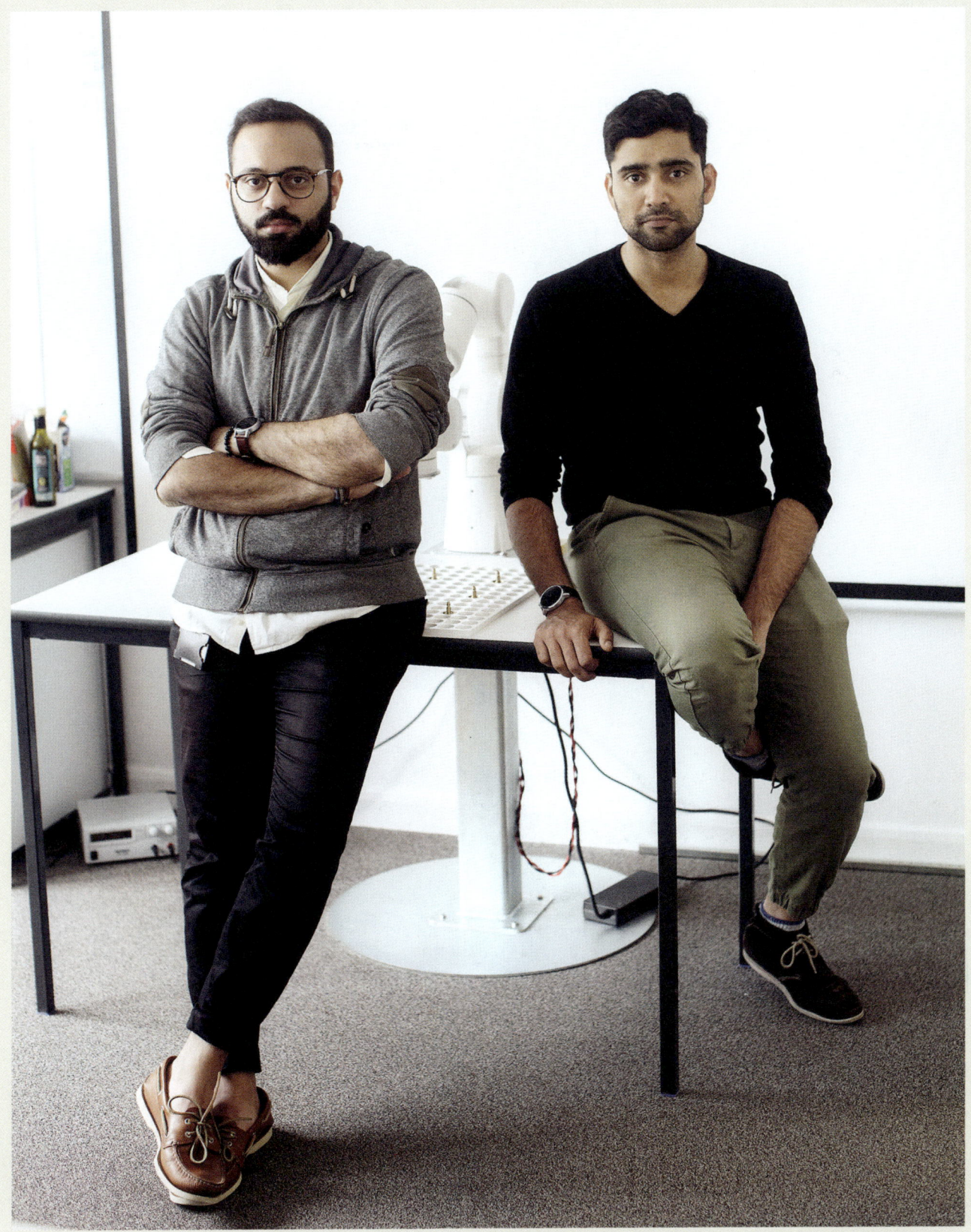

AUTOMATA TECHNOLOGIES

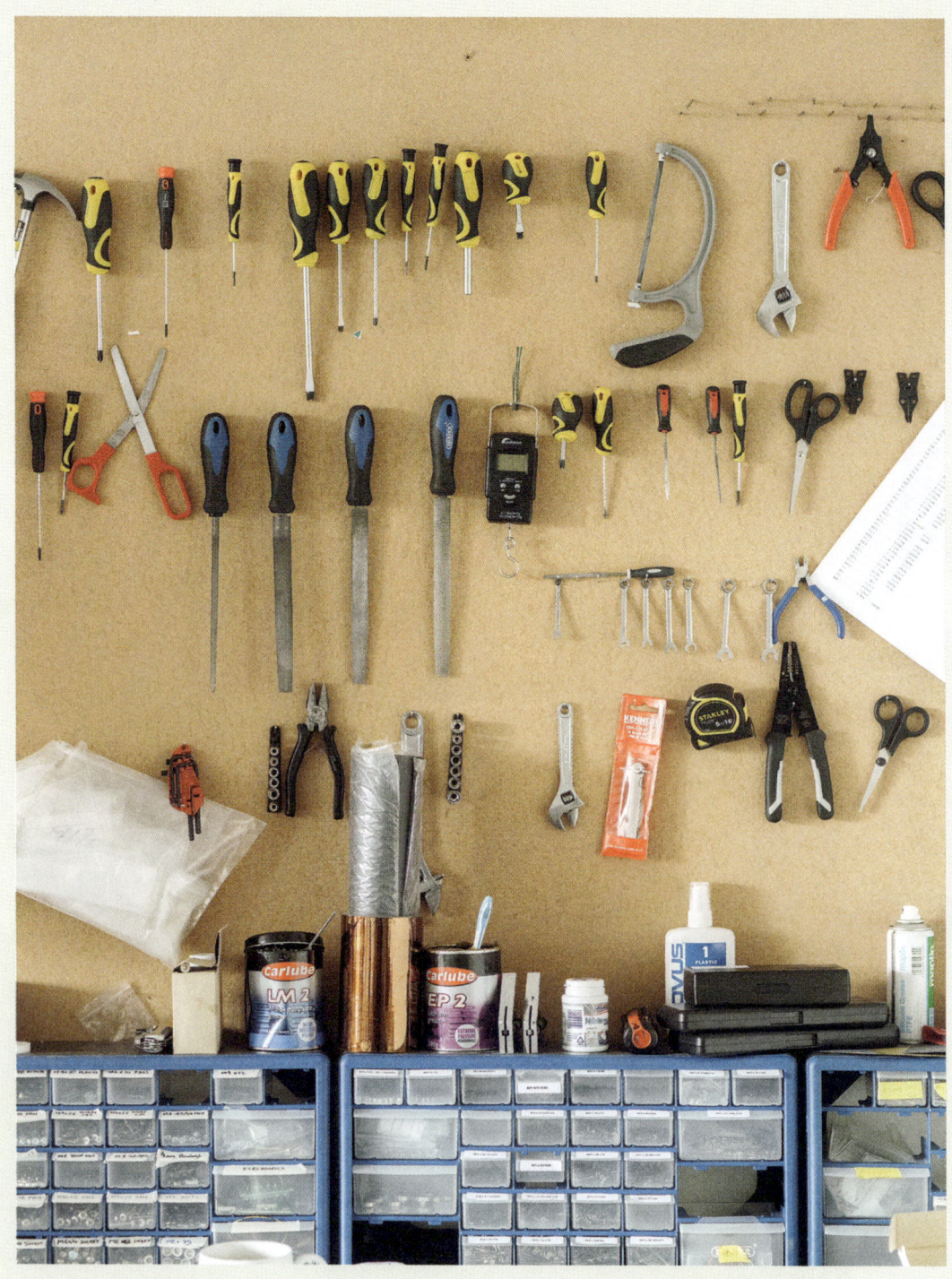

AUTOMATA TECHNOLOGIES

AUTOMATA TECHNOLOGIES

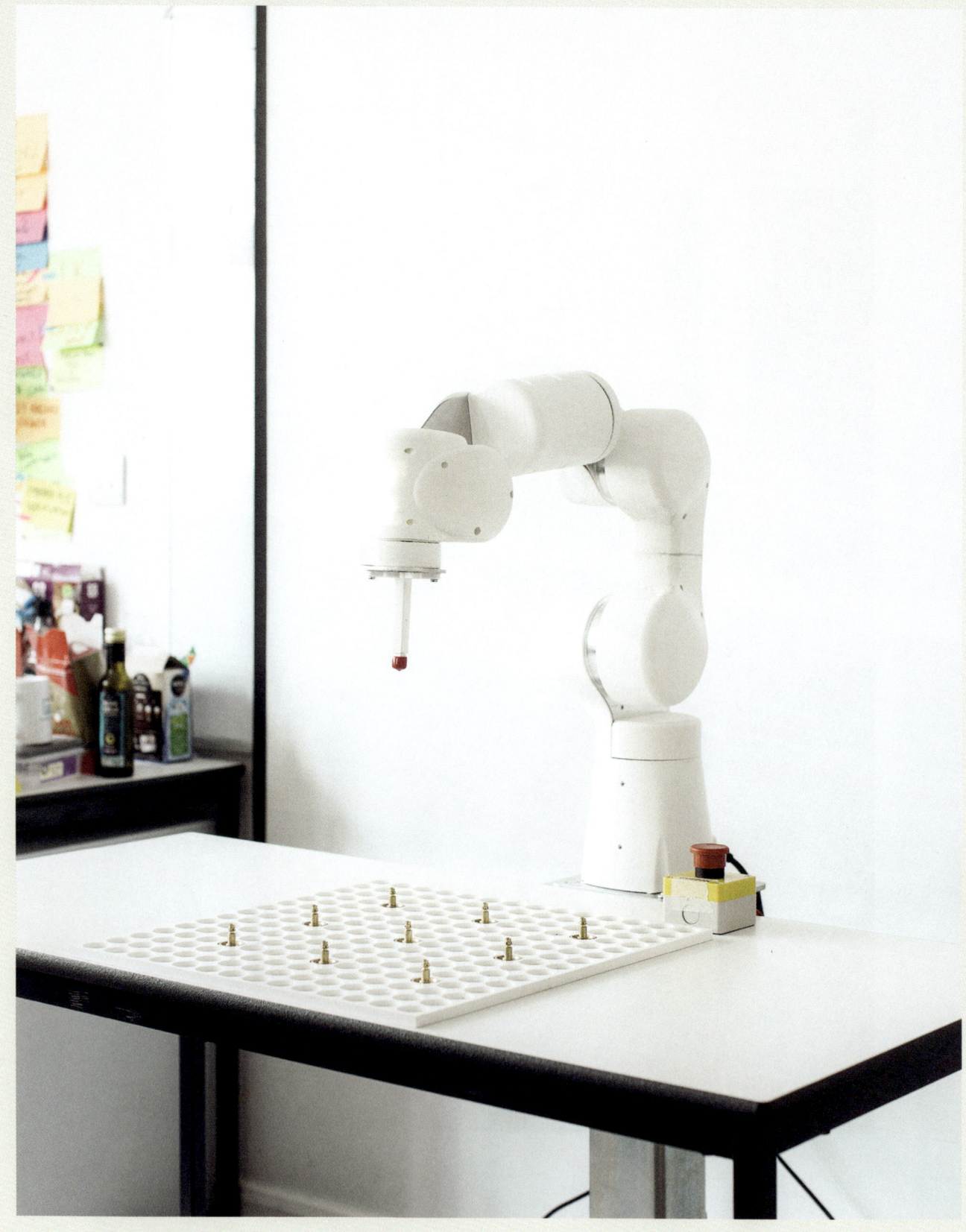

rather than a knowledge of the market. They aimed to make a simple robotic arm that they could sell for around $5,000, but what they didn't know was who'd want to buy it. It was a talk from a man running a t-shirt factory who expressed enthusiasm for what they were developing that finally convinced them that this was to be an industrial rather than a consumer product. 'He had people loading and reloading t-shirts onto a printing machine every 18 seconds,' recalls Suryansh. 'There are jobs like that in small-scale manufacturing where people can't take a toilet break. Any small factory that makes stuff will find a use for our arm.'

The decision to name the arm Eva was based on a joke made by Suryansh's girlfriend about the robot in Pixar's *WALL-E*. 'As you can see,' concedes Mostafa, 'a lot of our decision-making was not based on research or logic, but serendipity.'

That's not to say it's all been easy. In January and February of 2017 they performed an extensive technical test that, had the robotics failed, the company would have failed too. For these two months, Mostafa and Suryansh were under a constant cloud while trying to remain positive in front of their 12-strong workforce. To their immense relief, Eva passed.

They underestimated how long it would take to get the robot to a market-ready state, particularly as the critical last remaining improvements took a tantalisingly long time. In the early days, they grappled with big improvements, such as 'stopping it from punching itself in the head', but towards the end it became a painful process of finessing.

But now, finally, the time for Eva the robotic arm to go out to market is imminent. Have they revived the highs of their early days at Zaha Hadid? 'Absolutely,' says Mostafa. 'I've completely recaptured my own agency. It's frustrating, it's educational, it's exciting.'

Eva the robotic arm will offer small industries an affordable, simple robot to carry out repetitive tasks quickly and efficiently.

Standout Advice

'There are two approaches to finding a gap in the market: one is to race to the bottom, to make the cheapest; the other is to pull up the floor and define what the product should be capable of.'

The Castle Cinema
How to revive a 20th century cinema in a 21st century way

Who
Danielle Swift and Asher Charman

What
Historic cinema revival

Website
thecastlecinema.com

Follow
@thecastlecinema

The Castle is not so much a startup, but a re-startup; involving the restoration of a cinema that had been built in 1913 but used as anything but since 1958. Its incarnations – cinema, bingo then snooker hall, storage unit and cinema once again – give a neat history of the rise, decline and recent resurgence of East London.

It might be a historic site, but the way that Asher and Danielle started their business and use the space is far from its century-old origins: crowdfunded, curated and sharing its space with a supermarket and bar, the Castle would be unrecognisable to 1920s cinema-goers.

And those customers would have been equally befuddled by Asher's first venture, Hot Tub Cinema – the big screen watched from, yes, a hot tub. 'It came about as a private party in our garden, then it snowballed and we sold our first show on the roof of London Fields' Netil House in 2012, and I could give up my day job installing high-end home cinema screens.'

Danielle joined Asher in 2014, having come to London to do a neuroimaging masters. 'I wanted to take a break from

Restored early 20th century elegance is married to modern luxuries to offer cinema-goers a complete experience.

'I wanted to take a break from my studies and then I never went back.'

my studies and then I never went back.'

Hot Tub expanded into Pillow Cinema – with giant beanbags and blankets provided – both of which toured the country. But finding suitable venues was an exhausting process. 'With popups, you're constantly on the lookout for spaces and there was a sense of loss and frustration as well as transience,' recalls Asher.

They were given the confidence to see a permanent space as the next step when they got the chance to take over an unused, unusual space – the old Shoreditch Underground station, now marooned on a closed line and no longer used by Transport for London. At last, they could concentrate on putting on films instead of scouring for venues, but 'Shoreditch sadly got taken off us in early 2015, not even a year after we'd taken it on,' rues Asher.

What they needed was an equally quirky permanent space, suitable for a screen, preferably in their spiritual home of East London. An impossible dream, surely. Then, as if by magic, they heard about Walthamstow restaurant Eat17 taking over the disused Castle Cinema on Hackney's Chatsworth Road and opening a neighbourhood supermarket and deli downstairs. 'The magnitude of the find was obvious,' says Asher. 'Location, history, built as a cinema . . . it had everything.'

In its previous incarnation as a snooker hall, the space had been turned into two storeys. Eat17 had already kitted out half the upper floor with a mirrored bar and perfect Art Deco-style seating, which left the other half crying out for a cinema.

They quickly realised that their most essential expense would be a cinema-quality projector, costing at least £45,000. They set this as a target on crowdfunding platform Kickstarter and

duly raised over £57,000, 'which we easily spent . . . and then some!'

Kickstarter fulfilled two functions: raising the funds but also creating a ready-made community of fans. 'It's such a nice way of raising money,' says Danielle. 'It gives people input and makes them feel like it's theirs.' It even supplied them with a website designer prepared to do the front end of their site for free.

Having raised their funds, Asher said they were faced with, 'Another massive dose of naivety. Things like carpets and other expenses were far more than we'd thought they'd be, but with the Kickstarter boost we were able to get a bank loan.'

Developing a website that automatically loads listings and sells tickets took weeks of research. 'One of the things we've learnt is that you can do something on a shoestring budget but it takes every waking hour, whereas if you've got enough money, you can say, "Here's the money - go do it."'

With the wealth of content that people can watch at home on demand, the Castle recognises that it's got to offer a whole experience as much as a film: food, drink and like-minded fellow viewers. The films are carefully curated, with opportunities for the community to get involved.

They employ six regular part-time employees and are now, finally, getting the occasional weekend off. Their ambitions at the moment don't extend beyond 'seeing the Castle mature into a space that runs smoothly and gives us enough time to explore other projects'.

Is there anything they'd tell their past selves, back when they embarked on it? No, says Asher, 'There's nothing I'd want to tell myself or it would put me off. And I wouldn't want to have not done it.'

Standout Advice

'Ignorance is key. For God's sake don't learn too much or it will put you off doing anything.'

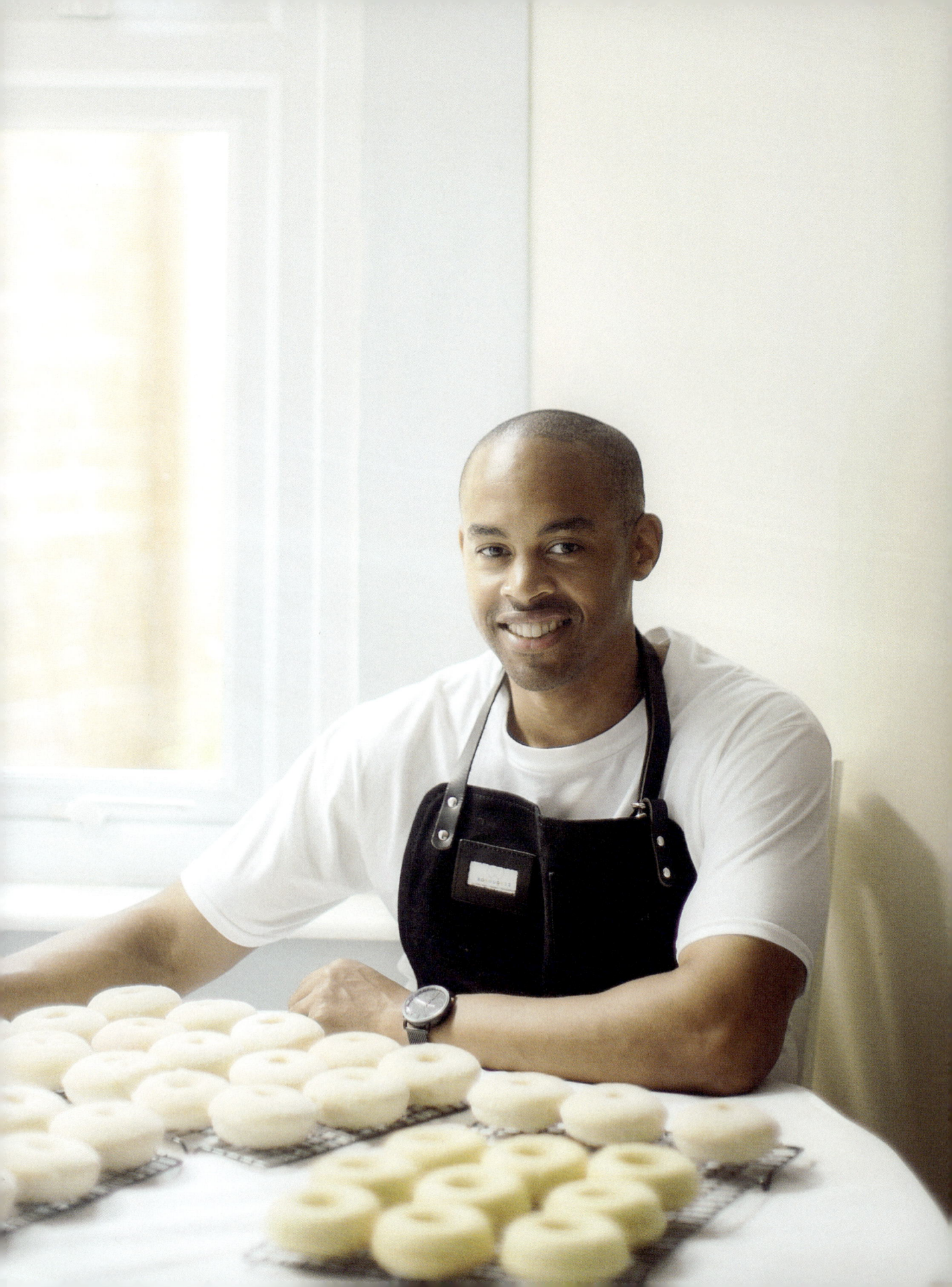

Borough 22
How to turn your family's food intolerances into a gluten-and-dairy-free doughnut business

Who
Ryan Panchoo

What
Gluten-and-dairy-free doughnuts

Website
borough22.com

Follow
@borough22

Ryan had never intended to be a food entrepreneur. All he wanted was for his wife and two kids to be able to enjoy a doughnut and was amazed to find that no one else was offering this simple pleasure.

His wife Madeka had long been dairy intolerant but after having their two children also became gluten intolerant, while 'the kids would be in agony if they ate cheese or milk, screaming the house down'.

Ryan began experimenting with different recipes to make his family their own treats in the kitchen of his Plumstead home. First he worked on creating the perfect brownie, and in October 2014 his wife encouraged him to start selling them.

But brownies were already the go-to dessert for those with intolerances – what they really clamoured for was the sugar-and-fat hit of a really good doughnut.

'I'd been selling brownies for a while via Facebook when I put up a cute photo of my son with a doughnut online and it went crazy,' he recalls. 'Everybody loves doughnuts – I've seen people physically fighting over the doughnuts in the Charlton Asda!'

These proved to be more complicated to perfect. 'It's not as simple as replacing flour with free-from flour,' he explains.

'I was terrified about supporting a family without a regular wage – but in retrospect it was the best thing that could have happened.'

'Too often you get the consistency of wet sand.' To make a doughnut tasting as good, if not better, than the standard fare he's had to work an alchemy on a mind-boggling array of ingredients: chickpea flour, tapioca, potatoes, xanthan gum, apple sauce, pumpkin puree . . .

Eventually the recipe was right, but how he was going to deliver them to customers quickly? Unlike brownies, doughnuts have a shelf life of only a couple of days.

'I announced on Facebook that I'd do any flavour and deliver them to anywhere in London. I'd put them on a granny cart, get on public transport and spend a whole day delivering. It was crazy, but it created personal relationships with my early customers. I'd arrive sometimes with a mess of doughnuts, Nutella and cream.'

Initially these doughnuts contained egg, but Ryan realised that it made commercial sense to remove all animal products to make them vegan too.

Ryan was still working as a project manager at a property company, constantly telling himself that 'soon' he'd give the business his full energies, but was always finding excuses. Then in February 2017 he was made redundant. 'I was terrified about supporting a family without a regular wage – but in retrospect it was the best thing that could have happened.'

Back in 2015, Ryan had been contacted by Selfridges who offered to sell Ryan's doughnuts in their Oxford Street store for a limited period. Ryan remembers going in on the first day with the whole family to gaze at them. As a part-time, one-man brand, this short stint was as much as he could manage in such a large store, but being made redundant gave him the chance to revive this relationship.

Selfridges in Birmingham and Manchester were particularly keen to have the doughnuts and by 2017 Ryan had

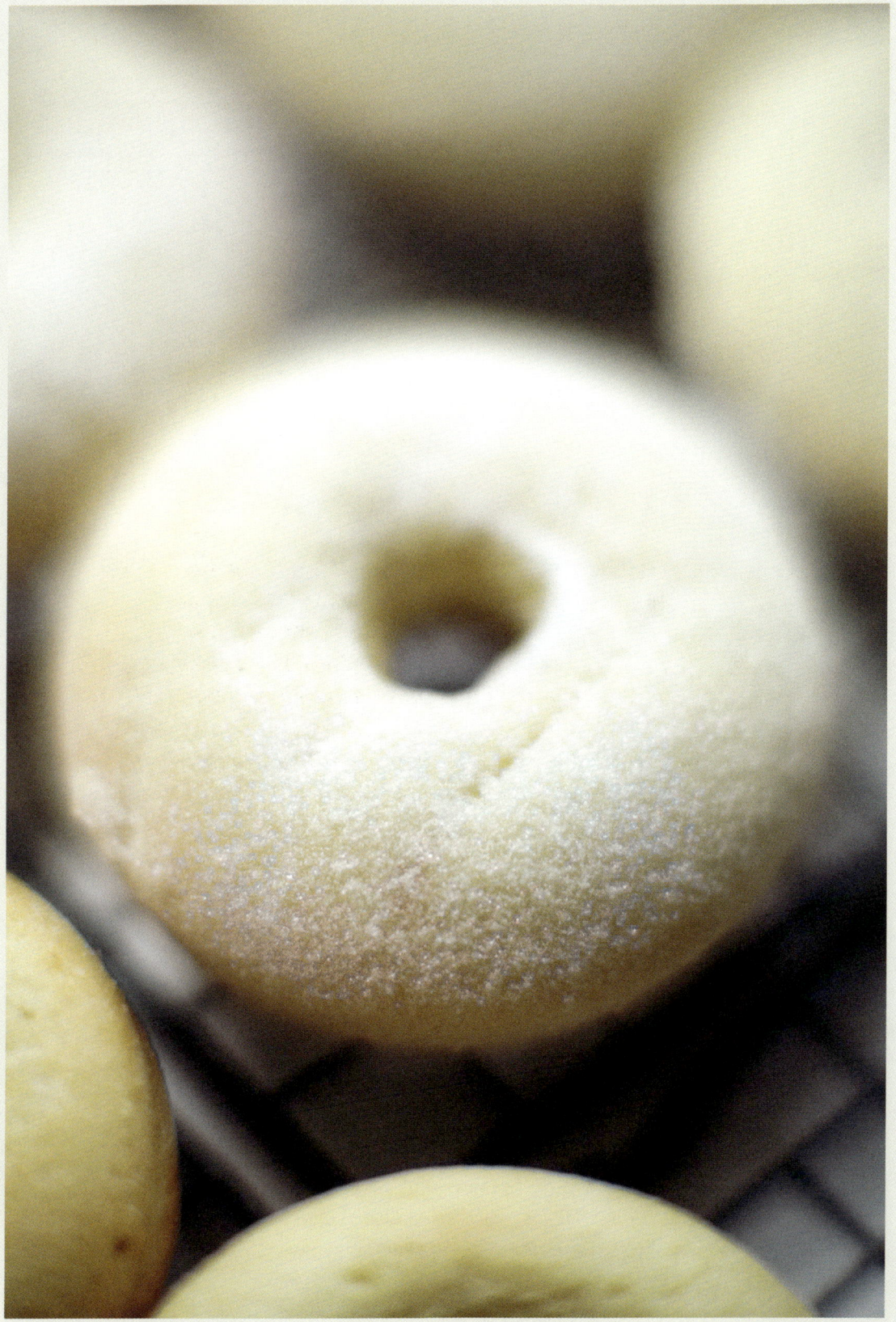

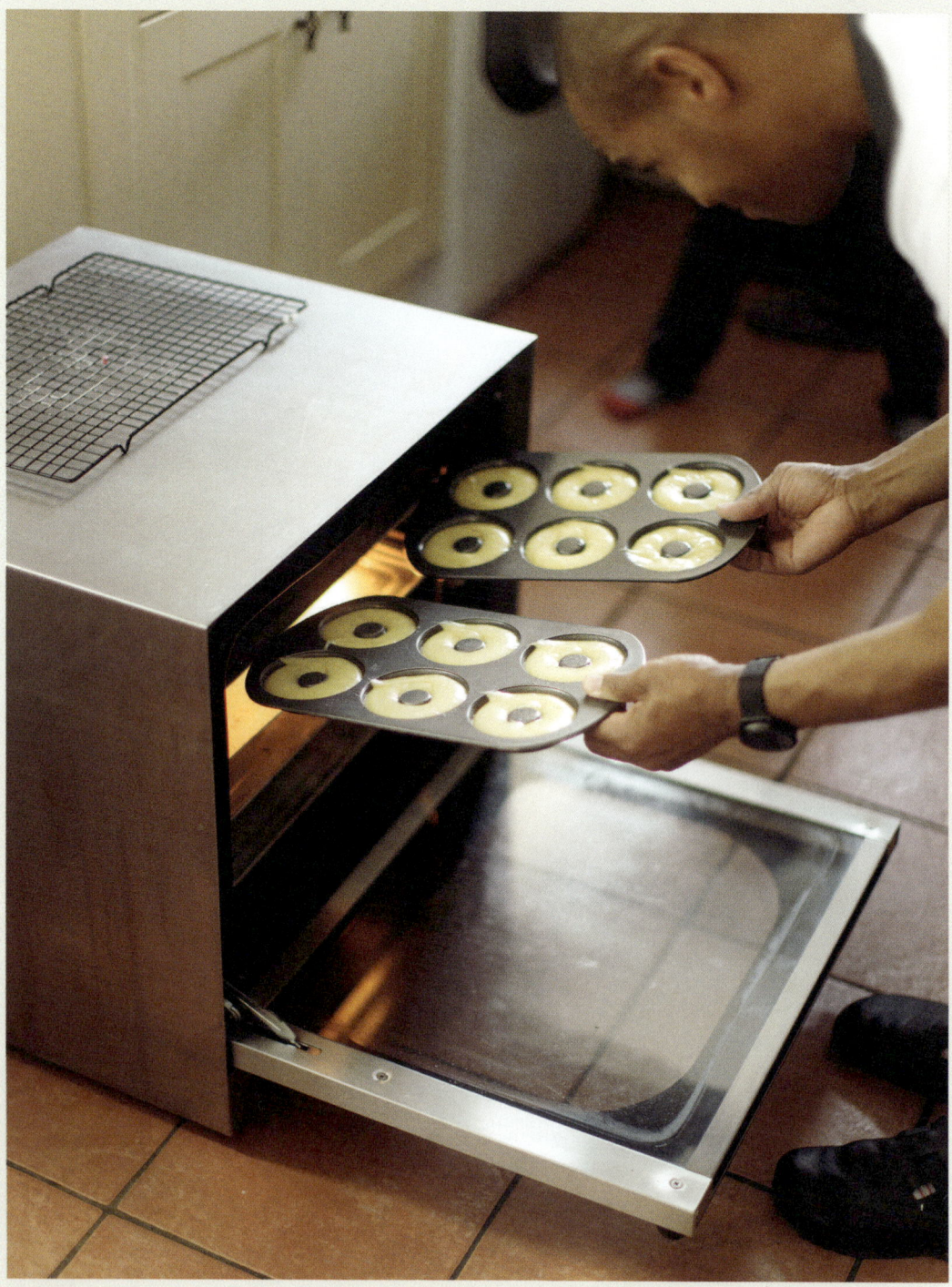

Ryan is continuing to manage to bake for Selfridges and his online business from the family kitchen.

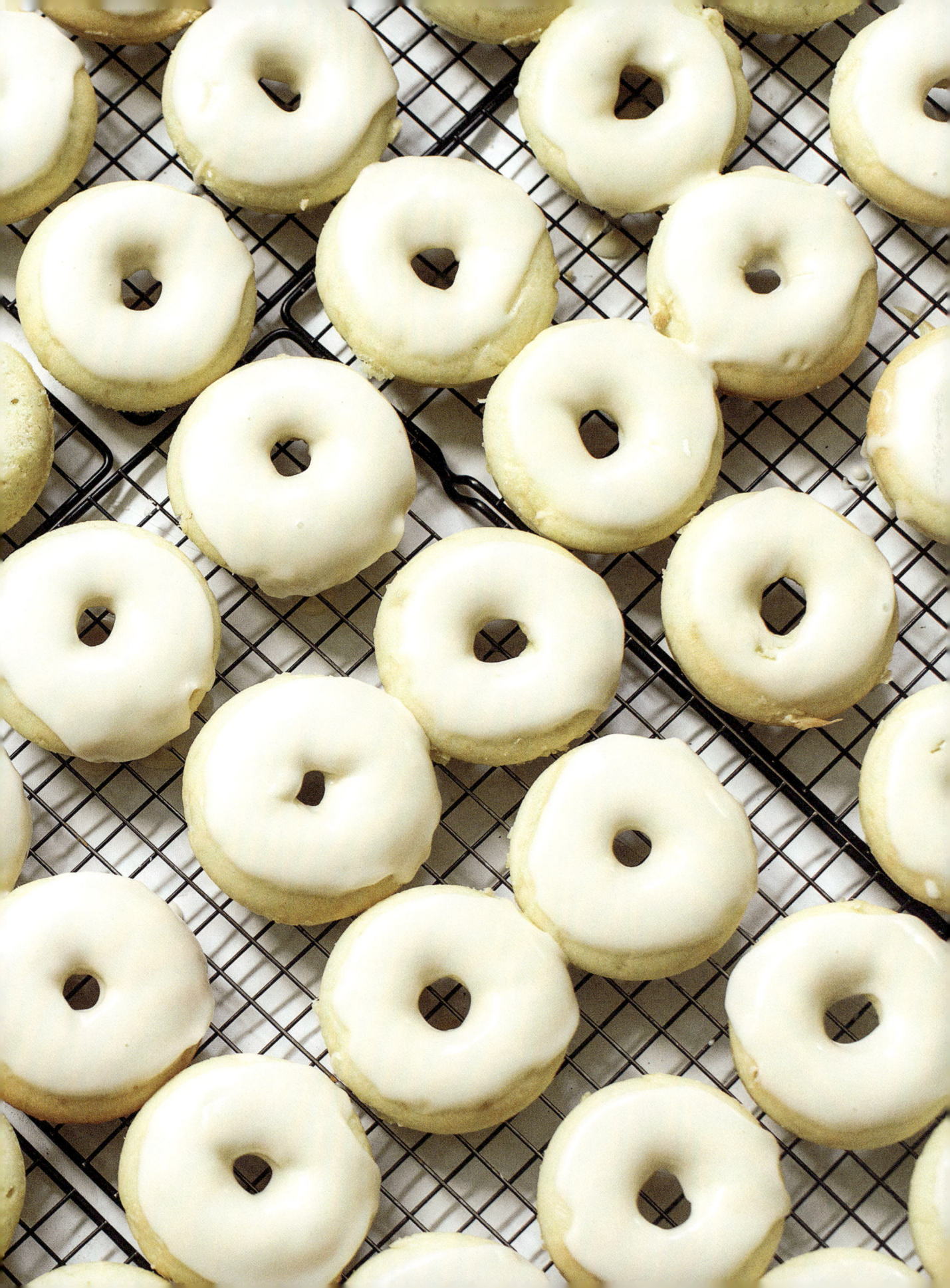

developed a way of freezing and defrosting them while retaining all the taste. He had worried, though, as to whether there was a market for gluten-and-dairy free outside the rarefied world of London.

He couldn't have been more wrong. An initial order for 200 for a month from each store ballooned into almost a thousand by the end of the first week. 'I realised that London is pretty well provided for – if you live in Clapham you can go somewhere local; there's two gluten-free bakeries on Upper Street in Islington alone. But if you live in Wolverhampton, Solihull or Coventry, you go into Selfridges in Birmingham.'

The combination of the steady supply to Selfridges and a burgeoning mail-order demand means that Ryan has reached a pivotal point in his business. 'Things have escalated since going full-time. There is an expectation that I'll be taking on more employees than just my mate's son who helps out and I'll get premises – expand, expand, expand, get in more stores, franchise it.'

But for the moment, he's resisting such pressures. 'I'm not a greedy person, I started this business for my family and I don't want it to become the reason I don't see them. I work really hard but I still get to take the kids to school.'

However much his wife wants him out of the kitchen, he's wary of the extra expense of renting a unit but plans to take on one or two part-time employees. 'There's a huge market of amazing mothers at the kids' school who are interested.'

'My business is a success on my terms – I'm happy, I'm making people happy and I'm seeing my kids.'

Standout Advice

'Listen to people's stories and let them hear yours – if you build this relationship, they'll be much more forgiving of any mistakes along the way.'

Butternut Box
How to deliver freshly cooked food to the nation's dogs

Who
Kevin Glynn and Dave Nolan

What
Freshly cooked dog food

Website
butternutbox.com

Follow
@butternutbox

Kevin and Dave met in 2011 while interning and later working at Goldman Sachs, the banking behemoth of famously huge bonuses. If that fact conjures up a stereotype of slick city boys, think again. As Dave says, neither of them 'comes from money', and while it's impressive to have got into such a competitive environment, it's even more impressive to have walked away from it to start Butternut Box, their freshly cooked dog food company. Dave admits this wasn't easy, 'But we wanted to leave it before we got too used to the money that comes with it . . . we wanted to do something that was ours, built by us that people loved.'

Exactly what this would be came with the arrival of a flatulent, scratchy and unhealthy Staffie from Battersea Cats & Dogs Home into Dave's family. For all the love and medication that she was given, Rudie's various ailments failed to get better and the vet suggested that a change in diet could work. By cooking from scratch and eliminating foods that irritated her, Rudie's health dramatically improved. In other words, Rudie was eating unprocessed food just at the time that there was a focus on humans finding similar benefits by following such a diet.

Unlike Rudie, Dave's family weren't eating so healthily. 'After three years it came to a point where we didn't have time to cook for ourselves, but were still cooking for the dogs. It was Deliveroo for us and organic, freshly cooked for them.' When a Google search for companies offering a similar service for dogs proved fruitless, Dave and Kevin began to wonder whether this wasn't the business idea they'd been waiting for.

At the time, they knew nothing about 'the meat industry, manufacturing, pricing, behavioural science, digital marketing, fundraising . . . anything really'. Undeterred, they trialled Rudie's recipes of high-quality meat, vegetables and carbohydrates along with antioxidant herbs (all of which have been tested by humans) with 20 dogs. 'We were working at Goldman Monday to Friday, on Saturday we'd cook up a batch, and on Sunday we'd deliver,' remembers Kevin.

They were emboldened by both the

canine and the human response. 'We immediately got reports of improvements in skin and behaviour issues. If your dog is jumping around, it's probably because he has 20 E-numbers in his food.'

In January 2016, they quit their jobs in order to concentrate on Butternut Box as a two-man band responsible for all aspects of the business, from production and delivery to marketing.

Their time working at a blue-chip company proved extremely valuable for a number of reasons. Two ex-mentors put up £100,000 of funding almost immediately, while Dave believes that their employment history opens doors to other investors because 'they know you've got half a brain, you're a hard worker and you've given up that whole life for this'.

In 2017 they raised £1 million from venture capitalists Passion Capital, but their connections counted for nothing when pitching to their toughest critic. 'We made up a box for a dog at Passion and my heart skipped a beat when we set it down for him, but luckily he loved it. We always call Frank the "million-pound dog".'

Their first six months were backbreaking; making up all the food and delivering it themselves, working 36-hour shifts. Growing from their first 20 clients to 70 felt like an unassailable mountain. As they admit ruefully, they couldn't have made life more difficult for themselves by choosing a perishable product that was so new to the market. A brief attempt to subcontract out production failed when they realised that the factory wasn't meeting their exacting standards on quality.

Even now with 15 employees in the company they're still up until 2am answering customer emails, as forging a connection with them is crucial to their business plan. 'People really want to talk to companies,' says Kevin, 'and find out what goes on under the hood. You don't get that with a supermarket brand.'

'And this morning,' adds Dave, 'we were up at 4am because we were meeting a better supplier of turkey.'

This schedule, as well as their offices in an industrial park in a rather unlovely part of Northwest London, seems unglamorous, especially in comparison to their previous working life, but they're unrepentant. Says Kevin, 'It gives me the option of trading money for learning and experience, and I'll take the trade every time.'

There are 8.7 million dogs in Britain and, they estimate, at least 1.5 million of them are in the market for premium dog food – 'and we want all of them'. If they have to drive the van themselves, they're determined to do it.

Standout Advice

'Chase all introductions you're offered – it's always the lead you weren't going to follow up which turns out to be the most important.'

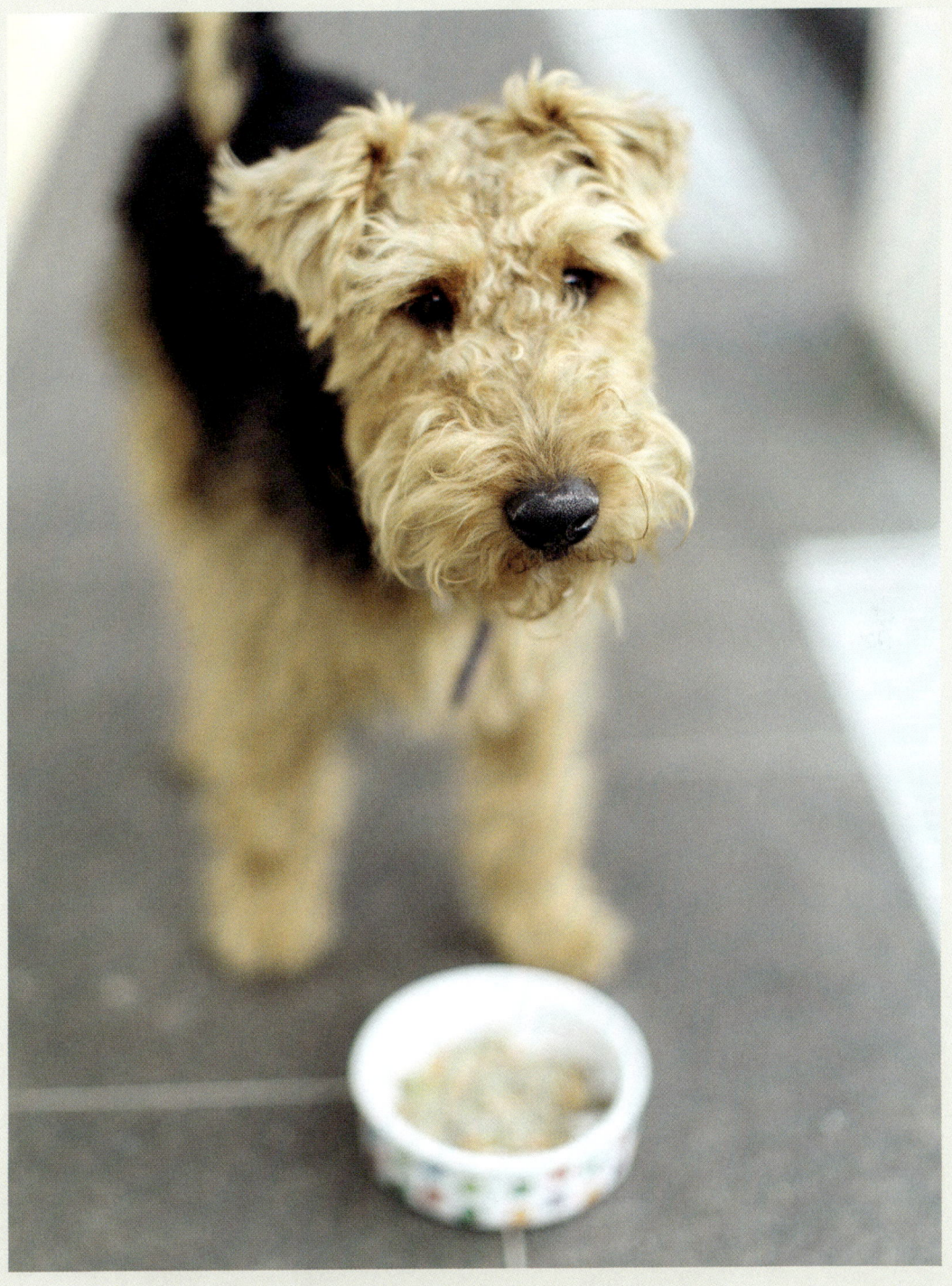

Seenit
How to set up a million-pound tech business as an art school graduate

Who
Emily Forbes

What
Crowd-sourced video app & platform

Website
seenit.io

Follow
@_seenit

Seenit, the app and online platform that allows brands and broadcasters to source user-generated phone footage, is a company on the move – a fact that has taken even its founder by surprise. While clearly determined and dynamic, Emily still pinched herself in disbelief when she recently had to finish a meeting early to fly to New York. 'I was internally punching the air, thinking, "I'm going to New York to find Seenit a US office!"'

Emily was filming a documentary in South Africa when the idea for Seenit first came to her. There she saw that anything she captured was nothing in comparison to all the footage being generated by the surrounding people with camera phones. 'The whole world is being recorded in a new way and this was an opportunity to create a new process for production.'

Rather than just clocking this observation and getting on with her job, she decided to see how this footage could be captured and used. 'I made myself a backpack with phone chargers out the back of it and I'd go to festivals offering to charge people's phones in exchange for their video.' This process was laborious – 'I came across lots of headaches like transferring videos into the same file format, getting people to sign release forms, the similarity of so much of the video.'

But what she produced was good enough to sell to the events' organisers and convinced her that there was mileage

'The whole world is being recorded in a new way.'

in her idea. 'I realised that I wanted to create a product that would allow me to scale up what I was doing.'

There were two big hurdles to starting up a tech business: she had neither tech nor business experience. Aware of these shortcomings, she approached Collider, an accelerator specialising in funding for tech and marketing startups. Rose Lewis, its founder, gave Emily an invaluable piece of advice: 'When you meet an investor, don't sell your product, ask questions and build a relationship first.'

Emily points to the fact that there are so many more ways of getting investment than there once was. 'It used to be that you raised your seed and that was the way it was done. But actually there are so many alternatives – grants, loans, venture debt, private investors, syndicates. It's not as black and white as it was anymore.'

The way the platform works is that a project is created on Seenit; a script or direction is written; users are invited to contribute and they upload directly into the area devoted to this story – a sort of private online studio. There it can be collated, edited and then shared with little oversight; often with just one person in charge. The alternative – random users emailing in their content in different formats – would be so cumbersome as to make the process expensive and inefficient.

An ongoing project with BT Sport illustrates how the crowd-sourced footage can be used by broadcasters. On their weekly football roundup, the show's sports pundits are joined by 50 fans who are linked into the Seenit platform. They upload their self-shot material onto Seenit where it is easily accessed and edited by the programme makers to incorporate into the broadcast.

Three years on and Seenit's clients have included the BBC, NBC, Unilever, Coca-Cola, The Body Shop and Adidas, while Emily's team is 30-strong and

'I'm now interviewing for roles I didn't even know existed.'

growing. Along the way, the challenges that they face are constantly evolving. 'In the beginning it was developing the technology, then it was selling it, then, as we grew, I needed to hire people and do PAYE and HR. I'm now interviewing for roles I didn't even know existed.'

Women heading tech startups are still a very small minority – a 2017 survey by the Entrepreneurs Network found that only 9 per cent of funding in the UK went to female-led businesses. 'Yes, but we're growing,' says Emily, 'and we need women not just at the top level, but at every level throughout companies.' She admits to having been patronised, put in a box and told she needs a male lead beside her when presenting, but she also points to a hugely supportive network of women in tech who talk to each other every day.

She even manages to turn her lack of either business or tech experience into a positive. 'In a way, going to Chelsea art school enabled me to be braver and take risks because there you're constantly being told to be more creative, to try something new.'

Next, Seenit will be developing the work they do with large companies on their internal communications as well as growing with their existing clients. They're also focused on further automating the platform so that first-time users can be more creative.

And, of course, that new Manhattan office beckons.

Standout Advice

'Be super frank with yourself about what you're able to do and bring in people to help with what you can't.'

Cubitts

How to combine heritage and new technology to make and sell spectacles

Who
Tom Broughton

What
Affordable, stylish spectacles

Website
cubitts.co.uk

Follow
@cubitts

Those of us who wear glasses are all too aware of what a dispiriting experience going to an optician can be. Bustled through an overly lit space, given a set of meaningless numbers and shown frames that cost more than a bicycle – and that's all before being asked whether you'd like to pay extra for the thin lenses with anti-scratch surface.

Tom Broughton feels this more acutely than most since being a glasses-wearer is central to his identity. 'I've always been "Tom in the glasses",' he says. 'I even had two pairs at a time when everyone thought that was crazy.'

But unlike the rest of us, he was determined to do something about it. 'I knew we could do something better than the high street and cheaper than a good independent.' In short, he wanted to offer a high-end experience and product at a high street price – a complete pair of Cubitts glasses, including frames and lenses, costs as little as £125 (less than the price of the frames alone from a designer brand).

He nurtured this idea for ten years, saving money from working for the big accountancy firm Deloitte, which he hated, and freelancing in a variety of jobs.

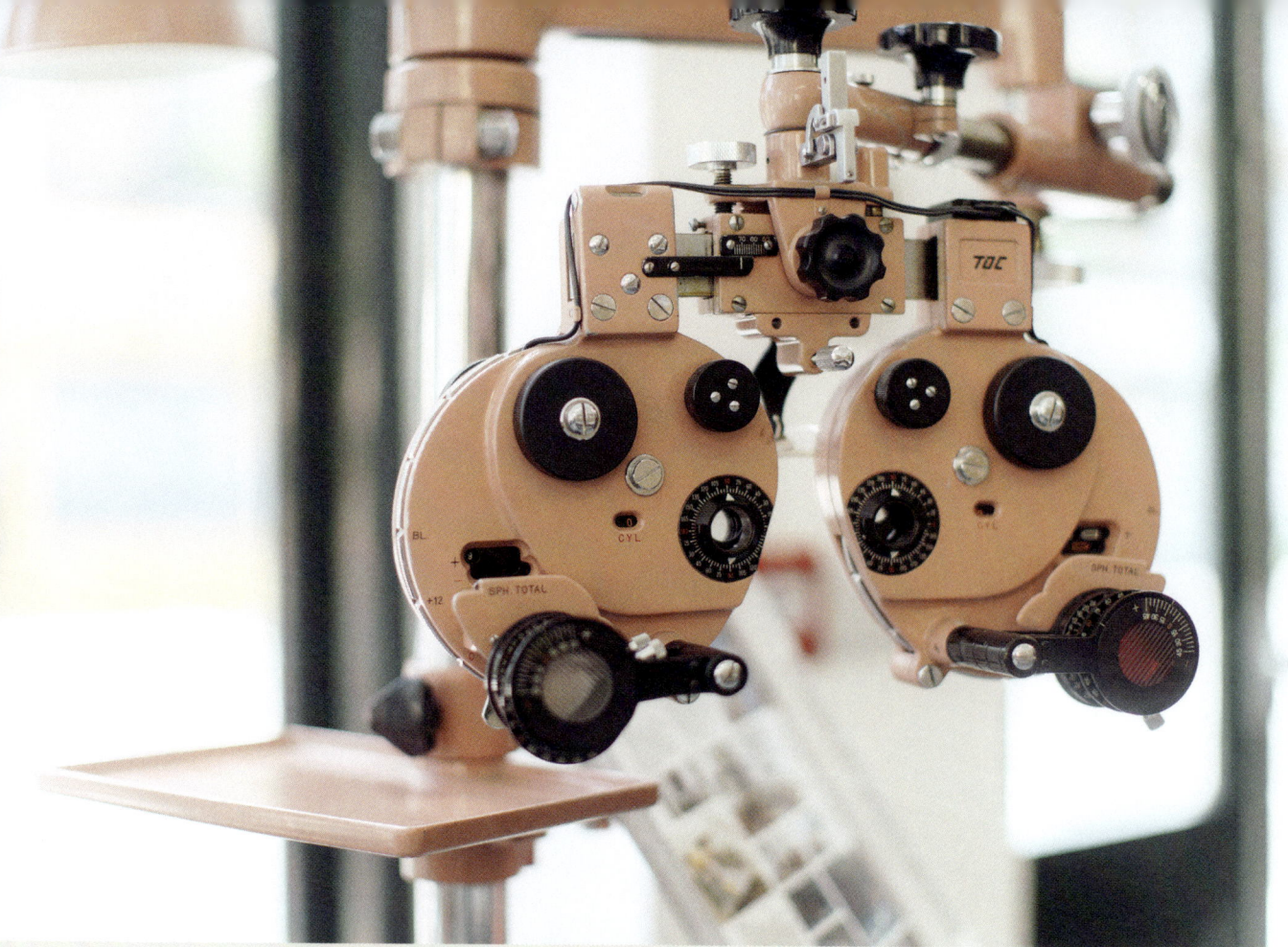

Cubitts uses a mix of traditional opticians' equipment, such as this pink phoropter to measure the eye's lens, alongside cutting-edge facial imaging technology.

Three years before launching Cubitts, he began an apprenticeship with Lawrence Jenkin, the godfather of spectacles who used to run Anglo American Optical.

'It was absolutely amazing,' recalls Tom. 'It gave me an understanding of how you work with different materials like horns and acetates and the relationship between design and construction, how hinges work, how it relates to someone's face . . . everything.'

Then in October 2013, his spectacle-makers Cubitts was launched online, funded by Tom's savings and consisting of just him and his first employee and general rock, Joe Bell. But despite their low overheads, within six months they'd run out of money. 'It was gutting. After ten years of saving, bang, we were about to go out of business.' In desperation, he phoned his parents who re-mortgaged their house to lend him the £20,000 he needed to keep going. 'I always remember that time when it was absolutely terrible – I was crying with no one to talk to. Without sounding trite, you learn a lot about yourself.'

All this is hard to believe as I sit in Tom's office at the back of his fourth London store and HQ on the Caledonian Road in King's Cross. Upstairs is the shop itself, staffed by people working the

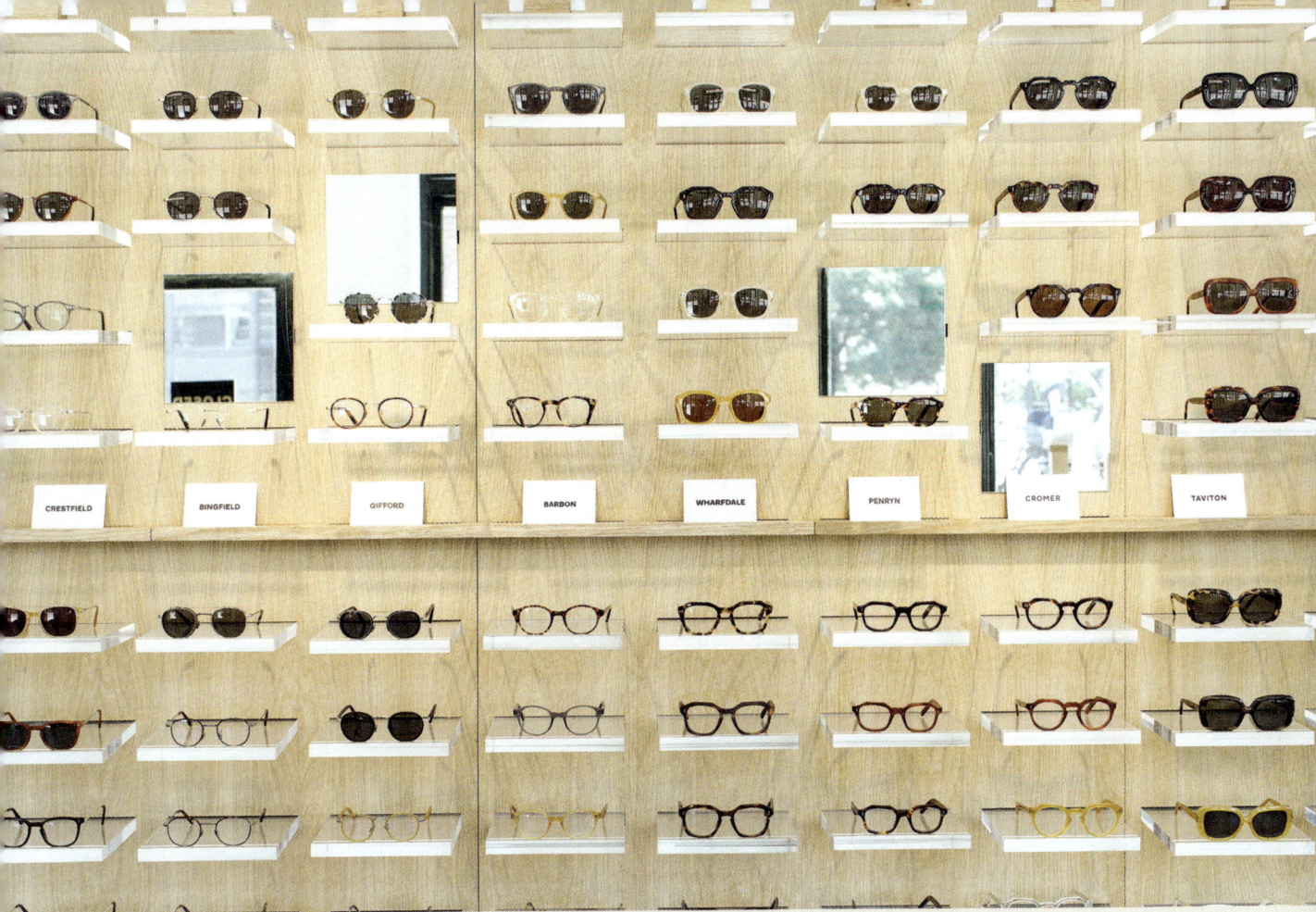

A selection of frames at the King's Cross store, all named after local streets like Bingfield and Cromer.

hot-geek look of J.Crew catalogue models. Behind is the office, which is littered with a cornucopia of historic optical implements that Tom constantly jumps up to show me with Willy Wonka-ish enthusiasm. Downstairs it gets even better, with the workshop where real glasses are being made by a mixture of old and newfangled machinery.

The King's Cross location is fundamental to Cubitts. The company's name and branding are rooted in the area. The three Cubitt brothers were nineteenth-century engineers and master builders who changed the way that London was built. The logo is based on a keystone designed by Lewis Cubitt that can still be seen in nearby Granary Square, while the frames are named after local streets. King's Cross and Clerkenwell were centres of the optics industry with thousands of small workshops supplying spectacles until the NHS began making frames in the mid-twentieth century.

Cubitts aims to revive the historic art of these craftsmen while marrying it to new technology. For all the Victorian eye glasses and Edwardian opticians' posters that fill his office, Tom is an enthusiastic adopter of 3D printing and digital facial scanning. 'Technology doesn't replace old skills, it makes them

'Technology doesn't replace old skills, it makes them more relevant.'

more relevant,' he says. 'Back then, all pairs were immaculately measured and dispensed, and now you have technology like the "cephalometrics" we're developing [which creates a perfect map of the face], so glasses can be fitted properly again. You end up getting a much better product but done in a more efficient, cost-effective way.'

So how did Tom bring Cubitts back from the brink? At first, he tried to get outside investment but was constantly turned down. 'The hardest bit wasn't so much the lack of investment as being ghosted by these people. You've worked so hard to put a plan together and then they wouldn't even get back to you.'

It was then that a crucial development took place. Tom managed to get his product into Albam, a premium menswear shop with stores in Spitalfields, Islington and Soho. Not only did this mean they went from selling two to ten frames a day, but it also led to an investor.

'A bloke called Gary Clarke bought one of our frames in Albam and sent a speculative email asking if we were looking for investment. I met him for a coffee and in five minutes we'd agreed on an evaluation and a stake for £100,000. This allowed us

to increase our product line and open our first door in Soho.'

They've also been lucky to coincide with a wider movement towards 'slow fashion' – a rejection of sweatshop-made fast fashion in favour of a connection between product and consumer. 'I honestly think if we'd started five years earlier, we'd have gone out of business. People want to know who's behind what they're buying.'

'It's all so different now,' he says. 'Traditionally you'd make your product and wholesale it to Selfridges, where you'd spend 20 years building up a brand before opening up your own shop. We short-circuited all that by building a website so that we had a direct relationship with the people who'd bought our product.'

Today Cubitts has 32 employees, a new store opening on Mayfair's Jermyn Street and ambitions to find locations in other British cities (the obvious ones being Brighton, Bristol and Edinburgh). Then, Tom's looking to take over the world. 'I want us to be a globally revered brand, like the German brand Mykita or Oliver Peoples. Possibly opening new shops in Japan, New York or LA. Who knows? I've got a direction of travel but I'm not sure exactly what road we'll take.'

Despite this rapid growth, Tom still gets overwhelmed when he sees someone wearing a pair of his glasses 'in the wild', an almost daily occurrence. 'I lose it, become over-emotional, and I can't speak to them.'

Standout Advice

'Be open and willing to change your mind – I always said we'd never do a rimless frame and now we're going to do one.'

OLIO

How to tackle global food waste with the world's first peer-to-peer food sharing app

Who
Tessa Cook and
Saasha Celestial-One

What
Food-sharing app

Website
olioex.com

Follow
@olio_ex

Tessa is a Yorkshire farmer's daughter and Saasha is the offspring of Iowan hippies (hence her non-corporate name) – their childhoods gave them a strong aversion to food waste while their professional lives have given them the skills to start a business that could do something to solve the problem.

OLIO is a free app that connects users with their neighbours and local shops so surplus food can be shared rather than thrown away. Users log on to the app and either choose to donate or pick up an item – a bit like a Freecycle for food.

Having become friends on an MBA course at Stanford University 15 years ago, Saasha and Tessa spent the next decade and a half working their way through a roster of companies including McKinsey & Company and the much-maligned Wonga, the payday loan provider. Their lives circled one another's until they both found themselves on maternity leave in London in 2012. They used this time to explore a number of business ideas that they could develop together, such as a company to bring innovative baby products to market. 'Very original from two mums on maternity leave,' Tessa laughs now.

Tessa went back to the corporate world, working in Switzerland, while Saasha made one of their ideas reality by opening a pay-as-you-go crèche in Crouch End, but they knew that their goal was to work together on a business that would be 'scalable and with purpose'; at the same time both global and local.

The concept came to Tessa when she was packing up to move back to the UK in December 2014 and had some food in her fridge that the removal men told her to throw away. Grabbing the perfectly edible items, her toddler and newborn, she

went to the streets to find someone who wanted this food to no avail. 'I'd spent 15 years in the mobile industry so it's natural for me to think there must be an app to make sharing food easy and I was stunned to find there wasn't.'

The idea clicked immediately for Saasha, especially when further research revealed that half of all food waste takes place in the home. They incorporated OLIO in February 2015, pooled their life's savings, and gave themselves until the end of the year to make a go of it.

Their first investor was the company they chose to build the app, Simpleweb in Bristol. 'They gave us reduced day rates in return for a small equity stake in the business, which was brilliant as we were partners rather than a client – it was transformative to our ability to get a semi-decent product to market,' says Tessa.

They subsequently raised $2 million from investors who shared their vision. 'All investors want a return, but the majority of ours also have a strong impact requirement, socially and environmentally.'

They admit they were not typical startup founders looking for investment. 'We're both females in our early 40s, breadwinners in our families and neither of us have a software engineering background,' says Tessa.

But, as Saasha adds, 'Our backgrounds do provide us with a significant advantage in that we've got over 30 years of corporate experience between us.'

They knew that they had to test the app in a clearly defined geographical area with the right sort of demographic. Fortunately, Crouch End and Finsbury Park, where they had both lived, provided this. 'I was well integrated into the community of small business owners,' says Saasha, 'who gave us free surplus food.'

The test proved that people were receptive to the idea and the app's area of use soon expanded to the rest of the UK, but also right across the world with pockets of activity in places as diverse as Stockholm, Australia and Ecuador.

Its societal good was quickly evident, but investors still need a return and OLIO's current focus is on revenue models. 'We've been through various incarnations,' says Tessa, 'as it's only through learning more about the problem you're solving and its value that you can monetise.'

They're exploring three main strands to make money. Their 'Food Waste Heroes' programme allows large retailers to harness volunteers to pick up surplus food and redistribute it via the app. They're prepared to pay for this service in order to be able to announce that they're zero waste.

Secondly, they've identified 'super users – people who are on OLIO all day long'. They're investigating a premium service for which they'll charge a fee, though the basic app will always be free.

The third is localised advertising based on brands that are in keeping with their ethos.

Their aspiration to change ingrained habits extends to the way their office works. Everybody has the same flexibility as the two founders – they work remotely and set their own hours, only using the office (in reality, Tessa's first London flat) as and when they need to. Tessa herself

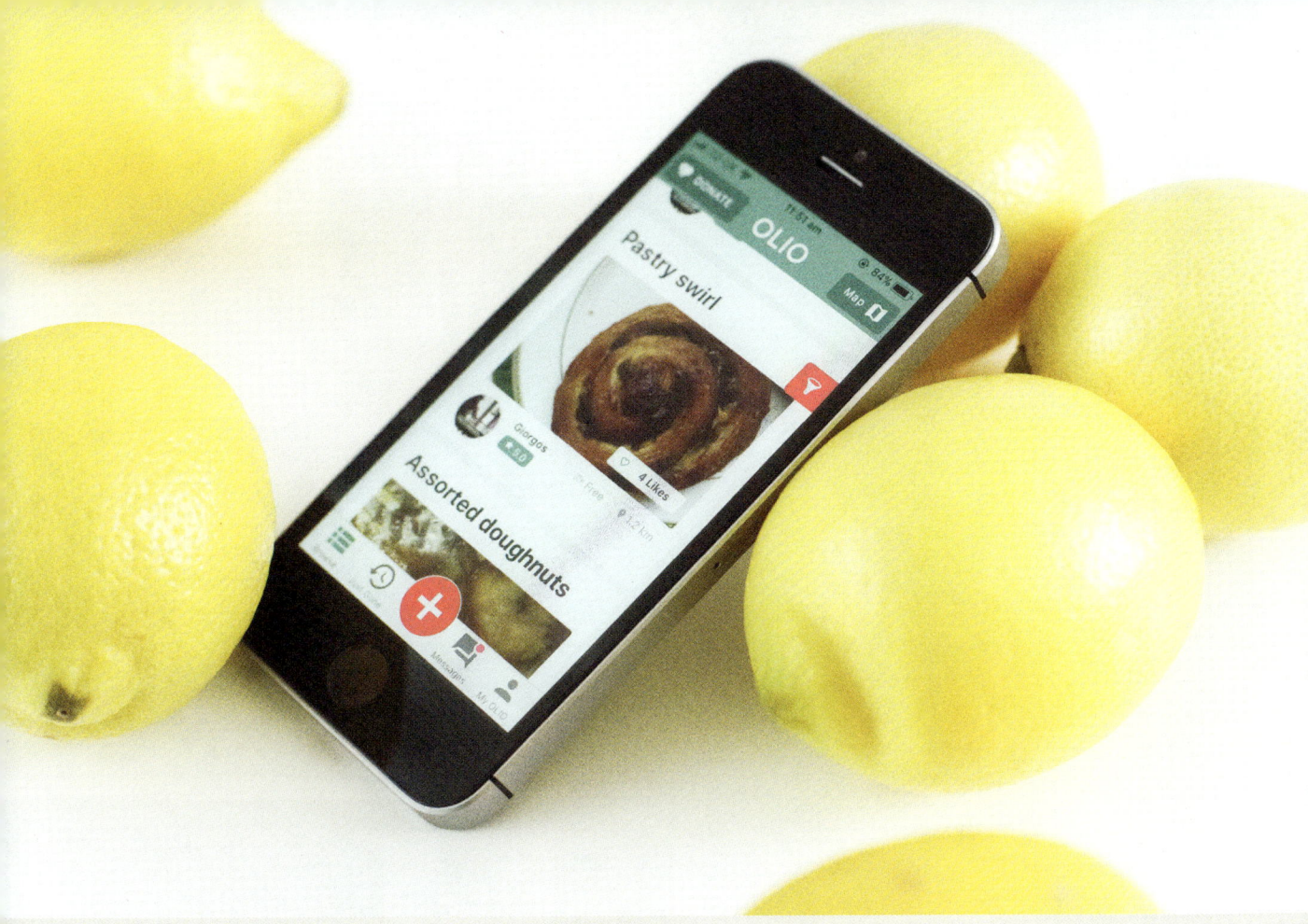

has moved to Wiltshire and schedules all her meetings for the two days she's in London. 'It's a transformational experience as being autonomous is so liberating and so we wanted to give that to the nine people who work with us.'

They're buoyed by the stories that OLIO users pass on to them: the woman with multiple sclerosis who feels her life has new purpose by being able to pass on food donated by local shops; the many members of the 8 million people in the UK living in food poverty; the mother of twins who was having to choose who to feed in her family.

The OLIO team are 'unashamedly ambitious . . . we just need a million more people on our app and we can solve the problem of food waste,' says Tessa.

'And,' adds Saasha, 'we also want an OLIO wedding with people who've met sharing food and where they'll serve food sourced by the app.'

Anyone with surplus food can upload a photo of what they're giving away onto the app, which will then alert nearby users who can message to request it.

Standout Advice

'Nothing goes according to plan and you can never scope out everything perfectly.'

East London Liquor Company
How to go from serving drinks to making spirits in the heart of the city

Who
Alex Wolpert

What
Distillery, bar and restaurant

Website
eastlondonliquor company.com

Follow
@eastlondonliquor company

Actor-turned-bar manager-turned-entrepreneur Alex had always wondered why there were no quality gins made by small distilleries selling at what he considered to be a reasonable price. While some might assume that this gap in the market is there for a reason, Alex was determined to fill it, despite previously only having made gin and tonics rather than the gin itself.

'People have this idea that if something's expensive, it's got to be good, and vice versa. Take any British brand, be it Rolls Royce or Fortnum's – they're based on excellence being at a high price. It's fun to play with that belief.'

As well as no distilling background, he'd never set up a business from scratch but, 'I did the maths and I thought – we can do it and why not? It's such a strong, honest proposal to say, "Let's make a really good gin that's affordable."'

Initial funding came from remortgaging his flat and getting an investment from his bosses at the time, the owners of a chain of pubs. He then hired 'a really

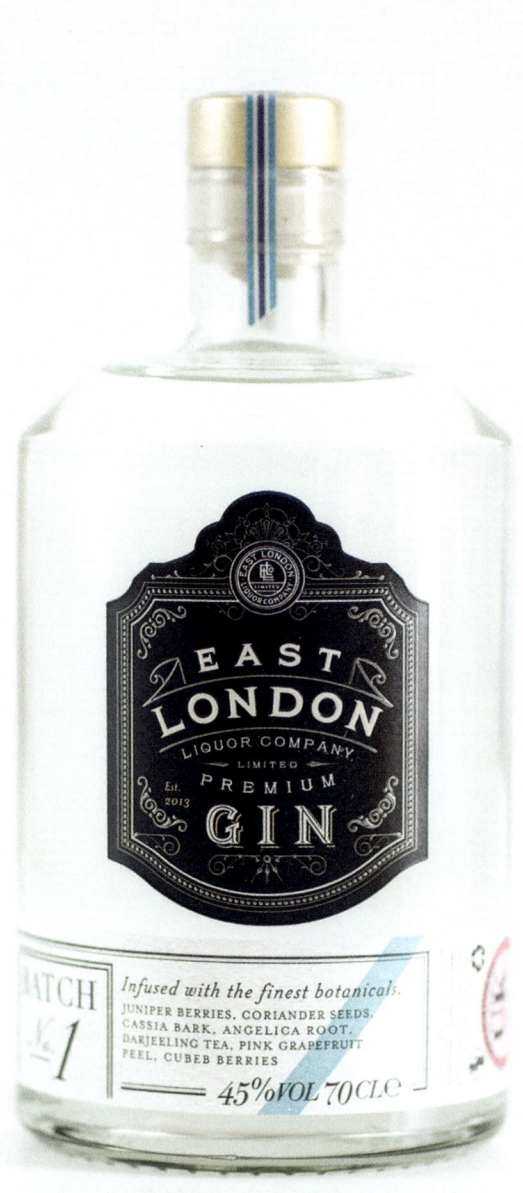

'People have this idea that if something's expensive, it's got to be good, and vice versa. It's fun to play with that belief.'

excellent distiller', Tom Hills, and began the slow process of making and testing gins. 'For six months, we distilled, tasted, bottled, gave it to bars to try and it wasn't until we were damn sure that it was consistently excellent did we start to sell it.'

Three years later and the East London Liquor Company is not only making three gins from its gorgeous copper stills, but also vodka, rum and whisky (the latter is currently undergoing the long process of ageing before sale). It has a shop, bar and restaurant in its Bow headquarters as well as a further shop in Borough Market.

All of which would suggest that Alex's guess that people wanted a gin that was special but not pricey was correct – the supermarket brands are around £15 a bottle while the smaller, more bespoke labels are nearer £40, while his signature London gin is priced firmly in the middle of the two. 'If you're going out for dinner and you were going to take a bottle of wine, you could instead take a bottle of our gin. Or both and have a really good party.'

While Alex admits that he's made many mistakes along the way, he's been abetted by some good decisions. The bottles' distinctive look comes from Stranger & Stranger, generally acknowledged to be the godfathers of alcohol branding and design and normally out of the price range of a small startup. 'I told them my tiny budget and they said they'd do it with the caveat that they'd only give us one concept and we'd have to take it. I thought, "You're the best at what you do, why wouldn't you get it right?" And so I went for it. After six months, they presented their branding and it was perfect.'

The capital and, more specifically,

The distinctive bottle labels were designed by 'godfathers of alcohol branding' Stranger & Stranger.

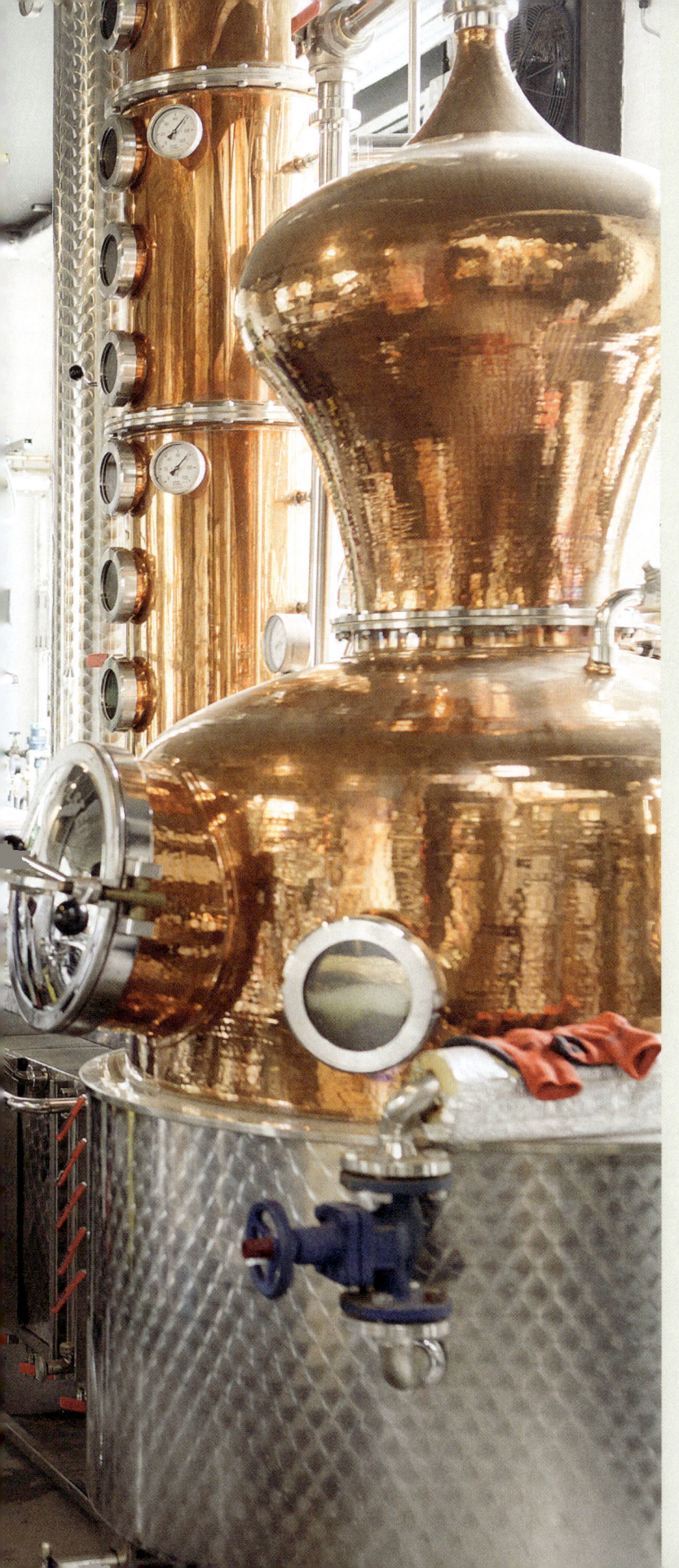

The two copper stills, where the spirits are distilled, are visible behind the public bar in Bow.

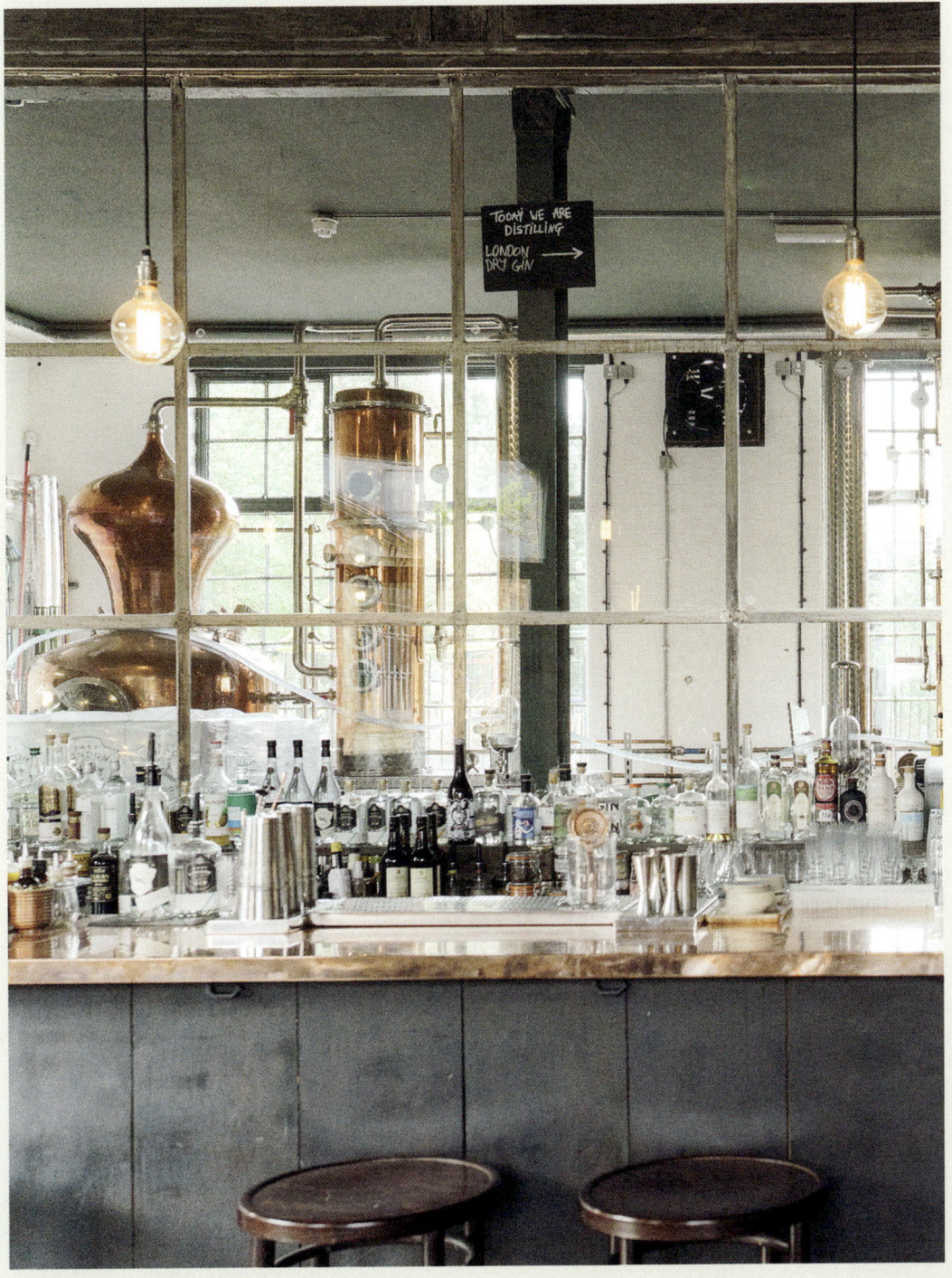

Left: Botanicals in the gin still.
Above: The bar, restaurant and distillery in Bow.

East London, has been key too. 'London has an appetite for trying new things and being open-minded. We're near Shoreditch which has a huge concentration of bars and restaurants. East London has, in some ways, become hideously gentrified but it's still vibrant, although less so where we are in Bow, which means we could afford the lease on our premises because it was a pub that went bust.'

This abundance of local bars meant that rather than spending money it doesn't have on marketing, the company concentrates on getting bartenders to come to the distillery to try the gin and then serve it, thus becoming advocates for the brand.

While there were 1,500 gin distillers in eighteenth-century London; when East London Liquor was founded there were fewer than ten. Whisky makers are even rarer: 'Nobody's made whisky in East London for 100 years, and even now there are only two others which means we can all stand out.'

Despite the exigencies of starting a business, there are some principles that Alex has maintained from the start. All employees are paid a London Living Wage and they keep the management structure as flat as possible. 'We really want to promote the idea that the people here run the business as much as I do.'

There are still, he concedes, plenty of bars in London that don't serve his spirits, something he's keen to rectify by continuing to get bartenders to try, then serve, East London Liquor, and they also have their eyes on the rest of the UK. Then there's a launch planned in New York and California for 2018, 'Though there's no export manager, just me, so that's a challenge.'

But having many jobs within the company, even with 30 employees, is part of the whole appeal of entrepreneurship for Alex. 'My role is constantly changing and it's a real privilege to be part of a business that grows and evolves this quickly. I'm 35 and I'll never get to do this again.'

As well as selling other brands of spirits, they're now developing their own whiskies which will take a minimum of three to four years to age in their casks before being made available to the public.

Standout Advice

'Try to make a difference - we pay everyone a London Living Wage as a base rate, we look after our staff and we focus on making our management as flat as we can.'

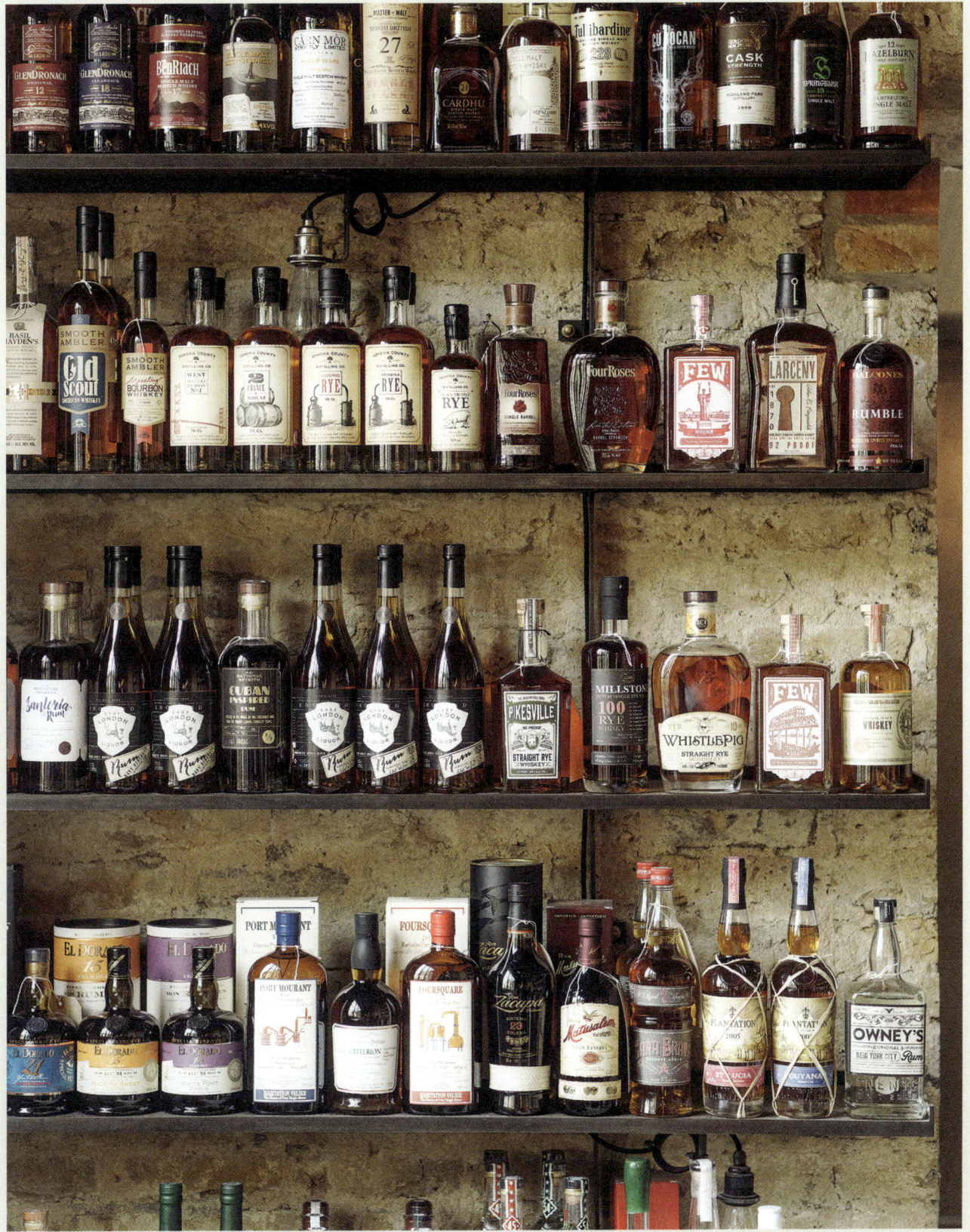

Riposte

How to launch a women's magazine with a budget smaller than the price of a designer dress

Who
Danielle Pender

What
Smart magazine for women

Website
ripostemagazine.com

Follow
@ripostemagazine

Danielle's life at 30 seemed sorted. She'd just got married and had a good job at communications agency KK Outlet. But, she admits, she was also a bit bored. So it was that when she looked at the women's magazines on display at the airport on the way to her honeymoon, instead of picking one up, she decided she could do a better job of creating a publication for people like her.

'There was nothing I wanted to read – women are nuanced, fascinating human beings,' she says, 'but there was nothing that represented that. Men's magazines have all sorts of topics in them and that's what women are into as well, but instead it all seemed to be style and fashion.'

Despite having no journalism experience, Danielle was determined to launch an alternative, one that 'would be feminist in that it featured badass women, but wasn't always viewing the world through gender politics'. Together with creative director Shaz Madani, she created *Riposte*. 'It was really naive of me to think I could do it, but sometimes that's great.'

A Smart Magazine for Women
Issue 8

Riposte

UK 10, EU 15, US 16

Nº8

'You don't have to be in an office from nine to six every day to be productive.'

Issue eight's cover, featuring performer and breast cancer warrior Ericka Hart.

Her employers were supportive, both in giving her the time to put the first issue together but also in paying upfront for the first print run of 1,000 copies with printers Park Communications.

In November 2013, *Riposte* was launched with a striking cover that had no image, only text with the names of the women featured inside. Although having a cover so different from the norm made them nervous, it also made them excited and as novices they had nothing to lose. It turned out to be an inspired move, garnering them press coverage and visually emphasising their credentials as an alternative to mainstream women's magazines. They've subsequently moved to having images on the covers, but these are always thought-provoking, such as issue eight's, featuring performer and breast cancer warrior Ericka Hart baring the scars of her double mastectomy.

Nobody goes into independent magazine publishing to make their millions and Danielle readily admits that funding is a challenge. 'Money's been a massive stress. On a couple of issues we had a shoot that the issue depended on, and there was a location problem and I knew that if we'd cancelled the whole issue wouldn't have happened. I was weeping.'

They have distribution in the UK, Europe, US and Australia, but most of their sales of the now 10,000 print run are through their website via online subscriptions. However, their most sustainable source of income comes from another source entirely – large brands who

want to work with *Riposte* to ally themselves to the attitudes that the magazine represents.

Their first collaboration, with Nike on the third issue, came about through a chance introduction and has led to further projects with them and with other brands such as Levi's Made & Crafted. Doesn't Danielle worry about diluting the essence of the magazine that she's created? 'There are brands we'd never work with because our audience is everything and the minute you compromise your integrity, they instantly turn off,' she admits. 'But there are so many independent magazines that never make it past the third issue and this allows us to put out a great product without compromising it.'

The success of these projects, along with the birth of her first baby, Mazzy, at the end of 2014, has led Danielle not only to re-evaluate her working life, but the working lives of parents more generally.

Riposte will no longer be just a magazine, but also a studio that helps brands reach out to interesting women in interesting ways – be it through the creation of features in the magazine, videos or other content. 'It's striking,' she says, 'that women make 80 per cent of consumer choices but the amount of women who work in advertising, especially towards the top, is tiny. Brands are making content *for* women that's not *by* women.'

Danielle and Shaz hope that eventually this studio will be a magnet for creative women who want to work in different ways. 'Working in an agency or old-school company isn't possible when you have other commitments,' she states. 'They're still backwards when it comes to working flexibly. You don't have to be in an office from nine to six every day to be productive.'

Having shaken up the women's magazine market with nothing but a good idea and dynamism behind her, there's no reason why she shouldn't do the same to outdated notions of what work should mean.

Standout Advice

'A bit of expertise is good, but naivety and coming at it from a different direction is also useful.'

Tribe

How to ditch the suits for Lycra and launch a new brand of natural sports nutrition

Who
Tom Stancliffe, Guy Hacking and Rob Martineau

What
Sports nutrition products

Website
wearetribe.co

Follow
@the_tribe_way

The three friends behind Tribe, producers of natural sports bars and products, inadvertently tested their compatibility as business partners in the most physically tough way possible: by running the equivalent of six marathons in seven days across the Sahara Desert. Having successfully completed the legendary Marathon des Sables, they sought to replicate the high they had experienced by creating their own fundraising event.

'We wanted to create a bigger challenge for ourselves to raise as much money for charity as possible,' recalls Tom, who was a business insights executive before he became Tribe's co-founder in charge of marketing. 'That became Run for Love, which was 1,000 miles across nine countries to raise money for the prevention of child trafficking.'

Run for Love took on its own momentum when they opened it out to other runners to join them at different stages of the route. 'In the end we had 250 people and raised £250,000.'

They had proved to themselves, inadvertently, that they could work seamlessly with each other, as well as realising how the running and triathlete communities were always looking for ways to come together. Despite not coming from 'remotely entrepreneurial backgrounds', they felt emboldened by the success of Run for Love to decide to start a business

'We wanted to build a project together, create a community and be part of that community.'

together – they just needed a good idea to harness their enthusiasm and that of their fellow amateur athletes. 'We had about eight months of germinating ideas,' says lawyer-turned-head of product development Rob. 'We wanted to build a project together, create a community and be part of that community.'

Their only disappointment in Run for Love was the quality of nutrition on offer to amateur athletes; being either the sugar high of a chocolate bar or tasteless cereal mixes. 'There's a burgeoning group of people taking on Parkruns or Tough Mudders . . . everyday people who want to eat well and keep fit. There were no products on the shelves which spoke to these people.'

With no experience in nutrition or manufacturing, they set about making products based around trail mix in Rob's mum's kitchen and trialling them with 60 fellow runners. 'Looking back,' admits Rob, 'they were quite embarrassing, but it got us on track and gave us feedback.'

The experimentation eventually led to the formation of Tribe in 2016, which offers tailored sports nutrition, such as wild apricot and lucuma bars and goldenberry and pecan trail mix. The three factories they identified back then – in Somerset, Sunderland and Snowdonia – remain their chief manufacturing partners.

Given their lack of expertise and the fact that there are already a multitude of sports nutrition products on the shelves, how did they persuade investors? 'It helped,' says Guy, who is charge of finance, 'that we were from a corporate background. We also lucked out with one of our investors who had joined Run for Love as a participant.' They'd also given up their well-paid jobs and put in their own savings before even going out to look for initial seed funding, which proved their seriousness to investors.

Their products are indeed very tasty, but can they really claim to be different from their competitors in what they themselves admit is a 'crowded sports nutrition space'? They are convinced that their emphasis on community and 'fuelling adventure' is what distinguishes them from the rest, as well the functional purposes of each of their products (designed to be eaten, for example, 45 minutes before or 15 minutes after a run).

Tribe's bars, shakes and trail mixes are tailored to specific purposes such as energy boosts or endurance.

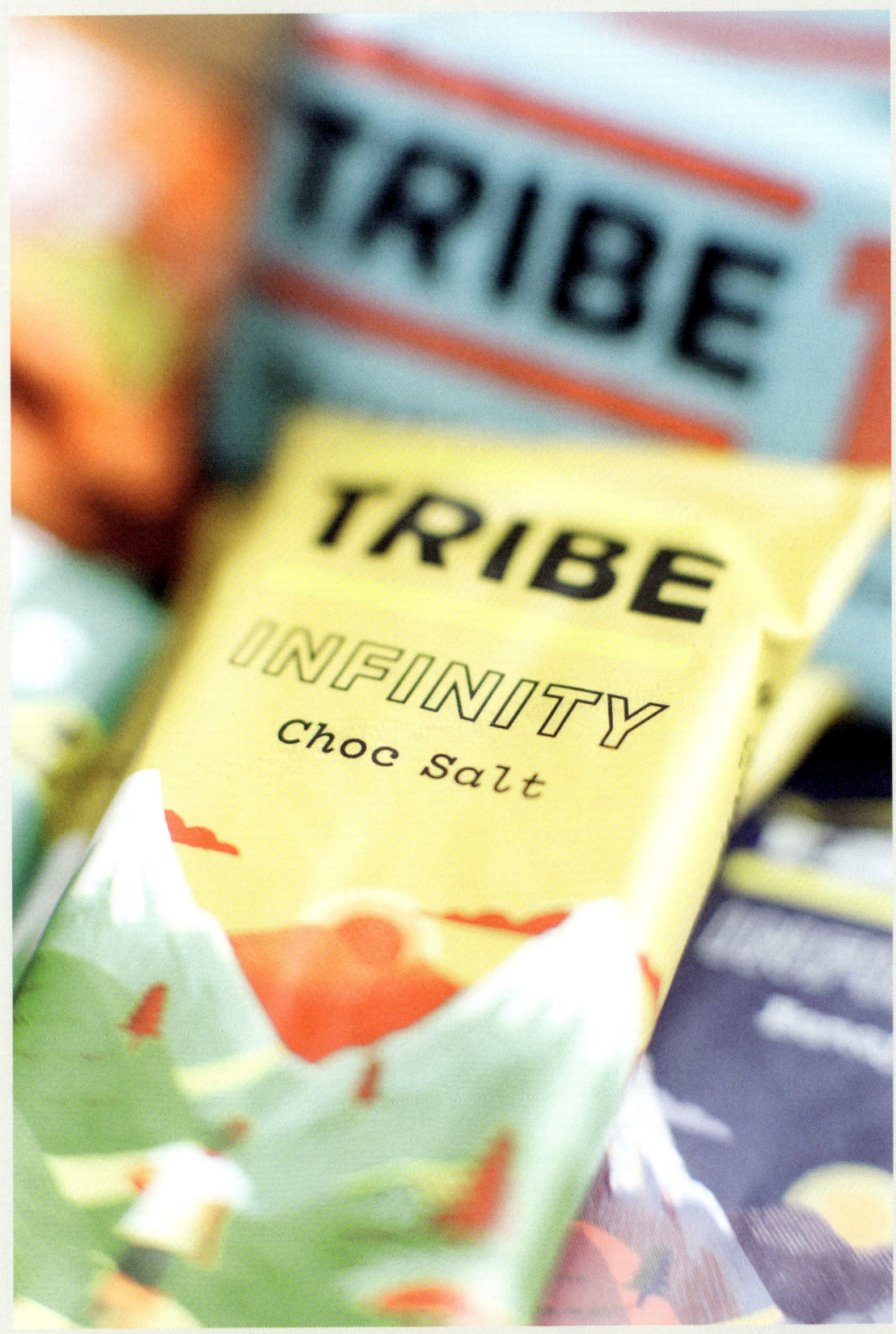

'People now understand it's no longer a simple calorie-in calorie-out equation,' says Guy. 'They're looking to understand how diet can help you perform better in daily life. Our competitors might emphasise something like simple ingredients or being all about protein, but our bars help with a range of very specific goals.'

They are still putting together bigger events like Run for Love, they hold a weekly, quick 'Tempo Tuesday' run from their office and are hoping to extend this via brand ambassadors across the nation. All their products are tested by their customers and a recent crowdfunding round via Crowdcube means that their target market has now invested back into them.

While lots of brands claim to have a special relationship with their customers, Guy, Rob and Tom at Tribe are adamant that it is something that can't be faked. Runners, triathletes and cyclists naturally gravitate to one another and while it makes business sense to harness the power of that community, it appears born of the genuine connection that comes from being runners themselves. 'If we were driven purely by customer acquisition or return on investment, it would be hard to justify the goodwill generated by Run for Love,' says Tom. 'But both we and our investors believe in and are part of that community.'

Initially their sales were through an online subscription model, but increasingly they've been selling through gyms and have their eyes on the supermarket shelves: 'The reality is you need to be in shops because people still buy a lot of things in shops.'

Tribe is intending to concentrate on the UK for the foreseeable future, but then the plan is to go after mainland Europe, where ideas around sports nutrition often arrive after they do in this country, having percolated from California. In the short term, there's a discussion to be had among the trio as to who is going to be leading tonight's Tempo Tuesday run.

Tribe build community around their short weekly runs as well as longer projects like their 1,000 mile Run for Love.

Standout Advice

'You have to start the business and get the ball rolling before you go out looking for investment – investors want to back businesses that are already making progress.'

The Goodlife Centre

How to make a business out of making things

Who
Alison Winfield-Chislett

What
Workshops in making & mending

Website
thegoodlifecentre.co.uk

Follow
@goodlifecentre

Space is everything to The Goodlife Centre's founder Alison Winfield-Chislett, so much so that her initial business plan consisted of a drawing of how she would use the Borough building to create an independent learning centre devoted to reviving the art of making and mending. And what a space it is – a huge, airy, light former cardboard factory near Tate Modern where tools, lathes, wooden objects and bolts of fabric invite you to reach out and stroke them.

Stroking and feeling is exactly what Alison wants; it's her mission to turn the ability to make and mend from a skill that's dying out to one that we all have. With this goal, she created The Goodlife Centre, a hub of workshops teaching DIY, upholstery, decorating, upcycling, woodwork and carpentry to everyone of all levels. The centre is a hive of creativity and practicality, with chairs being upholstered, wood carved and machines fixed in every room.

While many startups thrive on youthful naivety, Alison's business is born of the contacts and confidence that come from over four decades working

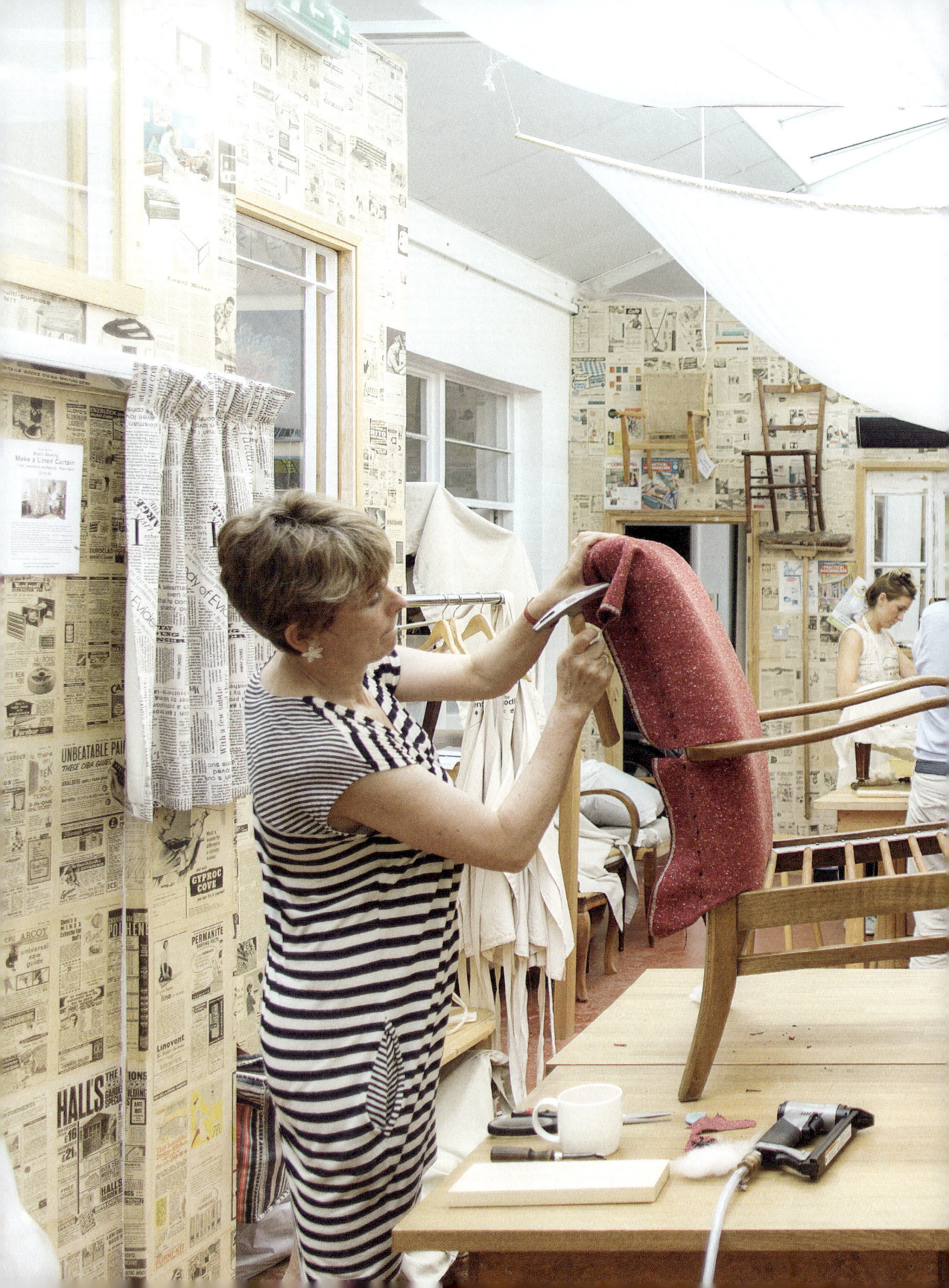

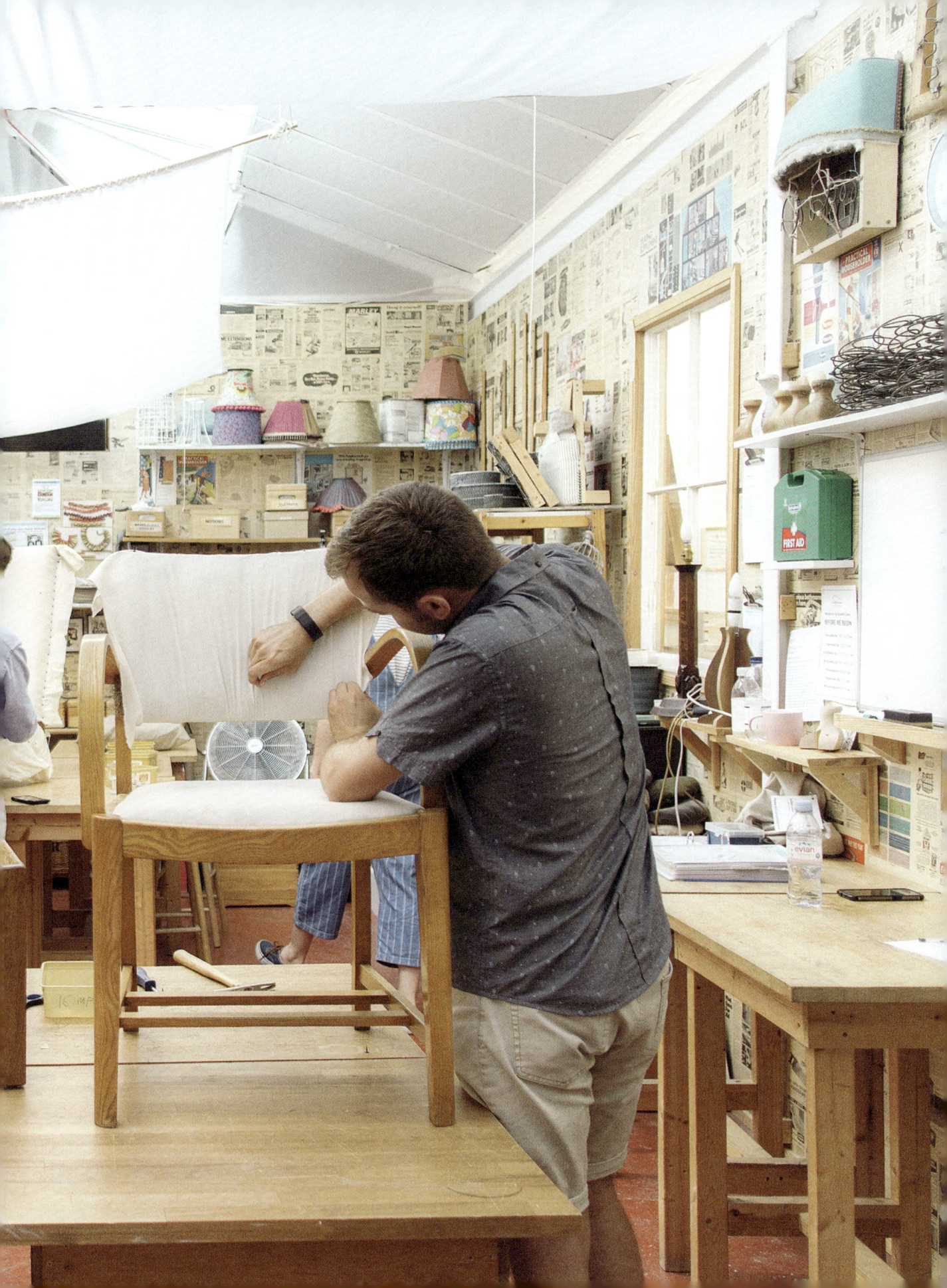

'Our future depends on having places where people can make.'

in creative industries. When she talks of graduating art college into a recession, she's referring to the three-day week of 1974 rather than the financial crisis of 2008. Her multi-faceted and successful career – working for Tiffany's in New York and Asprey in London, writing a book on DIY and much more – also lends perspective: 'My fantastic advantage is that I've got so much experience to draw on. I've never lain awake at night worrying because I know what works and what doesn't.'

Along with her ability to draw on the past comes an uncanny gift for seeing into the future. 'As a designer, you can't look at what's already out there, you need to see beyond that.' On returning from New York in the late 1990s, she identified Waterloo and the South Bank as an area that would blossom, and it's where she now both lives and works.

She also recognised the nascent 'maker movement' – what *The New Yorker* dubs a 'third industrial revolution' – in which homemade, hand-crafted goods are valued. 'I saw a skills gap with a small window. If we didn't teach certain skills now, then the people who can teach them will be gone.'

What places like The Goodlife Centre offer to those of us who feel we've reached 'peak stuff' is the chance to gain an experience and a skill, rather than just another possession. This is another way in which Alison was prescient, as people turn away from acquiring more things towards Instagramable memories.

Alison believes that it is vital that traditional skills, such as restringing chair seats, be passed on to a new generation.

A lifetime of hard work gave her the savings to allow her to found the centre without having to get outside investment or a bank loan, something she'd never do since she doesn't 'respond well to being told what to do'.

Originally she had a smaller premises rented by chance from a photographer she'd known in the 1980s ('you never know when the spider web of your contacts will pay off'), and then 18 months of searching led her to this, the most perfect of all spaces. Charm has helped there too, due to the connection she forged with the landlady, whose family has owned the space for a century and who charges an unusually reasonable rent for central London.

The former factory's spaciousness allows her to employ 30 tutors on a freelance basis as well as various tea and biscuit servers to provide the vital fuel for the students. These workshop attendees come from all walks – lawyers, doctors, IT specialists, the man I'd met who'd sold his vintage comic collection to fund a new way of life – and are a pretty equal split of genders. One film editor encapsulated the spirit of Goodlife when he said he was there because, 'I want to build rather than assemble.'

Alison is convinced that her business is part of a new and blossoming trend toward collaboration that is different from her youth. 'When I was leaving college, it was so competitive and there was a sense that if someone else got something, there was less for you. A 23-year-old emailed me asking for advice on how to set up something similar to Goodlife. In the old days, you wouldn't share valuable information, but I'm thrilled and excited to be able to cooperate as so many makers have done with me. Young people can stand on the shoulders of giants to build something bigger.'

What's exciting is that Alison is part of a great pan-London makers' network that aims to transform how we view manual skills. 'We've got too used to the idea that success means we can be idle; quite the opposite if you look at successful people. Our future depends on having places where people can make.'

Standout Advice

'My motto is "count us in" – all you have to do at every stage is say yes and one thing leads to another.'

Ugly Drinks

How to challenge the fizzy drinks world by launching a smart drink made out of natural ingredients

Who
Hugh Thomas and Joe Benn

What
Sugar-and-sweetener-free drinks

Website
uglydrinks.com

Follow
@uglydrinks

When Hugh was a teenager in Worcester, he heard the word 'entrepreneur' on *The Apprentice* and instantly knew that was what he wanted to become. At the same time, down in Bristol, Joe was the class wheeler-dealer, trading sweets with his school friends. True to their childhood ambitions, they're now the co-founders of Ugly Drinks, which makes 100 per cent natural fruit-infused sparkling water with no sugar or sweeteners.

On graduation, they both looked to find jobs that would help them learn what they needed to launch a startup. This led them to Vita Coco, the US coconut water company that was launching in the UK, where they immediately recognised each other as kindred spirits. They loved the 'scrappy startup' feel of the company, but as it grew so did their ambitions to branch out. 'When we joined,' says Joe, 'it was four people and then suddenly it

'Things are happening more quickly now – what used to take 15 years you can now do in five.'

was 50. We knew how good it felt before and we craved that and wanted to do it ourselves.'

Because of their immersion in the drinks industry, they were aware of trends before the general public felt them and saw how the conversation was increasingly about sugar content. Sure enough, in 2016, Scotland introduced a sugar tax squarely aimed at drinks, with the rest of the UK set to follow in 2018. 'We started questioning whether you could create something that was nutritionally just water but tasted more appealing.'

While continuing with their full-time (and full-on) jobs at Vita Coco they began to develop this idea, 'We thought it would take three months, it actually took 18.' This delay was caused in part by the Catch-22 of trying to create a brand before you've got a product: 'It's things like if you're emailing a manufacturer from a Google address you don't get a response, but they respect you as a business once you're @uglydrinks.com,' remembers Hugh.

They used their salaries to pay a product developer to see whether it was possible to manufacture an appetising drink without sweeteners. Meanwhile, they set to work thinking up a name. 'There were two branding routes,' says Joe. 'The obvious one, calling it "Well Water" or "Splash Water", or the disruptive, subversive route where we call it something completely different. And that excited us.'

After drawing up a shortlist of 50 names, 'Ugly' kept jumping out at them, despite occasional misgivings about what their mums might say. 'It made sense because we're all about transparency, "the ugly truth",' says Joe. 'At this point we had a drink and a name that was completely different to anything out there and we had to put it out into the market to show that it would work.'

To do this they raised £150,000 from friends and family. 'That makes it sounds like we have lots of rich benefactors behind us,' laughs Hugh, 'but it's actually a group of about 15 people from both

sides... a guy my dad plays golf with, three sets of aunties and uncles, siblings. It's a good thing as it motivates us.'

In June 2015, they produced their first Ugly drinks, then in the form of plastic bottles of non-carbonated water that bear little resemblance to the fizzy cans and arresting branding of today. 'Customers told us they wanted something carbonated, which made sense to us as the problem of obesity and diabetes is for a large part caused by sodas, so that's where we needed to offer an alternative.'

The flavours they launched with, too, were more self-consciously 'healthy', such as lemon and ginger or cucumber and mint. When they made the move to carbonated drinks it seemed to make sense to go with more traditional soda flavours (finally deciding upon four: lemon & lime, triple berry, orange and tropical). This was a massive change to the original business plan, but a further revolution came when they radically overhauled their original designs. They'd deliberately gone for a busy, almost chaotic design, but on seeing them on supermarket shelves they felt that they were getting lost. 'We had to be brave to change so dramatically. We could have done a small evolution but we decided to really go for it,' says Hugh. The result, launched in 2016, is something far more bold and playful that, they hope, jumps out at consumers. With the help of their first two employees, Bina and Orla, they took it out for tastings in over 300 stores, winning orders from Holland & Barrett and Selfridges in the process.

Online retail via Amazon has also been a key part of sales. They recognise that younger consumers are as comfortable buying drinks as books online. 'We wanted to be at the forefront of this as well as working with traditional retail. It's exciting – we had five orders yesterday, a Sunday, from people outside of London who've found our brand and want to fill their fridge.'

Ugly's short life has been a constant story of evolution and sometimes revolution, but perhaps the biggest development is imminent: taking on the home of the fizzy drink, the US. Joe is a few months away from moving to New York to spearhead this invasion. 'The average American consumes three ready-to-drink drinks a day versus 0.6 in the UK,' he says. 'We'd initially felt maybe we'd do this in ten years' time but we realise that things are happening more quickly now – what used to take 15 years you can now do in five and you need to be ambitious.'

Standout Advice

'We used to run informal events where entrepreneurs from small food and drink businesses could come together in the pub. If you've met someone a few times, it's much easier to pick up the phone and ask them for help or advice.'

London Terrariums
How to grow a business from discarded jars and a handful of moss

Who
Emma Sibley

What
Gardening under glass

Website
londonterrariums.com

Follow
@londonterrariums

It's hard to avoid terrariums as a metaphor for Emma's space – just like the self-sustaining gardens under glass that she sells, it's an oasis of greenery and light amid the bustling arteries of New Cross.

While terrariums were invented 160 years ago by a Victorian wanting to transport a rare fern, Emma's interest came about as a student yearning for but unable to afford a garden. 'At uni [the London College of Communication], we'd give each other little spider plant offshoots as birthday presents. A few of us experimented one afternoon with Kilner jars and plants without really knowing what we were doing and then I found myself making more and more until I provided some for a friend's café in Peckham.'

As her enthusiasm grew, so did the idea for a business, although becoming an entrepreneur had never been something she'd imagined for herself: 'I never thought I'd become this person – juggling an employee, premises and accounts.'

Instead, the whole process has been spontaneous and guided by circumstances. 'I've never written a business plan – it's been a hobby that turned into more than a hobby and now a job.'

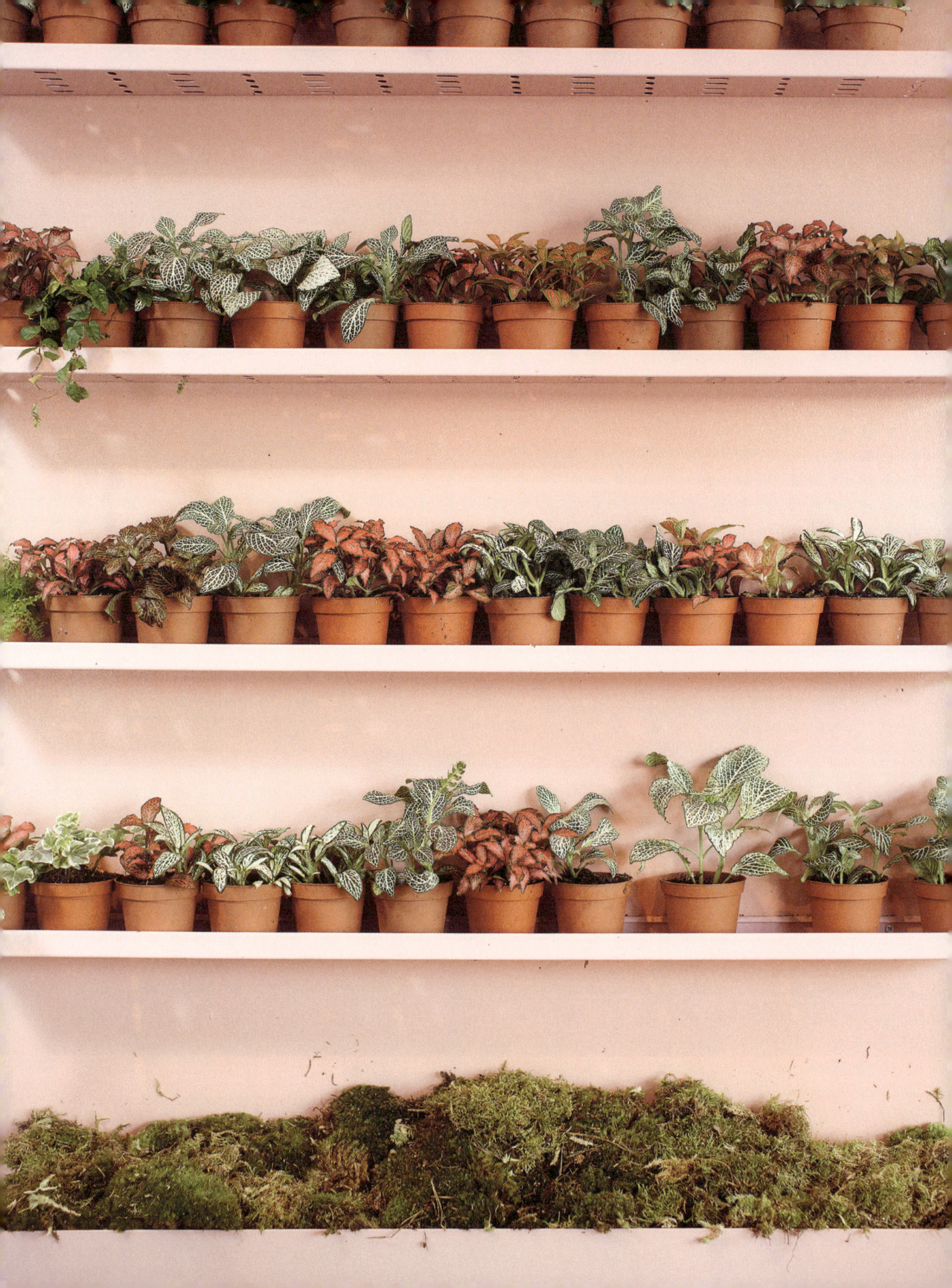

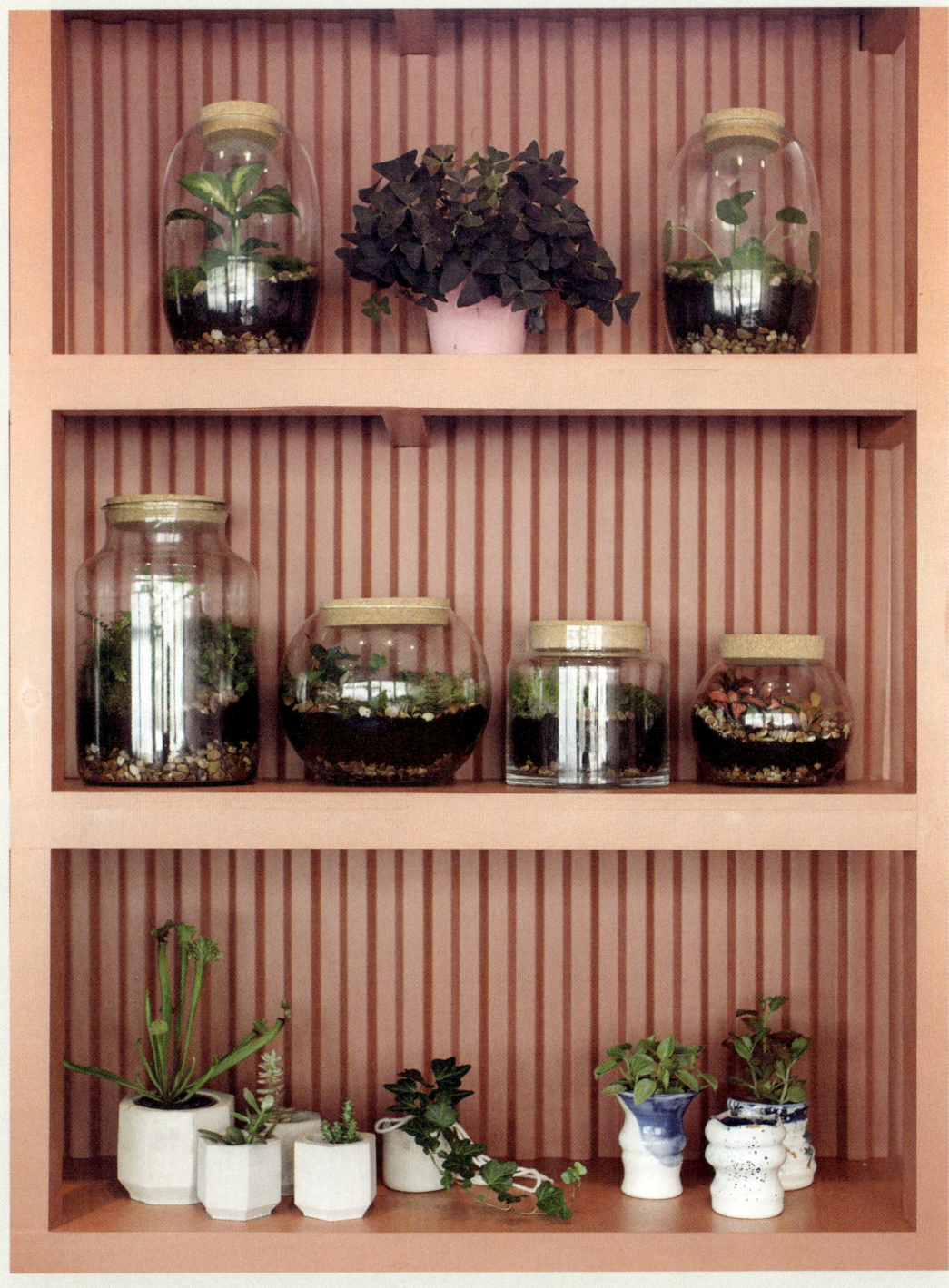

Emma was keen to use bright, warm colours in her New Cross shop, filling it with pinks, turquoises and yellows.

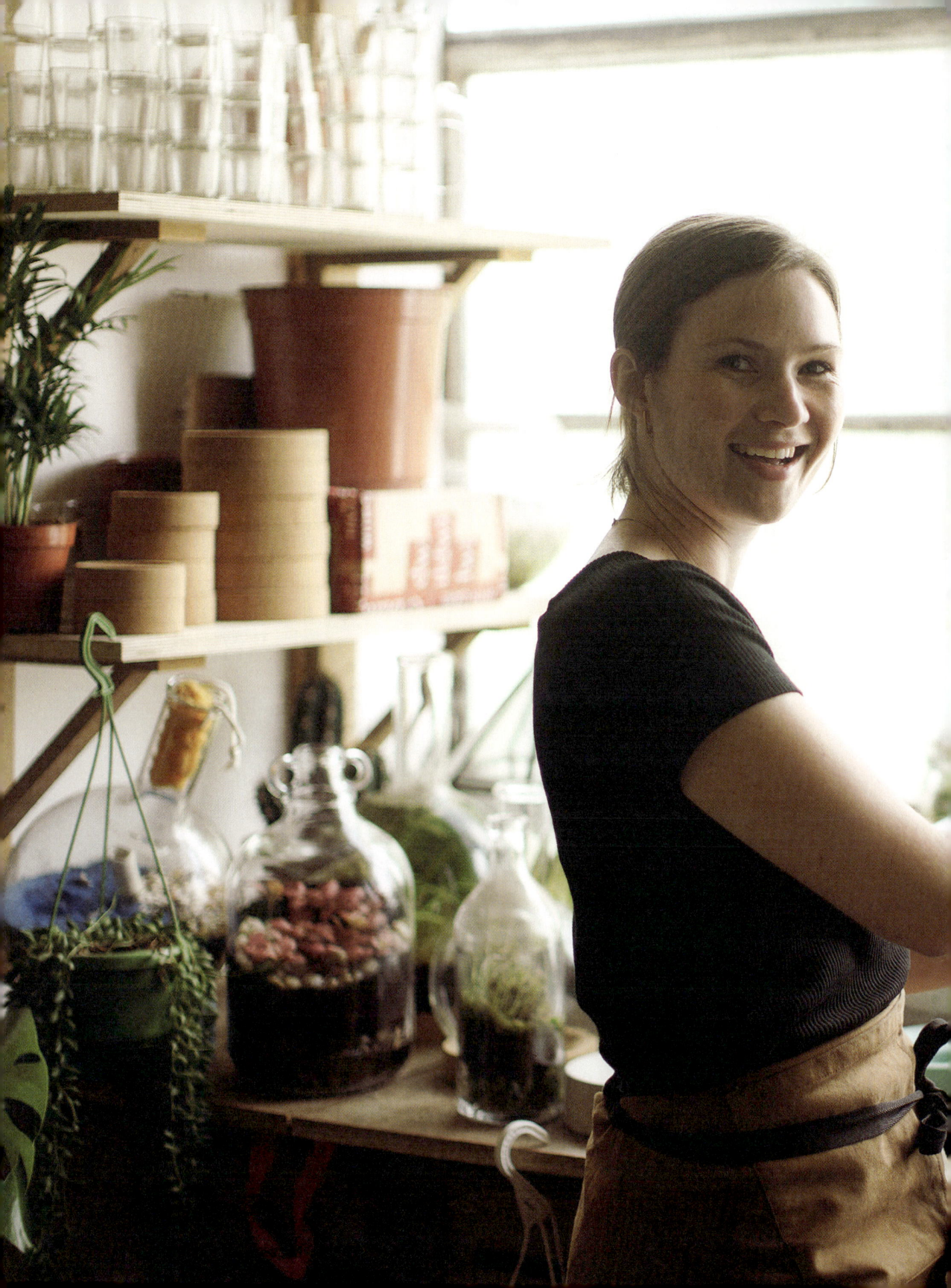

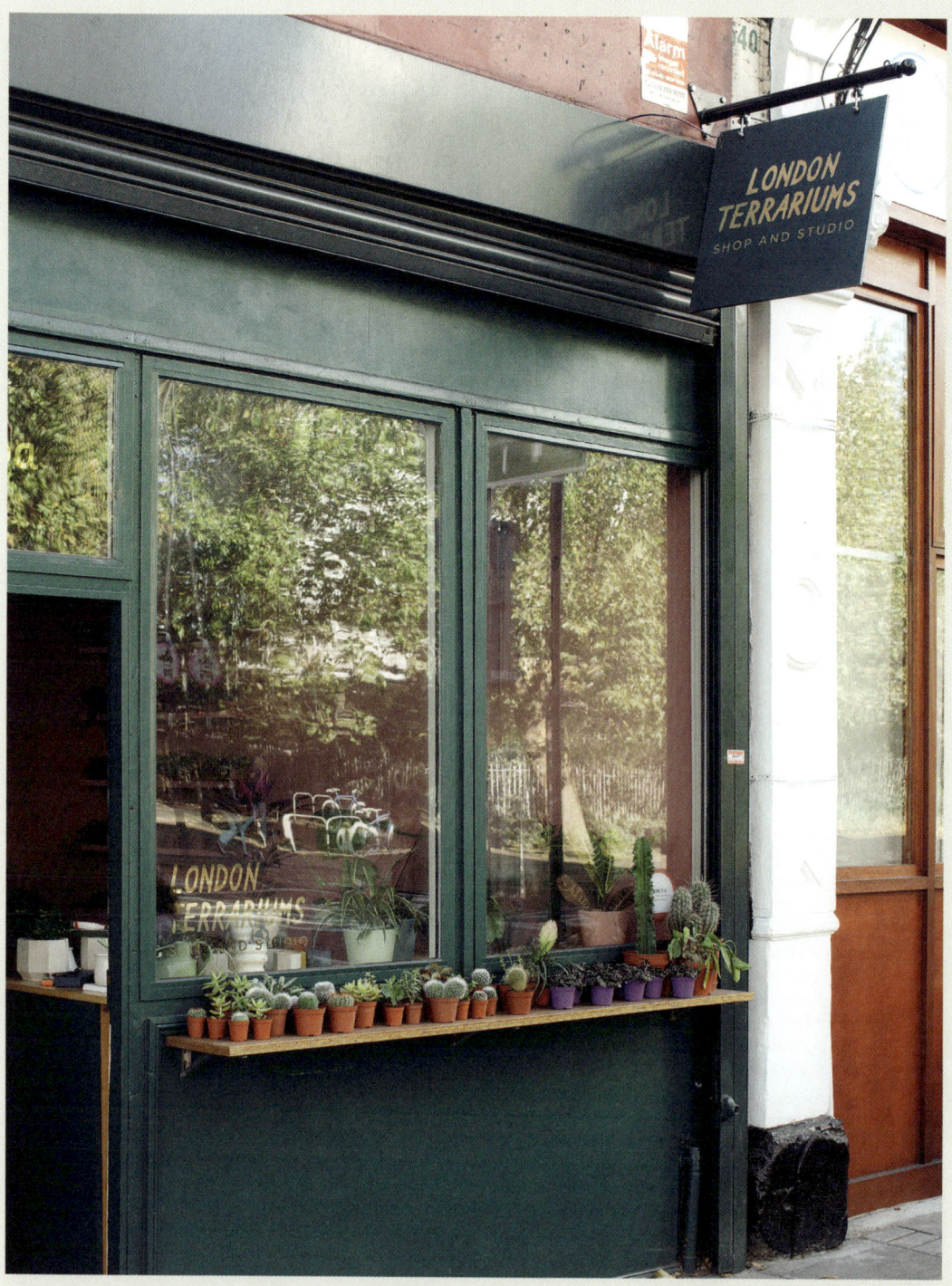

At the shop, customers can buy ready-made terrariums or attend workshops to make their own.

It might be a job, but the hours she works make it not so much '9-to-5' as 5am to 9pm. She's frequently up at dawn to hit New Covent Garden Market at Nine Elms; only getting back home to South London late at night after a workshop somewhere like Stoke Newington.

Back in 2014, when Emma and her then-business partner Tom Murphy began London Terrariums, she was working full-time as an e-commerce digital designer at Heal's, the central London furniture store. 'I was going to the flower market before work and then sitting at my desk with crates of moss piled up beside me.'

The turning point came when Tom decided to leave at the end of 2015 in order to concentrate on his screenprinting. 'I was faced with a dilemma as to whether to carry on, but financially his leaving enabled me to do it full-time as the business would then only be supporting one person.'

Emma and Tom had funded the business initially with the money they made from their day jobs and had low overheads since – thanks to tolerant flatmates – they were building the terrariums at their kitchen tables. When Tom left, she'd calculated the company's monthly income, largely made through the

'I never thought I'd become this person – juggling an employee, premises and accounts.'

workshops that she runs across London, and knew she could afford to pay herself a salary.

Throughout the history of London Terrariums, it's this ability to respond positively to opportunities that has been key, alongside Emma's passion for what she makes. She proudly cradles one of her most beloved creations, made in an old juice jar; she calls those terrariums made for her first big commission for Merchants Tavern in East London her 'babies', and refers to the occasional courier mishaps as 'fatalities'.

She has also benefitted by being surrounded by people who share her entrepreneurial spirit and refusal to be intimidated by the challenges of starting your own business. 'I've got lots of friends who are working for themselves and we have a WhatsApp group where we post anything of interest – alongside calls for a Friday beer. We all help each other out. For a long time London Terrariums went without a website and I just used Instagram, then one of my friends created a website for me, while my boyfriend helped me out with the accounts.'

There have been mistakes – there was the explosion she caused in Shoreditch when she filled jars with sulphurous white stone that created so much gas that the cork shot out – but they have all contributed to the knowledge she now has.

The opening of a shop in New Cross marks a new phase for London Terrariums. This too has been prompted by fate rather than design. 'I'd done a popup at a clothes shop which didn't last, and the owner texted me a couple of months ago and asked if I'd be interested in taking over the space.'

Without ever planning to be a doyenne of the startup world, Emma has managed to build a business by finding a sweet spot where craft meets gardening, where manmade meets natural and where greenery meets glass.

Standout Advice

'Boring but important, I wished I'd done my accounts properly from the start and kept all my paperwork.'

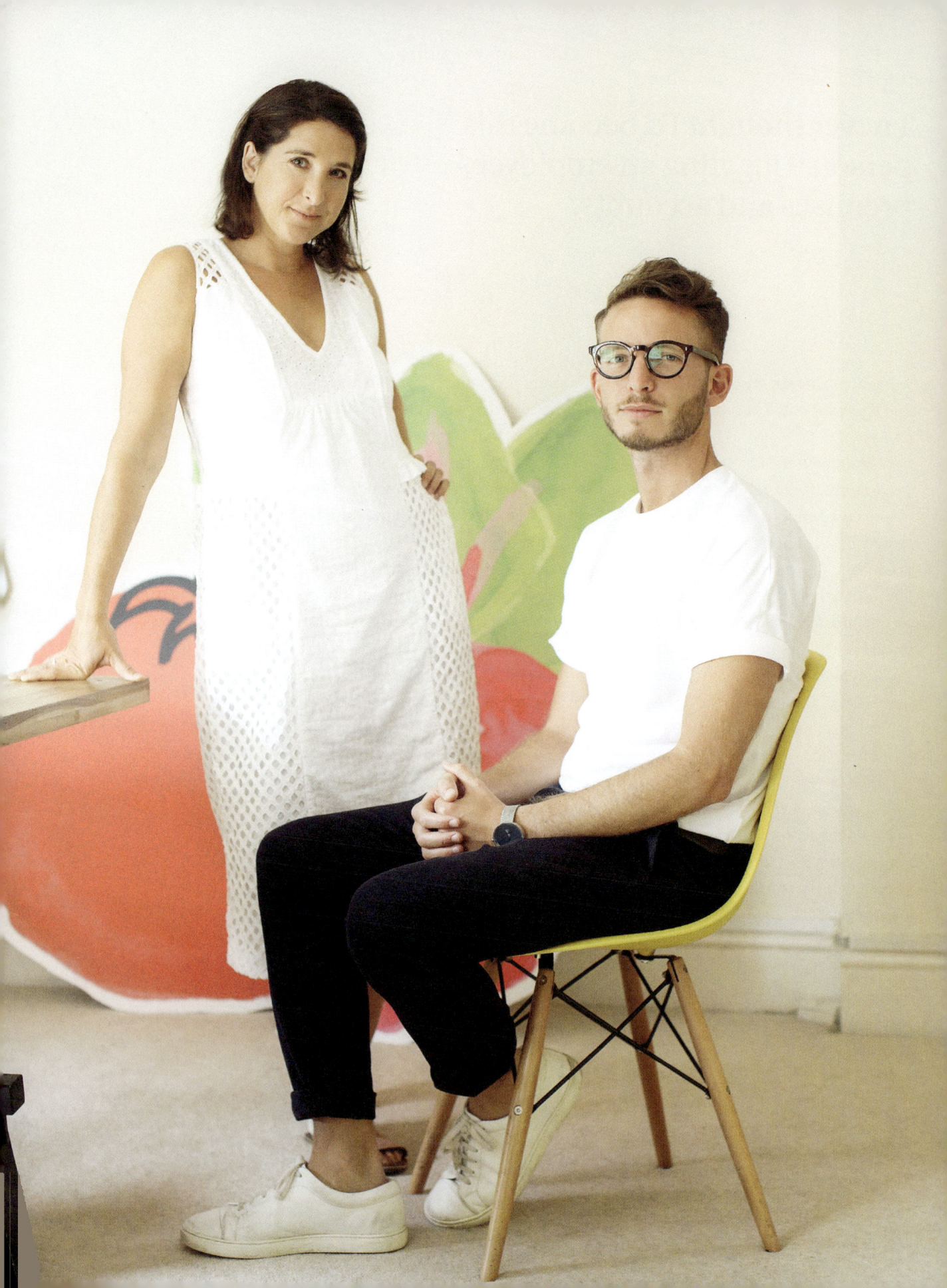

Piccolo

How to launch a Mediterranean-inspired baby food in supermarkets across the UK

Who
Cat Gazzoli and
Kane O'Flaherty

What
Organic baby food

Website
mylittlepiccolo.com

Follow
@mylittlepiccolo

Cat Gazzoli was head of Slow Food UK, the grassroots organisation supporting locally made food and sustainable production, for six years, but her colleagues used to joke that she's the opposite of slow – speaking and acting at breakneck speed.

Take the rapid growth of her organic baby food company, Piccolo, which produces entirely organic, preservative-free pouches of purees. It launched in April 2016, went nationwide immediately, stocked supermarkets as diverse as Waitrose and Asda, and achieved a £2 million turnover in its first year. It wasn't as if her timing helped – she was promoting the 'Mediterranean goodness' of her native Italy just as the UK was riven with divisions over Europe in the run up to the Brexit referendum.

Although she's a fast-talking force of nature, she's keen to emphasise that Piccolo and its growth has been fuelled as much by the people she surrounds herself with as her own energy: 'I have amazing mentors like Craig Sams from Green & Black's chocolate,' she says. 'I had a plan, but I went to them for guidance and financial models.'

Her years at Slow Food gave her the contacts to get influential investment fast, including from Prue Leith, long-time campaigner for food education and now best known as a judge on *The Great British Bake Off*. 'Prue and I both felt that there was a lot of work being done with school foods, but the zero-to-two age group was missing,' she recalls.

The investors were betting on Cat, but also on her belief that parents across

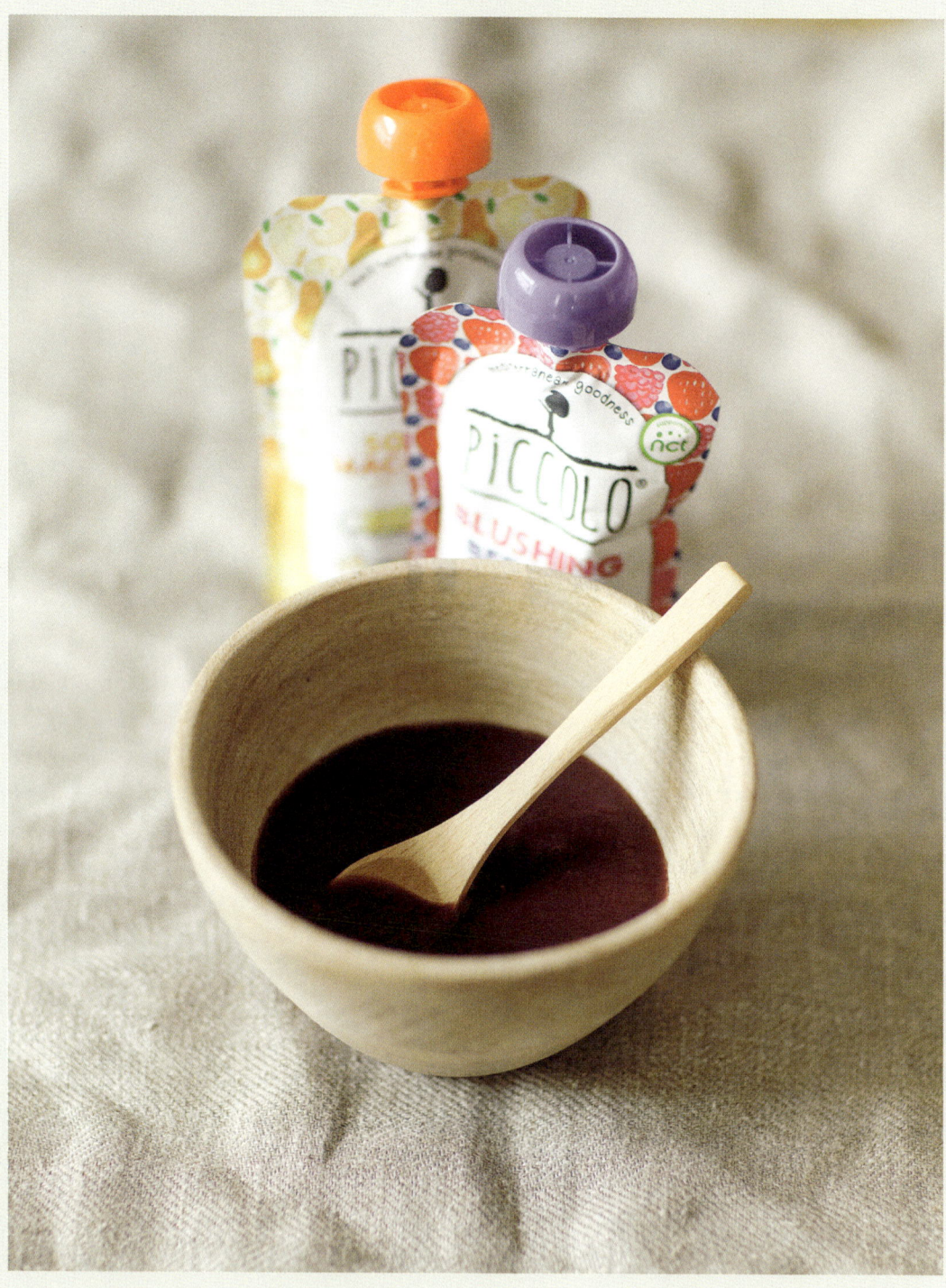

Piccolo's pouches use ingredients not usually associated with baby food – kale, beetroot and red pepper.

all socio-economic groups were interested in preservative-free, tasty and organic baby food. 'I worked at Slow Food for six years and saw food trends across the whole country, not just in London. Thanks to chefs like Jamie Oliver and Hugh Fearnley-Whittingstall there's an interest in ingredients and goodness that isn't just for the upper class. Consumers change when they become parents, too. They start thinking about pesticides and move into organic.'

Cat was determined that Piccolo should offer grown-up flavours to babies, such as three grain vegetable risotto and yoghurt with mango, pear and kale. The packaging too, doesn't talk down to parents: 'It's not a talking pouch with "eat me" and puppies on it.'

'A hundred per cent of business success is hiring the right people,' advises Cat. 'I have an amazing co-founder, Kane O'Flaherty, who had worked with Julian Metcalfe [founder of Itsu and Metcalfe's Food Company] and has done all our branding and design.'

Alongside Kane, nutritionist Alice Fotheringham has been with Piccolo from the start and is also their head of sales.

She was always determined that Piccolo have a charitable arm. 'We're an accredited social enterprise, which means we give money to the National Childbirth Trust and to the charity we founded, the Food Education Foundation, that does weaning workshops in deprived parts of London. We give this funding whether we're profitable or not.'

Cat explains that places like the UK, Scandinavia and Australia have a far more buoyant market for high quality baby food than in places where being a working mother is less prevalent. 'There are huge factors outside of baby food that influence the market,' she says. 'In Italy, women typically get off the career ladder completely because the incentives and employment law aren't there and the grandparents tend to be more involved.'

Her own daughter, Juliet, who was born four years ago at the same time as the idea for Piccolo, has been looked after for much of the summer by her devoted *nonni* in Italy. 'I'm super close to my in-laws and I couldn't have done it without them.'

Cat is refreshingly honest about how starting a business is not easily juggled around the needs of a child. 'If you want to be a mum first, it's difficult to do a startup. It's not fair to investors to take their money and deprioritise them at the drop of a hat. Your career has to be number one *alongside* your family.'

Cat develops the Italian-inspired recipes in her Covent Garden flat near the Piccolo offices.

Standout Advice

'Looking after your people is key. I have someone who sits down with each employee to ask them about their mental health and any other issues and who then gives me anonymous feedback. You have that stuff in big companies, but it's rare in startups.'

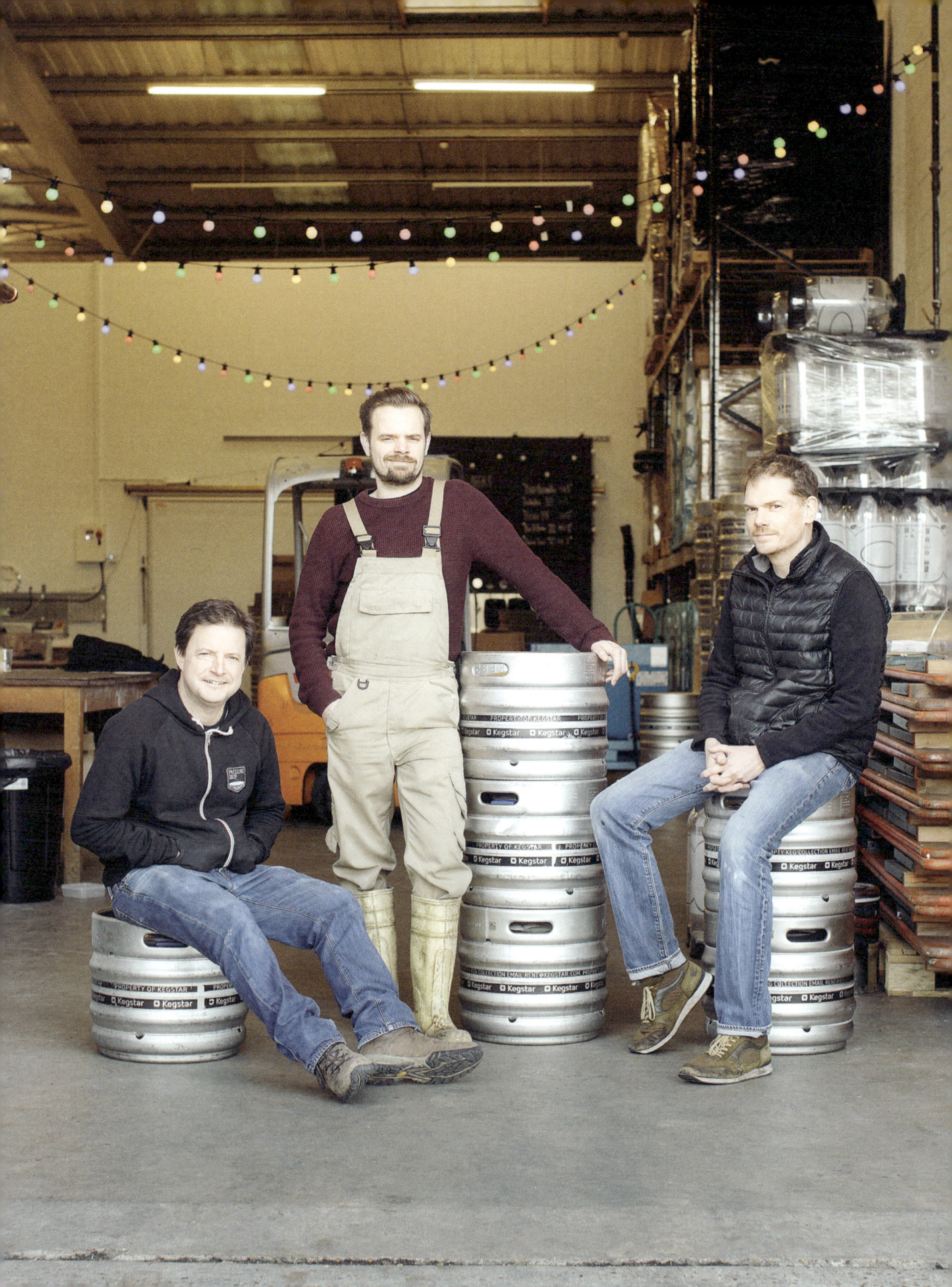

Pressure Drop

How to go from making beer in a garden shed to a brewery in the heart of London's craft brewing district

Who
Sam Smith,
Ben Freeman and
Graham O'Brien

What
Brewery and taproom

Website
pressuredrop
brewing.co.uk

Follow
@pressuredropbrw

What does the place Tottenham conjure up? Spurs, mainly, or perhaps the riots of 2011. But when we think of N17, we should really be picturing breweries, since the area has evolved into the hub of London's renascent beer industry.

Pressure Drop is just one of the five breweries (Beavertown being the biggest and best known) within a few hundred metres of one another on an industrial estate by the River Lea. Its founders Graham and Sam were at secondary school in Islington together, while Ben is a recent friend made through an internship at London Fields Brewery.

Back in 2012, Sam was a project manager in IT and Graham was working as a gardener and looking after his three children, having previously been a web designer. 'We'd had various pub talk pipe dreams of various businesses,' says Sam, 'but we knew how different it is having dreams and actually doing it.'

Meeting Ben – then an engineer but also a fellow beer enthusiast – proved to be the catalyst for the change. 'When we

PRESSURE DROP

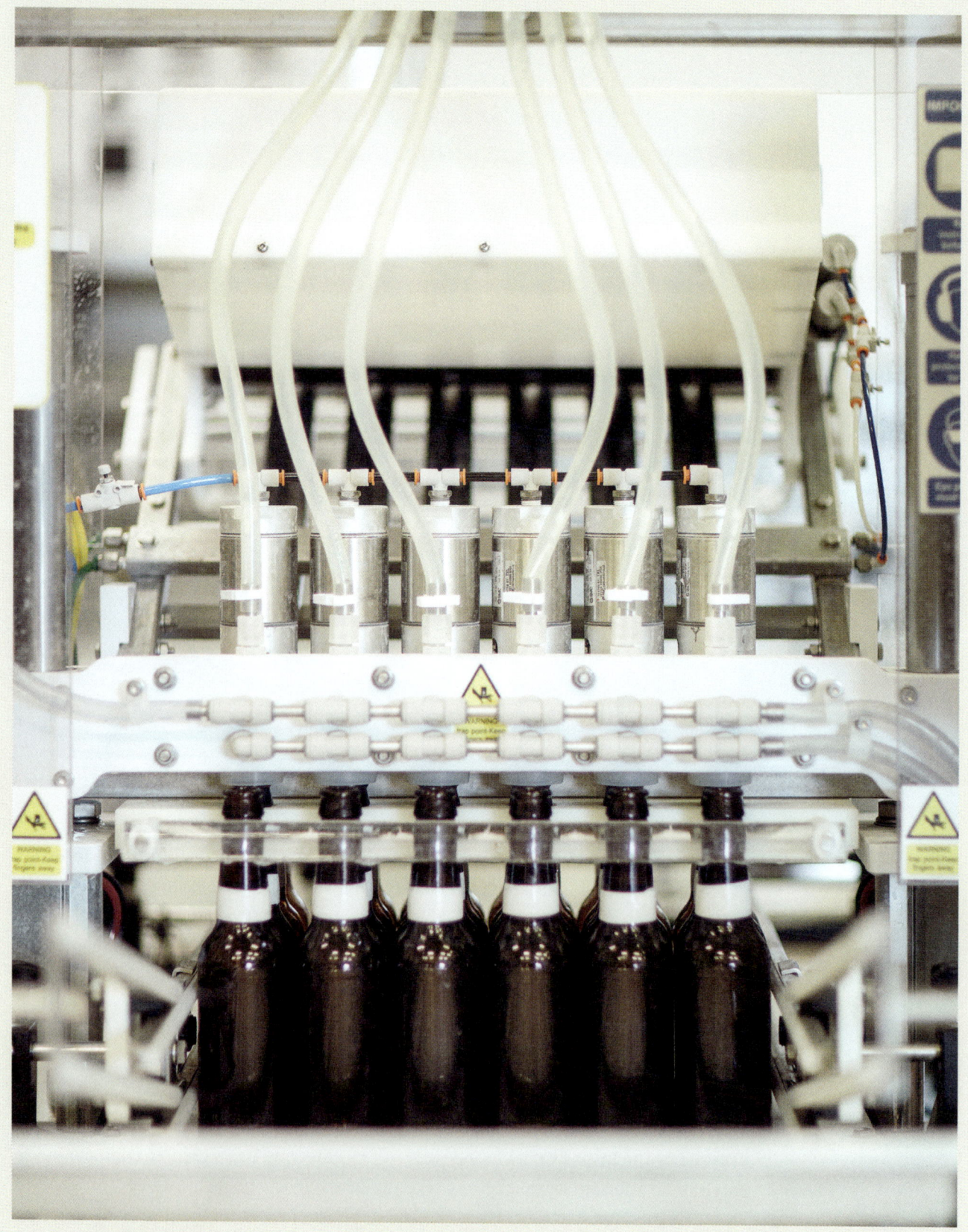

'It was the Olympic summer, so don't forget that everyone was very optimistic.'

met the right people at the right time, it all happened quite naturally.'

The other prompt was the whole brewing renaissance that was going on around them, as Sam says, 'This sort of beer didn't exist when we were younger.' Sam and Graham had always wanted to start their own business, but had got stuck as to what they'd actually produce. Beer was something they knew about as consumers and they set about learning all they could to enable them to become producers.

They began by experimenting with recipes in Graham's garden in Stoke Newington using high-end home brew equipment costing over £2,000 and quickly 'sacked off' their day jobs, relying on savings to get them through the first six months. It seems a remarkably carefree approach to starting a business, but as Ben points out, 'It was the Olympic summer, so don't forget that everyone was very optimistic.'

It soon became apparent to both them and Graham's family that they needed to move into bigger premises, so they rented a railway arch in Hackney. This had the additional benefit of galvanising them. 'Everyone knew then that the other two [Graham and Ben] were serious about it and we had to decide on a name,' recalls Sam.

There were a hundred also-rans to choose from, but Pressure Drop was the one they finally agreed on because it both describes something technical (the difference in total pressure between two points of a fluid carrying network), and is also a classic Toots and the Maytals song. The musical theme is carried through to the designs of the labels for the various brews, which Graham describes as 'mini album covers'. Such bespoke and distinctive branding could have been expensive, but a detailed brief and the hire of a designer who, like them, was just starting out kept costs down. The labels continue

From a Stoke Newington garden to a Hackney railway arch to an industrial estate in Tottenham: Pressure Drop's moves have allowed them to invest in large-scale machinery such as this bottling machine.

to be Graham's 'baby', though he admits that these days he has to be more concerned with whether they stick to the bottles or not than with their aesthetics.

For the first four years, Pressure Drop never made more beer than they could sell, leaving them to concentrate on getting the brews perfect rather than on marketing or sales. This changed in 2017 when they moved to Tottenham – lured by an affordable industrial unit, the collaborative atmosphere among the local breweries and a loan from Haringey Council's Opportunity Investment Fund, set up to encourage businesses in the wake of the riots.

Starting up a business is, says Sam, a continual process of learning things from scratch: 'How to set up a company, how to get a logo designed, how to get barcodes, where you order cardboard boxes from.' The Tottenham move has made the learning curve that bit steeper with the addition of a taproom, open to the public on Saturdays where they sell their brews. 'Now we've had to learn how to run a bar, what you do when someone's drunk and won't leave, knowing when you have to order more bog roll.'

Despite producing beer on a much larger scale since the move, they're still keen to keep the drinking of it relatively local. 'There's a hierarchy,' says Sam, 'the taproom is where I'd like to sell the most beer as it's the freshest with the best vibes, then it's to a pub round the corner, then the UK and lastly exporting.'

One place where they've no desire to sell their beer is in supermarkets. 'We'd become less of a niche craft product and more of a mainstream product, which would affect our identity as a company.'

The plan today is the same plan, they believe, that they've had since the start. 'Make good beer, have a sustainable business that breaks even and, now that we've six employees, make it somewhere they're happy to work and where they can develop.'

Each bottle label is designed by a different artist as a 'mini album cover'.

Standout Advice

'Stay adaptable. At each level you expand, you'll have to learn everything all over again.'

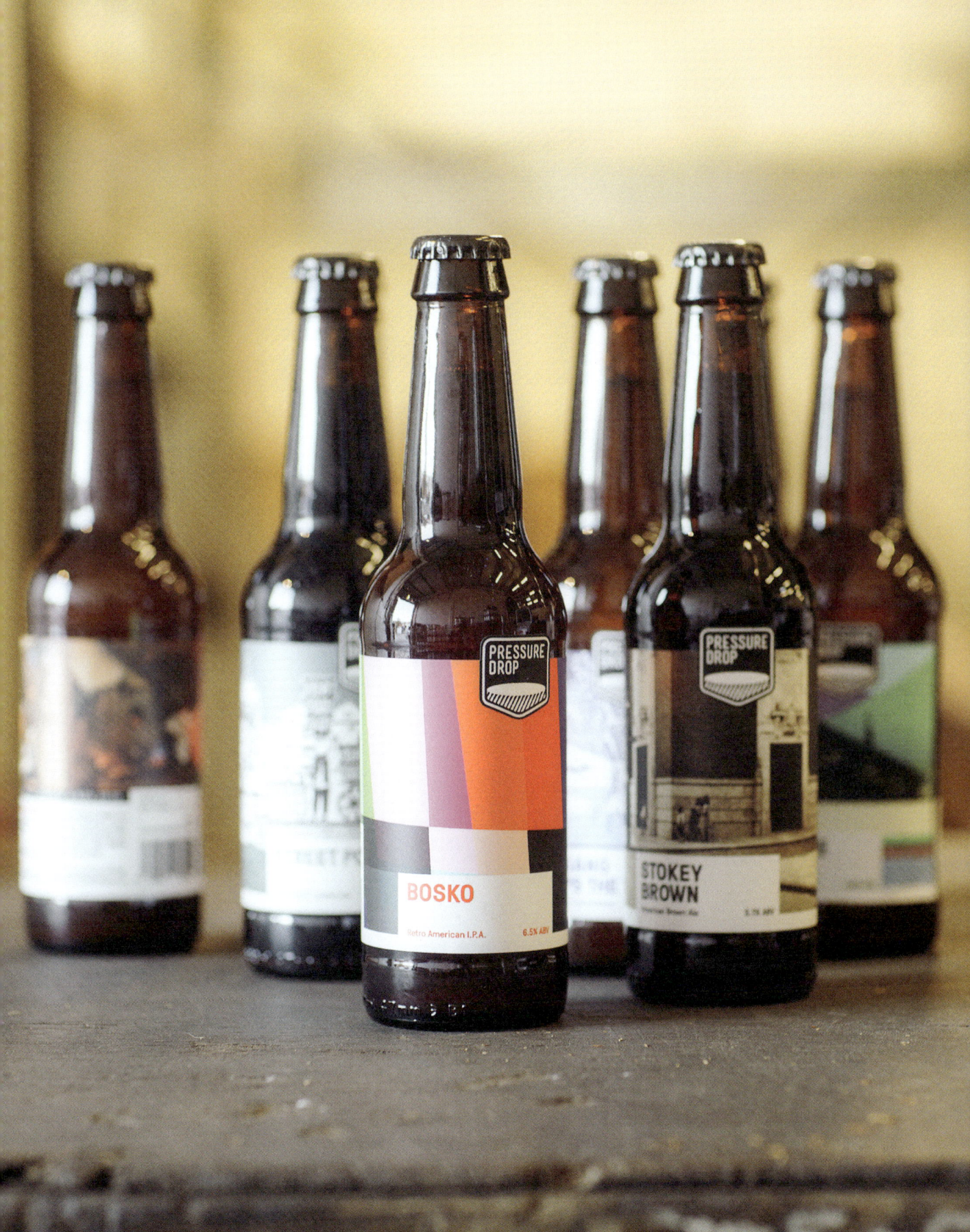

Quill London

How to write your own success story with a stationery and calligraphy business

Who
Lucy Edmonds

What
Calligraphy and stationery

Website
quilllondon.com

Follow
@quilllondon

When Lucy founded Quill London as an online store selling beautiful stationery sourced from around the world, she had no plans to become London's queen of calligraphy. Yet five years later, she's speaking to me from Quill's exquisite Clerkenwell premises surrounded by copies of the book she was commissioned to write on the subject, *Modern Calligraphy*.

It's fair to say, then, that things have not gone according to plan, which is ironic since Lucy spent nine months before launch working hard on a meticulously detailed business plan.

'I found an incredible book, *The Definitive Business Plan* by Richard Stutely, which explains the process of writing a plan clearly and I became passionate about the value of a really good one,' she says. 'I focused on marketing and specific tools I'd uncovered, as well as some product categories I'd intended to incorporate. The plan also focused on developing the online store into bricks-and-mortar quickly which, because of

'I noticed on social media that calligraphy was becoming a big thing in the US but that nobody was doing it over here.'

the calligraphy (not in the plan!), didn't happen to the full extent.'

She wasn't entirely new to business having spent the previous four years selling homewares, the side project of two women who already had a successful furniture retail business. 'Using someone else's money, I had a great opportunity to run a business almost single-handedly but with the guidance of experienced people. Since then, there are many occasions where I felt I already knew the answers, from getting press in magazines to pricing things.'

As well as detailing her plan, Quill's gestation also included finding the perfect stock. 'I really wanted to launch a well-rounded collection as you can only launch once . . . I didn't want to test the market before this, I wanted it to feel ready.'

Only once she felt confident that she had the right products did the website launch, funded by her own savings and a small loan from an uncle.

At the end of 2012, her stationery shop went online and began attracting a loyal customer base of stationery fans. The business had low overheads and she was making enough money to pay herself a wage when along came what has turned out to be both her greatest success and, occasionally, her greatest regret: calligraphy. 'I've always been able to spot trends just before they go mainstream. I wish I knew how, it's bizarre. I noticed on social media that calligraphy was becoming a big thing in the US but that nobody was doing it over here.' At the same time, she noted the growing trend for one-day or evening workshops as consumers became increasingly interested in buying

Lucy inscribing a copy of her book, *Modern Calligraphy*, published by Orion in 2017.

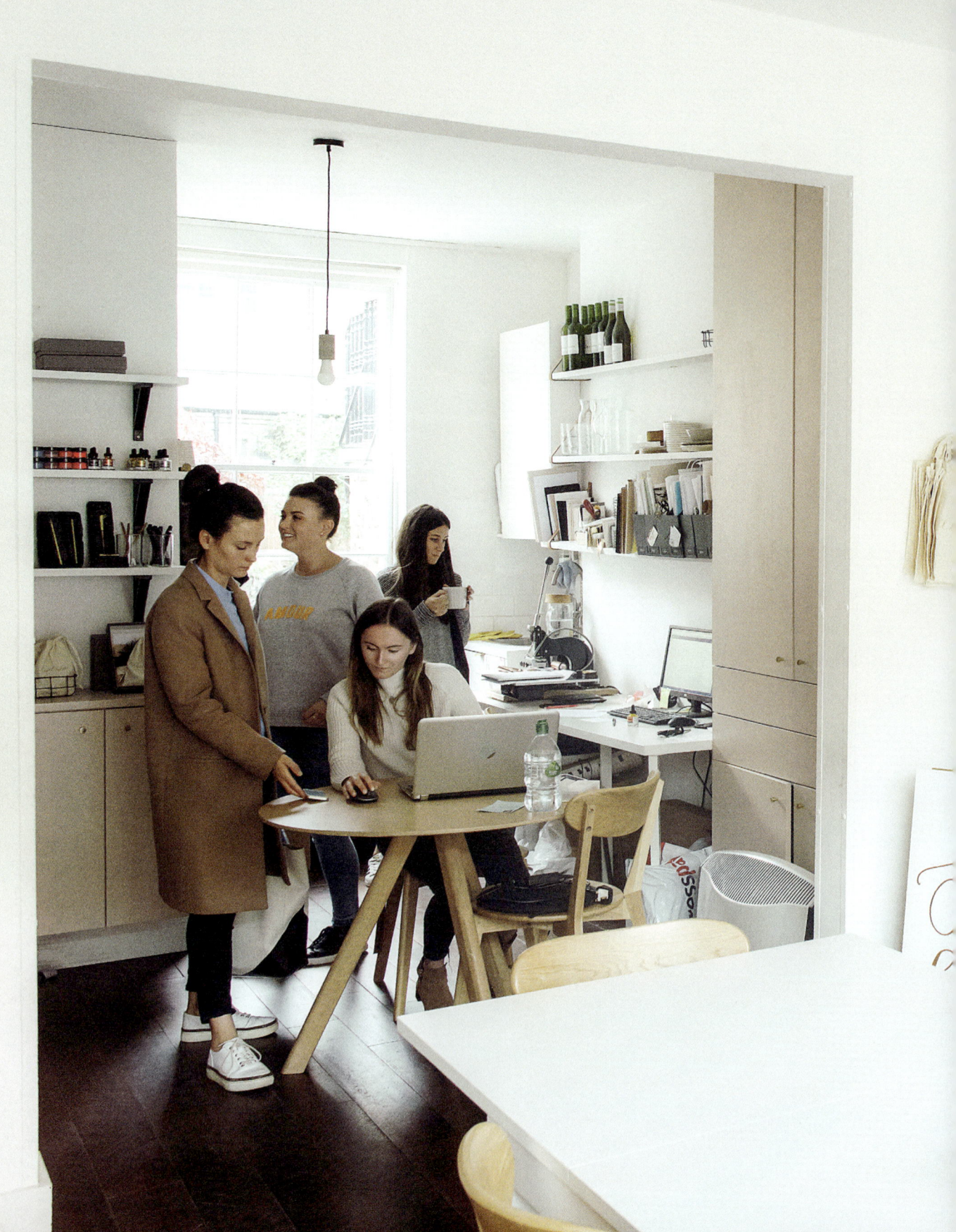

experiences and knowledge rather than just more 'stuff'.

Melding the two, she decided to offer a one-off workshop to stationery customers taught by the calligrapher Imogen Owen. But demand was off the scale and the one-off soon became a regular offering, eventually leading to the lease of the Amwell Street shop, Lucy training to become a calligrapher herself and the commissioning of the book on modern calligraphy (essentially a more creative, free-flowing version of the classic copperplate style).

The demand for workshops has continued to grow from its 'crazy' start, with attendees ranging from brides-to-be to graphic designers keen to do something away from a computer screen.

While the success of the workshops and her book has been a boon, there are times when it has detracted from the stationery element of Quill. 'We went from one to 24 calligraphy workshops a month, which is incredibly time consuming to organise. The rest of the business became very reactive because it was demanding so much of my attention, which has been frustrating.'

It's only now that Lucy has found the time to revisit her original business plan and to begin formulating a strategy of how she'd like Quill to develop in the next few years. 'I'm annoyed with myself that it's taken this long for me to do this, especially since I'm such a big fan of the business plan writing process.'

So far Quill has been self-sustaining, growing to four full-time employees and a raft of freelancers. It's the management of staff that Lucy finds most challenging, likening it to 'rubbing your head and patting your stomach at the same time'. The next stage will most likely require a loan to expand since she'd like to have shops across London 'in all the loveliest places, Notting Hill, Marylebone High Street . . .'

Standout Advice

'You need to make your launch perfect since newness is so important to the press and you'll only get one chance to get it right.'

ROLI
How to create revolutionary musical instruments for the digital age

Who
Roland Lamb

What
Digital musical instruments

Website
roli.com

Follow
@we.are.roli

Roland Lamb is the most polymathic person I've ever met. He spent a year living as a Buddhist monk in Japan; has a degree from Harvard in classical Chinese and Sanskrit philosophy; a PhD in product design from the Royal College of Art and is a talented visual artist and jazz pianist. Oh, and he's such a proficient cake baker that he ran a café as a child.

But it's as an entrepreneur and inventor of new musical instruments that he feels that his multitude of talents have found their ultimate outlet. 'It plays to all my different interests,' he says, 'it's about having a deep vision, having an invention, music, building a good culture for the company and working with other people. It's so multi-dimensional that I've found it to be really exciting.'

It's only someone with such a breadth of interests who could decide that they'd like to reinvent the piano keyboard to create an instrument that would be able to play in between the notes and have the flexibility and responsiveness of a saxophone or guitar.

Back in 2009, whilst doing his MA at the RCA, he first hit upon the idea of creating a keyboard that would have a single, continuous surface of silicon, rather like an undulating rubber sea. The initial drawings he made back then are remarkably similar to the eventual product, Seaboard, which was launched

Above: The latest product is BLOCKS, a modular music system which can be used independently or with the Seaboard. Right: The Seaboard allows musicians to play 'in between the notes' to create an instrument that has the flexibility of a saxophone or guitar.

'We've built up a dynamo of energy over here and London is a good city for music.'

in 2014. As a student, he not only came up with the product but also the name and was determined enough to incorporate the company and its name, ROLI, a full five years before the Seaboard came to market.

Any product that combines hardware and software in such an innovative way doesn't come cheap and the company has raised $50 million to get to the stage it's at today, employing over 150 people with offices in London, Los Angeles and New York. These millions have come via the venture capitalists Foundry Group and debt funders Kreos Capital, and include an investment from Universal Music Group. While it's not an eye-watering sum in the context of the tech world, it's a lot for a musical instrument. 'The combination of fields made it harder,' admits Roland. 'It's not some buzzy trend like artificial intelligence is now, or delivery and food prep was three years ago. Hardware is more difficult to raise money for because there's more risk around inventory.'

ROLI's London location was a further challenge. 'Being in Europe it's harder to raise a lot of money than in Silicon Valley. But we've built up a dynamo of energy over here and London is a good city for music.'

They're still in the Dalston offices they were four years ago, albeit with a 'bunker' of software developers and engineers housed in a separate building around the corner. The doors open from an unprepossessing alley to reveal a light, airy HQ with a long communal table where all employees are invited to tuck into a daily vegetarian lunch prepared by the resident chef. A blackboard displays the mouthwatering menu of crostini and curries.

A considerable chunk of the investment has been spent acquiring other companies, such as the coding framework JUCE and the interactive music-sharing platform Blend. Part of this was to buy key assets to build the company, but the other objective was to 'ask a few really smart people to join the team and become partners'. To ensure that ROLI continues to evolve, Roland has learnt that it's about recognising the things that he is not good at – in this case software development – as much as what he can do.

ROLI also launched BLOCKS at the end of 2016. If the Seaboard is the maverick child of the piano, BLOCKS is the energetic, multifaceted offspring of a drum

kit. This modular system is designed to allow users to customise their system, depending on their budget and the kind of music they want to make.

'The Seaboard was about bringing expressive depth to digital music,' says Roland. 'The next step is to bring breadth. For us, this comes from accessibility and that comes from price points, size and having something modular so you can start small.'

With typical ambition, Roland outlines the next steps for ROLI: 'We won't be changing offices, but we have lots of plans on how to scale and how to empower every person on planet earth to make music.'

Standout Advice

'I turned down early investment from the RCA in return for a 50 per cent share of the company. Sometimes the moments when you say no are the most important.'

Pip & Nut
How to take a nut butter from the kitchen blender to the supermarket shelves

Who
Pippa Murray

What
Nut butters and milks

Website
pipandnut.com

Follow
@pipandnut

As the daughter of two public-sector workers, with a creative arts background and a job at the Science Museum, there was nothing to suggest that Pippa Murray would turn out to be a supermarket-conquering food entrepreneur in her early twenties.

Except, perhaps, her hobby of running marathons at an age when many are more likely to stagger to the bar. The physical demands and solitary nature of long-distance running both led her to the idea of Pip & Nut and is key to explaining how, at just 23, she had the personality to see a gap in the market and to decide that she should be the one to plug it.

As a runner, Pippa needed protein-packed, filling food fast but noticed that most of the available nut butters were filled with palm oil and sugar. 'I just bought a powerful blender and began playing around with ingredients in my kitchen.' In contrast to tech companies, Pippa had the advantage that she could create her product prototype in an inexpensive way, especially since the butters

'We've made something that looks young and fun which disrupts the shelves to get traction.'

were such a simple combination of nuts and salt, with a few further ingredients, such as coconut or honey.

With what tech startups would call a 'minimum viable product', Pippa was able to go to market – literally, Maltby Street Market in Bermondsey, where she'd sell her jars of butters at weekends. This allowed her to refine the recipes as well as giving her valuable early consumer feedback. 'While a market-based butter wasn't what I wanted, it was a great step as it got me going and thinking about the product that I'd eventually make at scale.'

The desire to step up from kitchen to factory provided her with her next two challenges. Firstly, she needed money. 'I started with a £5,000 loan from my dad – which I've now paid back!' She saved money by forming a strategic partnership with her branding agency, B&B Studio, who took shares in the company in return for their arresting designs and logo, which would have been the most expensive initial outlay and has been such a key part of Pip & Nut's success.

Crowdfunding platform Crowdcube provided the next £120,000 and the rest came from small loans and even a few credit cards. She kept her personal expenses down by continuing to work part-time and living rent-free in a kitted-out garden shed for three months as part of a prize that she won from entrepreneurial support group Escape the City.

Then she had to find a factory to work with. 'Dealing with a fairly male environment at such a young age was a

An oversized jar of their bestselling Coconut Almond Butter.

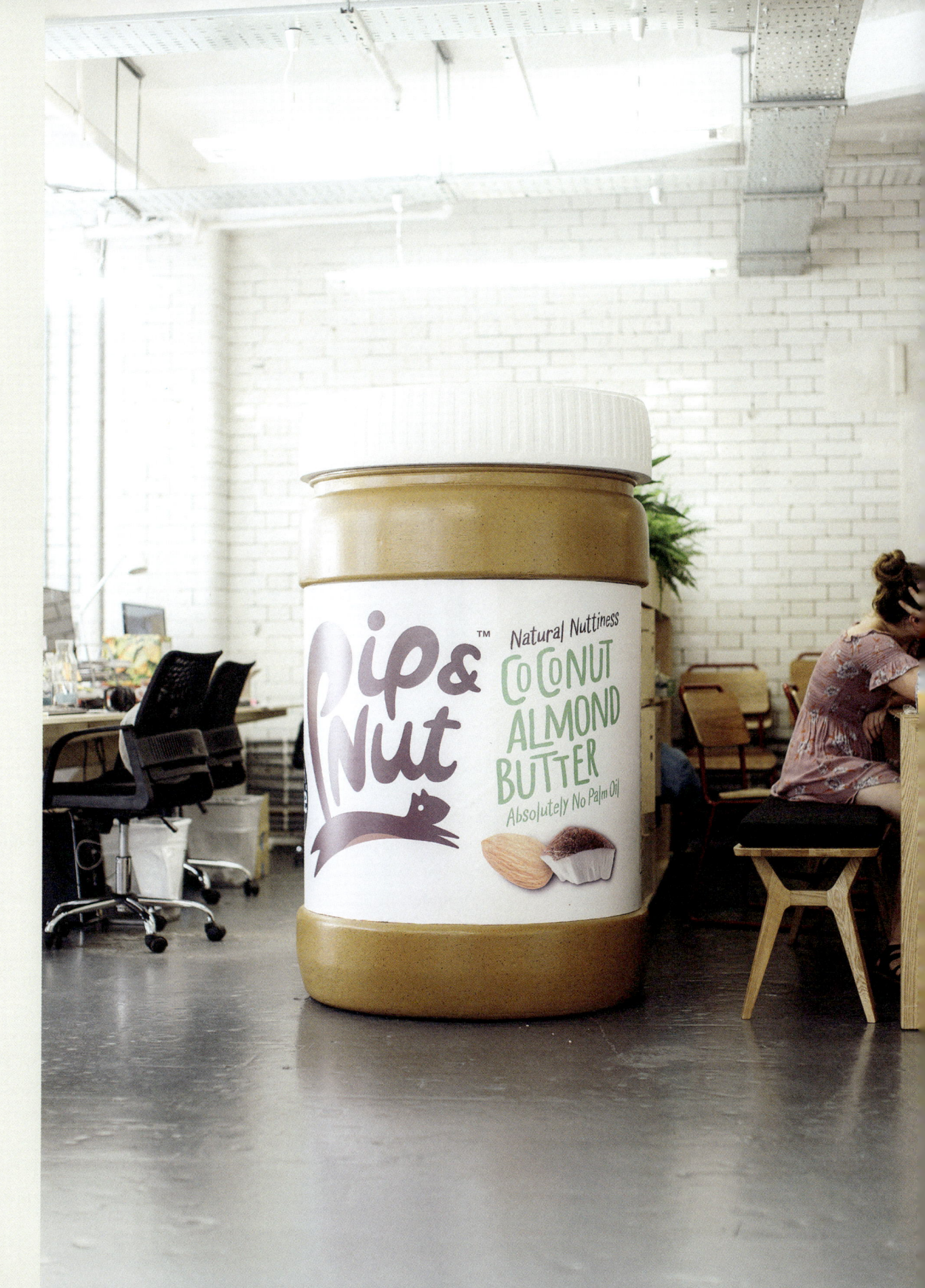

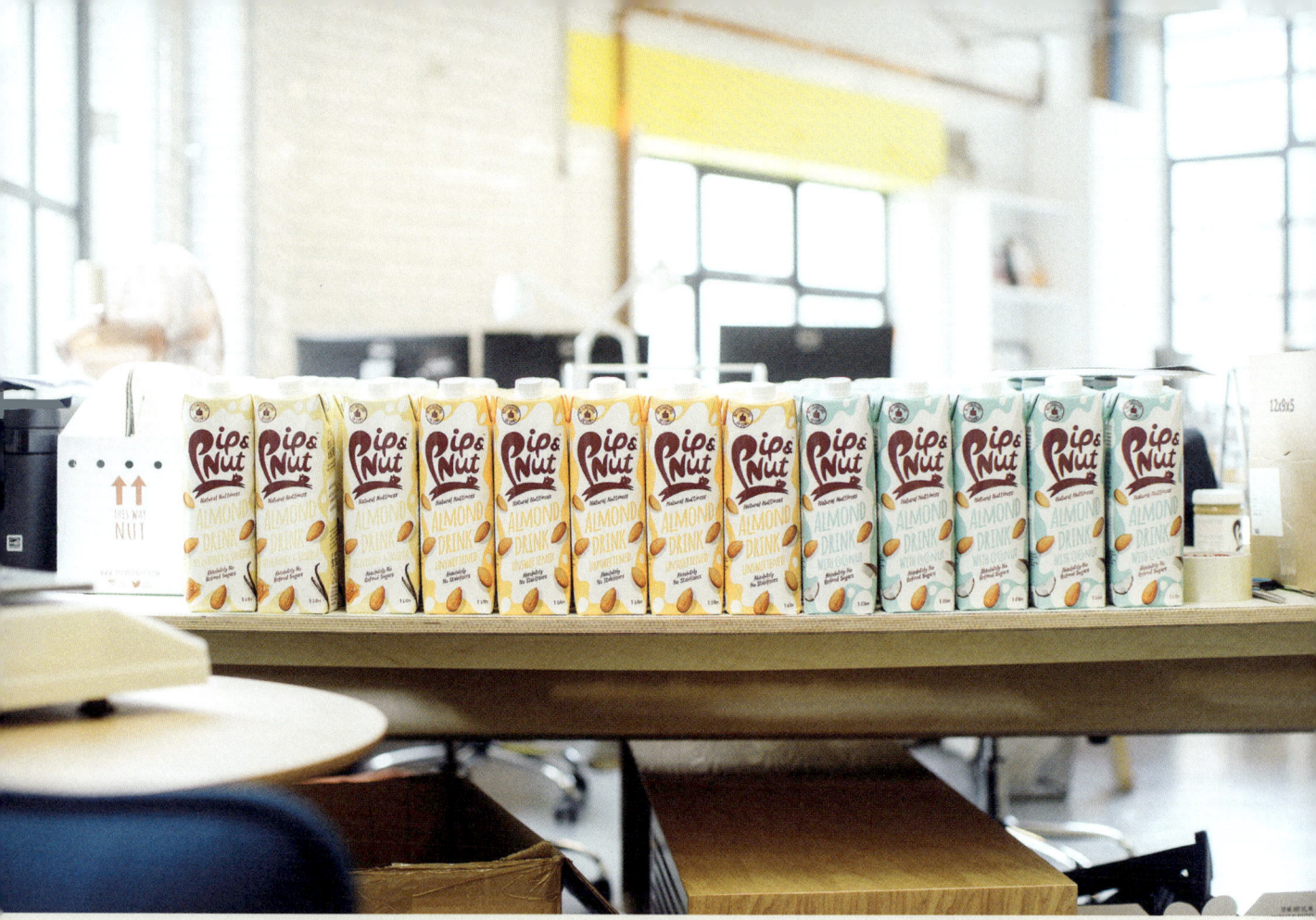

In 2017, Pip & Nut expanded into almond milks and have further plans for more products.

challenge,' Pippa admits. She says that she was often particularly conscious of her age: 'Now I look back and I think how embarrassing that there I was at 24, rocking up to a factory. That is difficult, especially as a sole founder.' It was an eight-month journey to identify the Dutch factory who could make the product in the way she wanted and who had the expertise necessary to buy the ingredients at a good price.

Success is often hard work combined with good luck, and this was true for Pippa. Selfridges bought her product, which in turn led to Sainsbury's rolling it out across 400 stores. 'That was huge for us. Proving your product works in small shops is one thing, but proving it works in Sainsbury's shows that it's genuinely scalable as a household brand. I give the buyers a lot of credit for giving us this opportunity.'

Pip & Nut was also fortunate to coincide with the growth in wellness, 'clean eating' and the rise of health guidance encouraging us to eat 'good fats', such as those in avocados and nuts. 'Timing is everything. If we'd launched a sugary drink, it would have nosedived, but we've got a product that's really relevant. You want to be going down the river rather than swimming up it.'

Wellness bloggers provide invaluable free marketing to the younger consumers

that Pippa wanted to target. 'Previously, spreads were bought by the over-45s and most of the styling is all horizons and browns. We've made something that looks young and fun which disrupts the shelves to get traction.'

Pippa says she found the beginning stages painfully slow but only five years on and she's got huge new offices in East London as well as ten employees, a new range of almond milks and plans to begin exporting. 'Nuts and a bit of health – they're the only limits on what products we'll do.'

She's even managing to get a few more marathons in.

Standout Advice

'Surround yourself with great people – whether that's a mentor, your employees, your partners, your factory or a brilliant co-founder.'

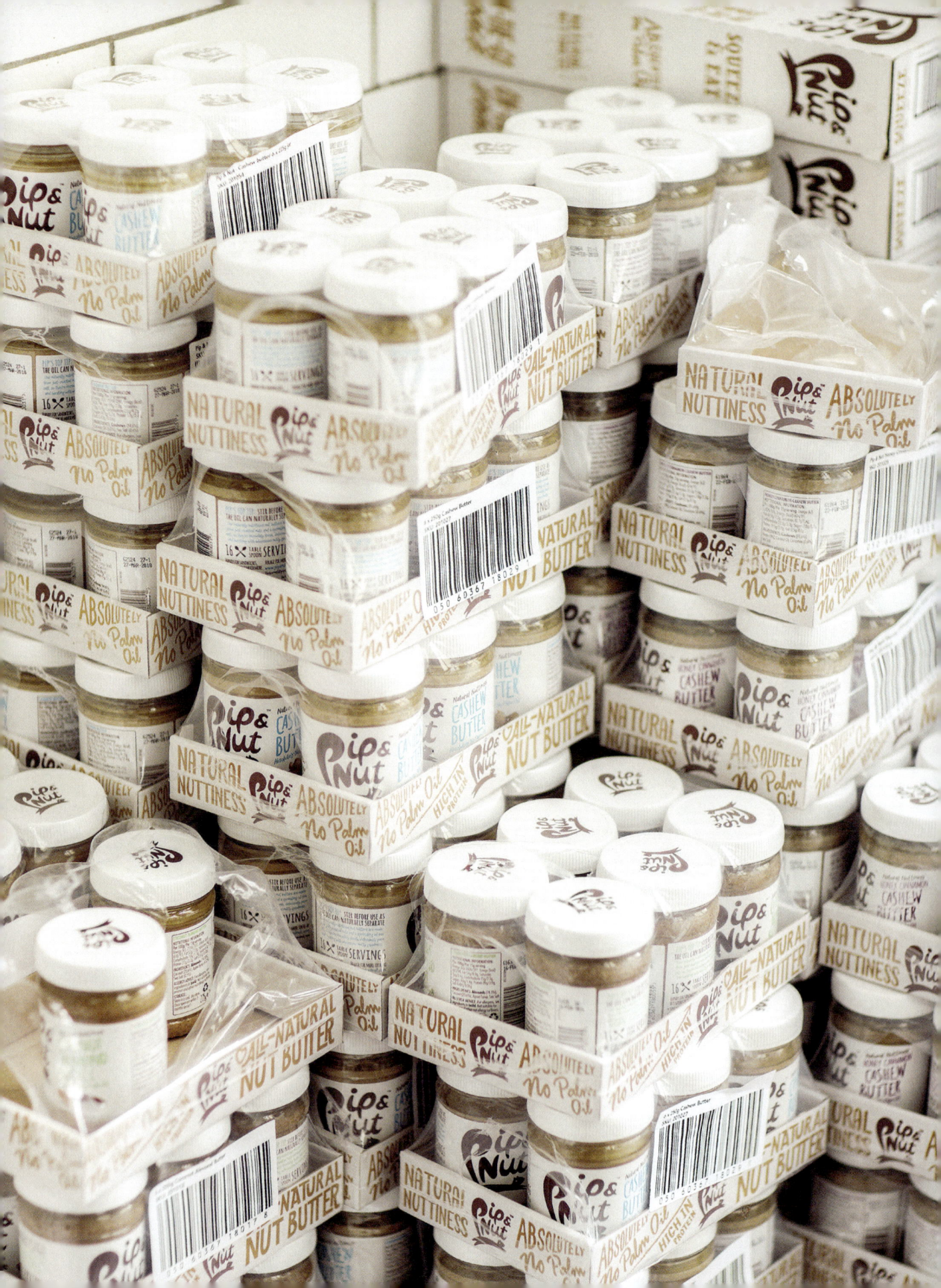

Left: Pip & Nut's distinctive branding was created by B&B Studios in return for shares in the company. Above: Running inspired Pippa to found Pip & Nut and now provides stress relief as her business expands.

Fitzcarraldo Editions
How to create a publishing house in an uncertain age

Who
Jacques Testard

What
Independent book publisher

Website
fitzcarraldoeditions.com

Follow
@fitzcarraldoeds

The decision to establish Fitzcarraldo Editions – an independent publisher specialising in long-form essays and contemporary fiction – in 2014 was a counterintuitive one. Jacques had just been made redundant by a similarly sized publishing house, Notting Hill Editions, and was frustrated by a dearth of editorial jobs that he could apply for. A more conventional response to this as a reflection of the state of the publishing industry might have been a radical career change.

But Jacques had faith that there was a market for books with an 'unashamedly intellectual nature', as well as experience in setting up something new and challenging, having co-founded and continuing to edit the literary magazine *The White Review* in 2010.

His time at both *The White Review* and Notting Hill Editions meant that he was fully aware of the Herculean challenges that achieving his aim would involve – the commissioning of authors, designing and editing the books, finding distribution, printers and warehouses . . . all long before being in a position to make any money by selling the finished works. 'I

'The point of the design was to build a recognisable brand quickly and to build on a continental minimalist aesthetic.'

knew it was mad, hence calling it Fitzcarraldo,' he admits, having been inspired by the Werner Herzog film of the same name about the folly of an early twentieth-century rubber baron trying to transport a steamship over a steep hill in the Amazon basin.

To further set himself against prevailing trends, he decided that all their books should have a very simple look created by designer Ray O'Meara, with no artwork or loud quotes on the covers. 'The point of the design was to build a recognisable brand quickly and to build on a continental minimalist aesthetic,' he says, but his distributors Faber & Faber deemed the decision to be 'possibly suicidal in the marketplace'.

Before leaving Notting Hill Editions, he had approached potential investors with plans for a possible buy-out of the company. The founder refused to sell, but one of these private investors was so convinced by the arguments in favour of a serious literary house that he offered to invest in a new one. Not only that, but he had a spacious Knightsbridge office, a stone's throw from Harrods, that Fitzcarraldo Editions continues to use rent free.

'The initial capitalisation,' explains Jacques, 'is from this private investor, me, my brother and my dad. I borrowed money from my father in order to be the majority shareholder and the private investor lent us a big sum to get started.'

Beyond this funding, there were further lessons in sales, distribution and cash flow, but, 'there's an element of being intuitive about it and I was cautious with the initial print runs of the first two books we did; only 1,500 copies of each.'

Just a few years on and Jacques' faith has been amply repaid. Booksellers have responded positively to the unifying look

of the books, even creating displays of them in shops when usually such promotion is paid for by publishers.

Most spectacularly, success has come in the form of the 2015 Nobel Prize in Literature for one of their authors, the Belarusian writer Svetlana Alexievich. Did Jacques have a hunch that they were publishing a Nobel winner? 'I knew it was a possibility – she's one of several incredible authors who are big in Europe but completely unknown in the English language. My competitive advantage is that I'm French and completely bilingual. By keeping an eye on French publishing output I knew people like Alexievich and she was top of my list of writers I wanted to publish.'

Fitzcarraldo had bought world English language rights to her books so, upon her Nobel Prize win, Jacques was able to sell them on to North America, Australia and India for 'substantial sums, which enabled us to publish more books quite quickly. We went from six in the first year to eleven in the second year.'

Despite this success, he knows that they will have to expand the business if it is to continue to be viable. To do this, Jacques is planning a classics list reviving out-of-print books that he feels are in keeping with the editorial line of the house, 'A sort of alternative history of twentieth-century literature.'

Secondly, there are plans to bring out cheaper versions of Fitzcarraldo's most successful books that will appeal to a broader market and can be sold in train stations and airports as much as Waterstones on Piccadilly. 'You take your most successful books and give them a different lease of life to reach a different audience, not necessarily your highbrow collectors of literature.'

All of Fitzcarraldo's books have a simple, pared-back look designed by Ray O'Meara with white for non-fiction and blue for fiction.

Standout Advice

'Remember, nothing is set in stone. We took a risk with our covers knowing that we could always change them after a year.'

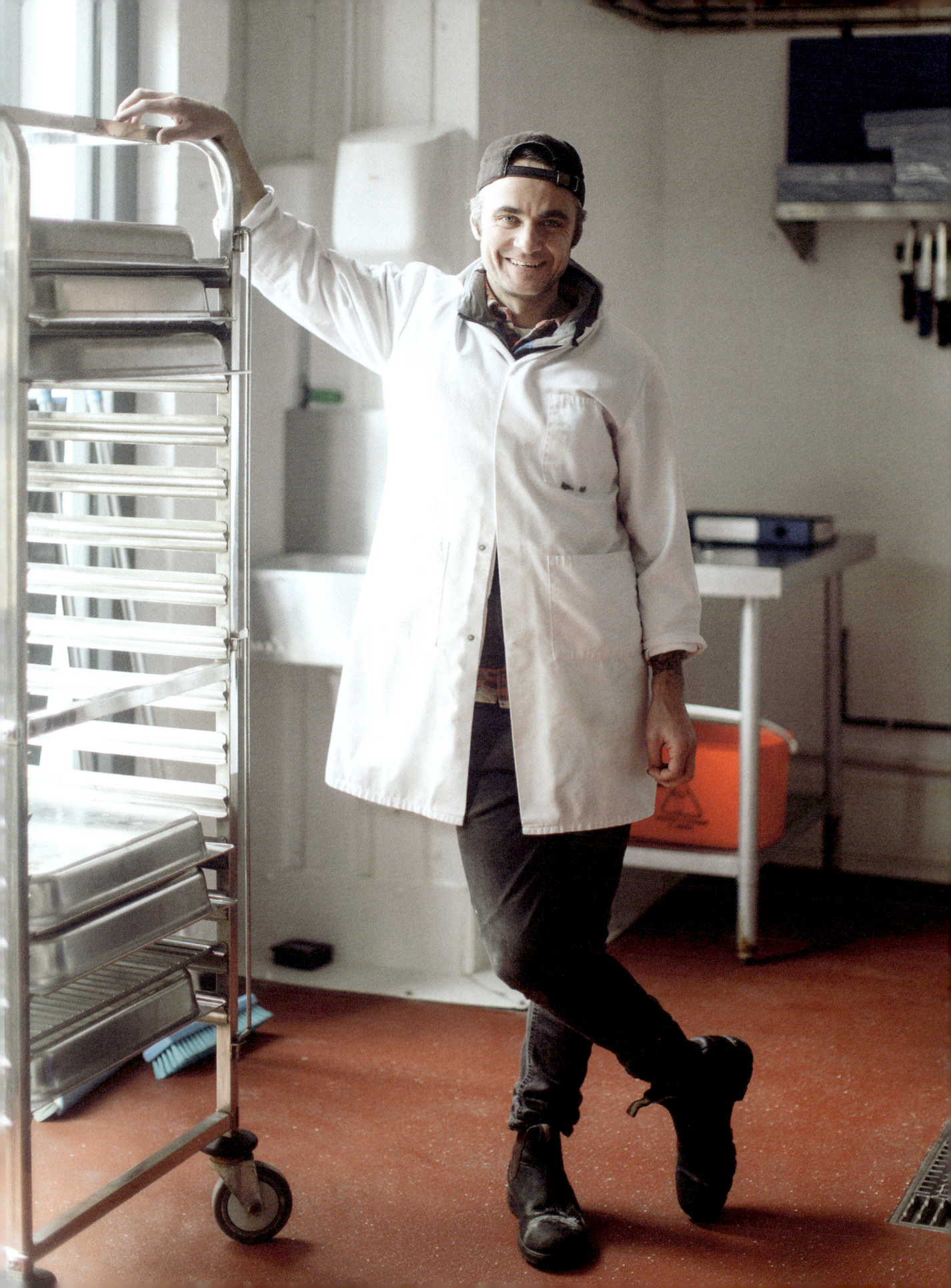

Secret Smokehouse

How to go back to basics and create a new business inspired by East London's food history

Who
Max Bergius

What
Fish curers and smokers

Website
secretsmokehouse.co.uk

Follow
@secretsmokery

Max is a veteran of two startups. The first followed the modern tech startup route of chasing seed funding and venture capital. The second is in the centuries-old industry of smoking fish, but it's here that Max has been able to apply the more imaginative solutions to challenges.

In fact, the whole process of setting up and building the Secret Smokehouse was almost a revolt against 'the constant pitching and year and a half of aggressive chasing' that he'd endured while looking to raise the £2 million he needed for an e-commerce site and magazine, *Art Wednesday*. In 2014, Max was in Las Vegas trying to set up yet another meeting with a venture capitalist when he had a realisation: 'I wasn't the person I wanted to be . . . my personal relationship was on the rocks and I needed to change something.'

He sold up his small share of the business and, while consulting for Condé Nast and on Lily Cole's Impossible app, retrained as a fishmonger at Billingsgate fish market, round the corner from the 'wee place' he'd bought in Stepney. He quickly realised how fulfilling he found

> 'You can get sucked into thinking, "I need a graphic designer, a funky website and fancy branding" but that's putting style over substance.'

the physical labour and the immediacy of transactions. 'There's no mucking about and you deal with actual real money instead of arguing with people over email – I really liked that.'

Max began thinking of ways that he could meld his newfound filleting skills with his hard-gained business experience. 'There seemed to be opportunities in that it was an old-school world which needed new blood.'

Max decided he had no desire to spend long days on a market stall, but opening a fishmonger has startup costs of over £200,000. Stepney was key in hitting upon smoked fish as the perfect blend of his skills. Talking to drinkers in his local pub, the Peacock, he began to unearth a rich history of smokehouses in East London. 'In the 1930s there were something like 67 smokehouses in E1. And then there were none.'

Max had smoked fish as child on the west coast of Scotland and he discovered there was a wealth of information on the best methods in local archives and on the internet. 'Forman's [the large scale maker of smoked salmon] began in Stepney and there's me living here. There were too many coincidences.'

All it took was £200, a little garden shed and some experimenting in curing and smoking using salt and no sugar – 'old school', as he dubs it. 'Before I knew it, I had a flavour and a smoke that I liked.'

He wasn't the only one to like it. He started selling it at the Peacock and soon was inundated with enough Christmas pre-orders to invest in a vacuum packing

The not-so secret location of the Secret Smokehouse in a railway arch just off London Fields.

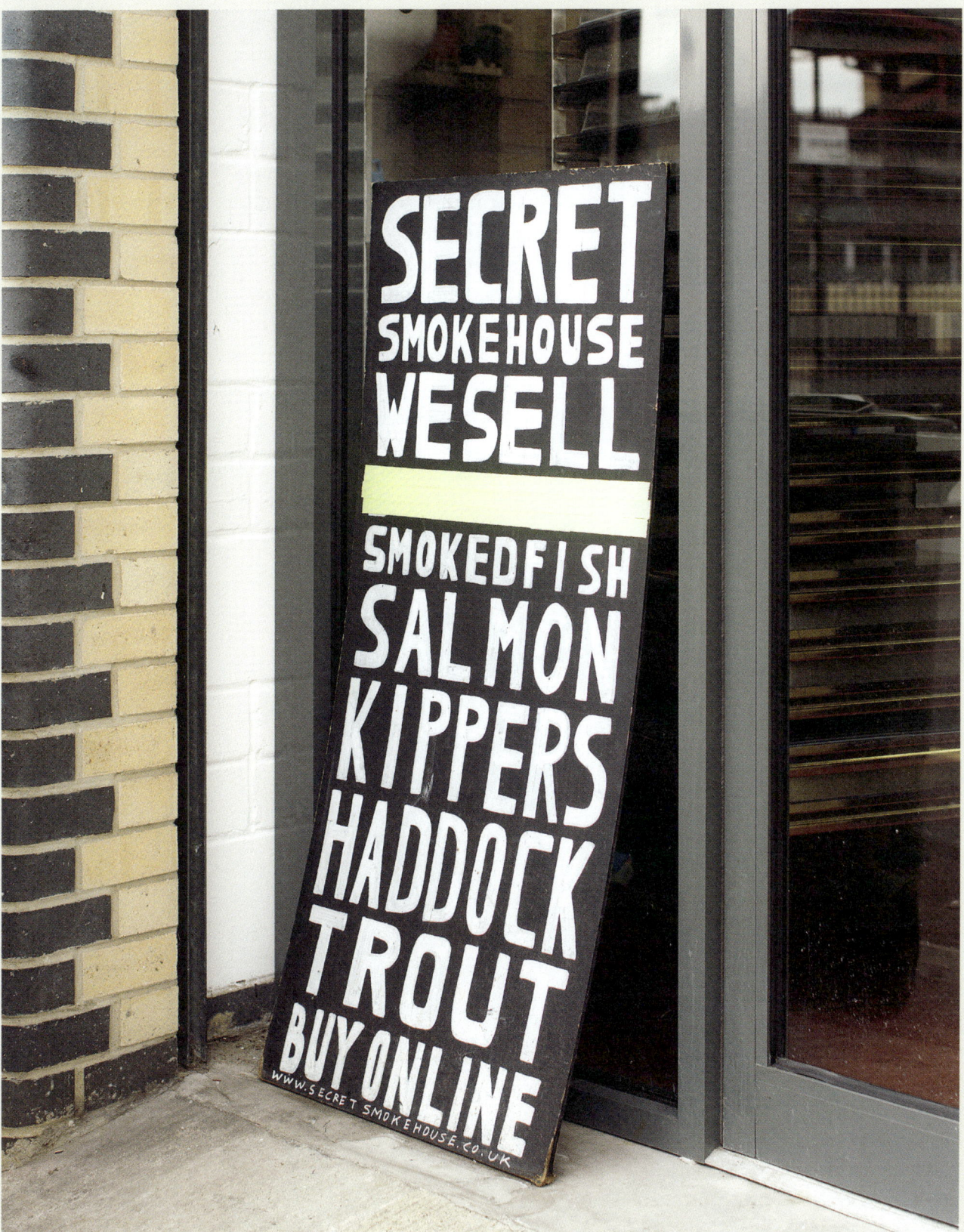

machine. Again, the lessons learnt in his previous life as a tech executive bore fruit. 'You can get sucked into thinking, "I need a graphic designer, a funky website and fancy branding",' he says, 'but we can get too transfixed on these things and it's style over substance. I realised all I needed was plain sticky labels.'

Part of the ingenuity behind the Secret Smokehouse is in Max's ability to combine the best of the modern world and older ways of doing things in quirky ways. Take fulfilment of orders for his smoked salmon, trout, haddock and kippers – instead of Amazon or DHL, he started out using his local milkman in Stepney. When applying for a specialised government startup loan was fruitless, Max just went to the bank and got a personal loan.

Word was spreading to the point where his consultancy work was being squeezed out at just the time when his wife and he discovered they were expecting their first child. The pregnancy that became baby Cosima provided the last push that Max needed. He decided that he would concentrate on the smokehouse full time. 'With a baby coming, this business had to work; no ifs, no buts.'

And work it did. Within a year, he had to move from his garden shed to his current premises under railway arches in London Fields with plans to lease a second arch.

In late 2017, Max's 'London Cure' smoked salmon was awarded a Protected Geographical Indication by the EU. This coveted and elusive award protects the names of high-quality foods and restricts the use of them to produce from specific geographic areas (think Stilton, Cognac or Melton Mowbray pork pies – none of them can be produced outside certain locations). London Cure must be smoked in Hackney, Tower Hamlets or Newham.

Along the way, Max has also secured contracts to supply Claude Bosi at Bibendum, the 'king of fish' Nathan Outlaw, Fortnum & Mason and many others, as well as continuing to sell direct to customers via the website. 'The plan is to grow and supply every Michelin-starred top restaurant and hotel within a six-mile radius of the smokehouse.'

Just salt, no sugar, is the key to their smoked salmon's distinctive 'old school' flavour.

Standout Advice

'It's so tempting to get seed capital from someone to make your dream work, but for me the best thing is to keep them out and borrow it directly from a bank so that you're responsible for it.'

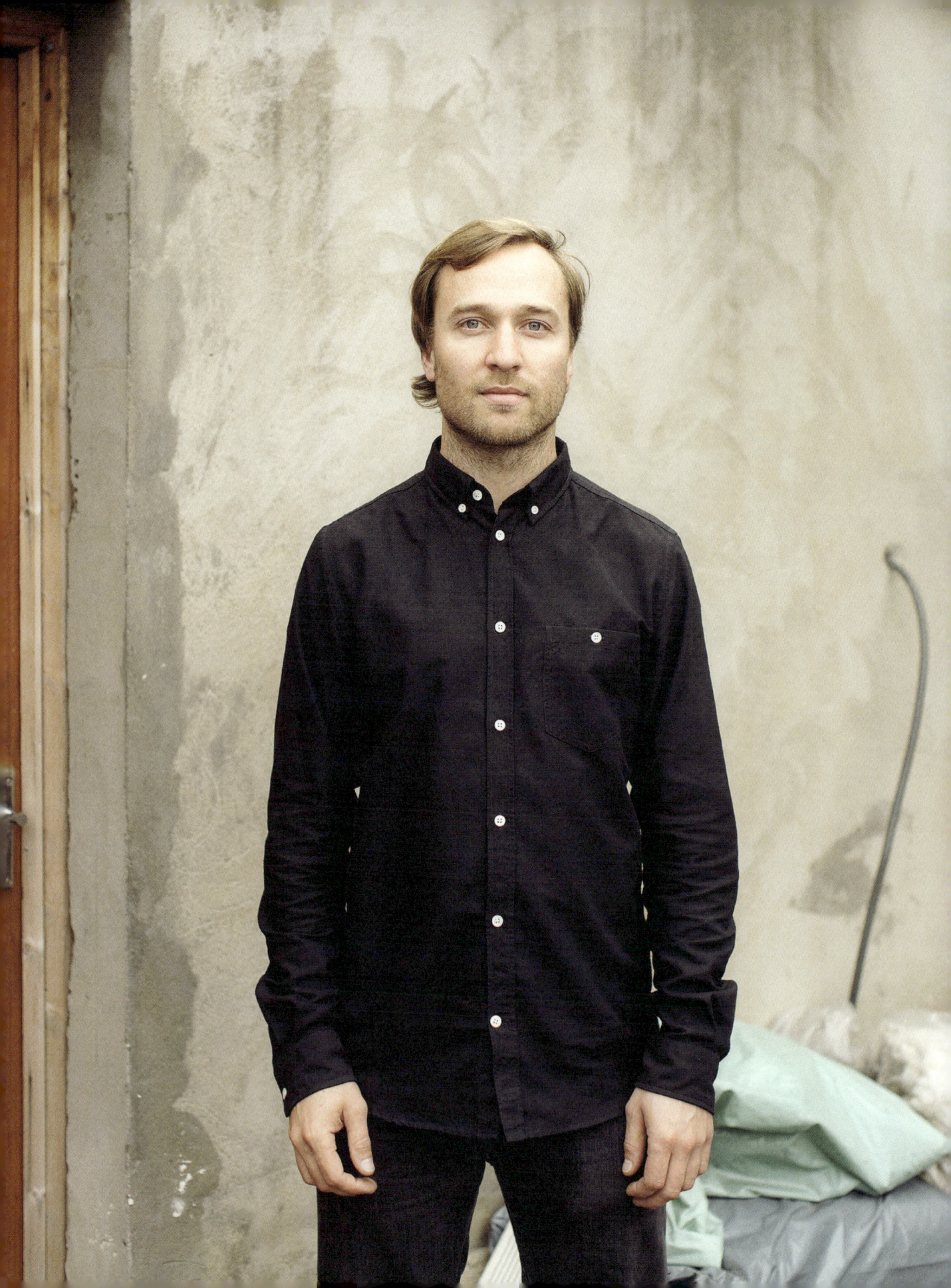

EJ Ryder

How to build a new way of construction and design for people who want something out of the ordinary

Who
Edwin Ryder

What
Design and construction

Website
ejryder.com

Follow
@ej_ryder

Edwin Ryder is an accidental entrepreneur – all he'd originally wanted was enough work to allow him to pursue his true passion: snowboarding. He still manages to maintain the laid-back air of a snow dude, despite the hustle and bustle surrounding him in his extensive Bethnal Green studio and workshop. His charm, however, is allied to an innovative spirit and determination to transform the way that building projects are carried out.

An ability to meld high-end craft with low-cost materials is one of EJ Ryder's USPs. The other is that they offer both design and build rather than separating the two, as is often the case. 'We take care of all those elements so that we can present a design at an early stage in order to collaborate with the client and check it's what they had in mind.' This unified process allows style-conscious clients like M.i.h Jeans and Lulu Guinness to avoid the expense of hiring an architect and a separate builder.

After studying building surveying at university, Edwin realised that the

> 'I was learning about lots of exciting new technology but nobody was really implementing it.'

construction industry was in need of a shake-up. 'I was learning about lots of exciting new technology but nobody was really implementing it . . . things like amazing wooden tower blocks; prefabrication. The industry isn't at all forward thinking.'

On graduating, he helped his father build an extension to the parental home in Somerset. There were no blueprints or drawings – instead he found he had a natural instinct for good design and an ability to explore new ways of doing things, such as prefabricated roof structure that could be dropped in perfectly.

Other bits of building work rolled in and Edwin found himself doing a stint of hard graft, going off snowboarding, returning to build a bit more. 'But I wanted to get out of it – I was doing too much moving round of stuff, clearing up every day. The noise, dust, cold and damp was getting to me.'

Through friends he was hired to make an eight-metre-high helium moon balloon for the Burning Man festival in Nevada and undertook a project for a set designer in London, both of which convinced Edwin that he had an almost unique ability to combine building know-how with the design skills that appealed to creative people.

These projects led to the offer of two large office builds – one from Gousto, the ingredients-delivery startup, and the other from Cambridge Medical Robotics – and the founding of his firm EJ Ryder in June 2014. The projects themselves were ultimately successful, but the process was not. 'I failed miserably and it was a complete disaster – I lost money and nearly had a breakdown.'

Edwin oversees all aspects of a build, from design to construction.

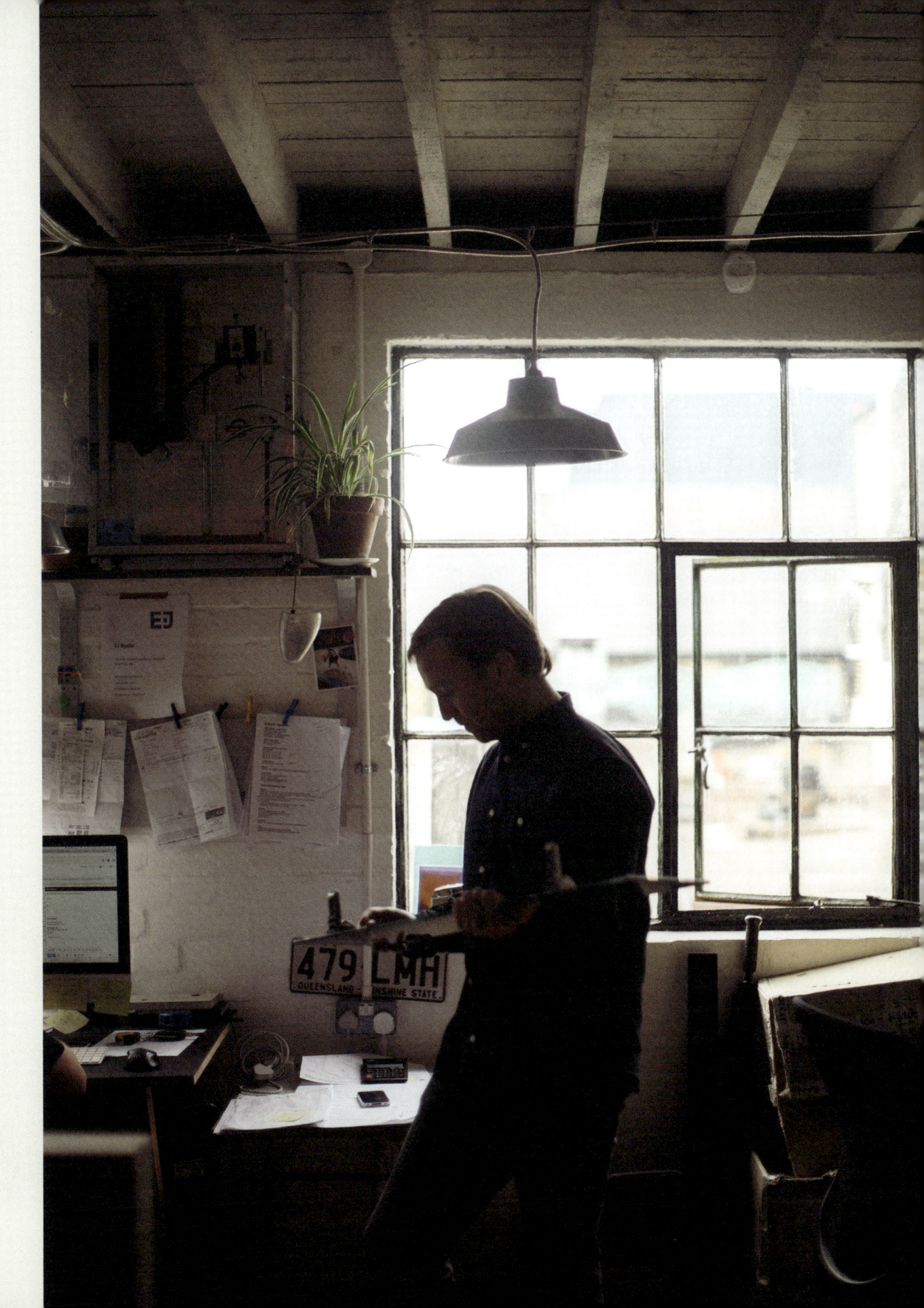

His experimental approach to design did not work when applied to starting a business. 'I was too chaotic, I didn't produce proper invoices or keep track of the work we'd done. It was 24 months of stress and struggling financially.'

Something, possibly naivety he admits, kept him going through these dark days. There was an essential optimism and belief that there was a different way of running a building company, one that could use innovative techniques and cheap, often disregarded, materials in order to produce high-quality design at a reasonable price.

'We joke that we turn lead into gold,' he says. He points to the exquisite table that I'm sitting at which has oak legs, topped with a cheap plywood sheet layered with linoleum, giving it a luxurious, almost leathery feel. By using plywood, he can offer clients a bespoke table made to exactly their specifications for the same price as a standard, mass-produced one.

In the future, he wants to continue to do this while further lowering costs to the client by using more customisable designs and prefabricated materials. 'We're developing a way of building garden studios and extensions so that the main systems are already designed with a simple core, but the client has the opportunity to bolt on further fully bespoke elements. It's not designed from scratch every time so as to reduce costs.'

Now that he has eight trusted employees, including an in-house architect, and better systems, he's even planning his first snowboarding trip in three years. 'Everything feels really good at the moment,' he says, 'but it doesn't take much for it to feel really bad. Luckily I've forgotten 90 per cent of the difficulties we've faced and I'm so glad we stuck it out.'

Standout Advice

'Surround yourself with creative, successful people who inspire you to be the same.'

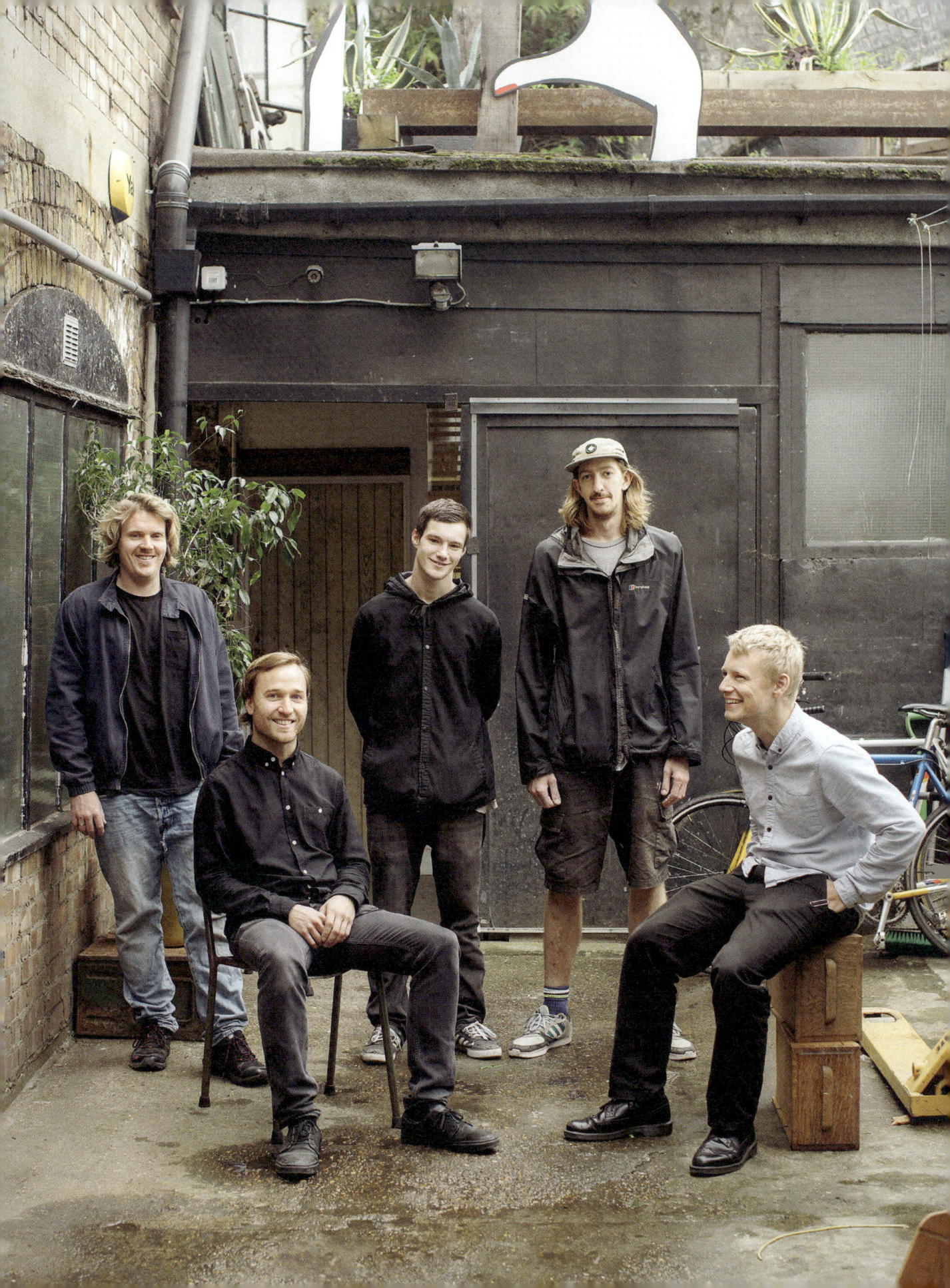

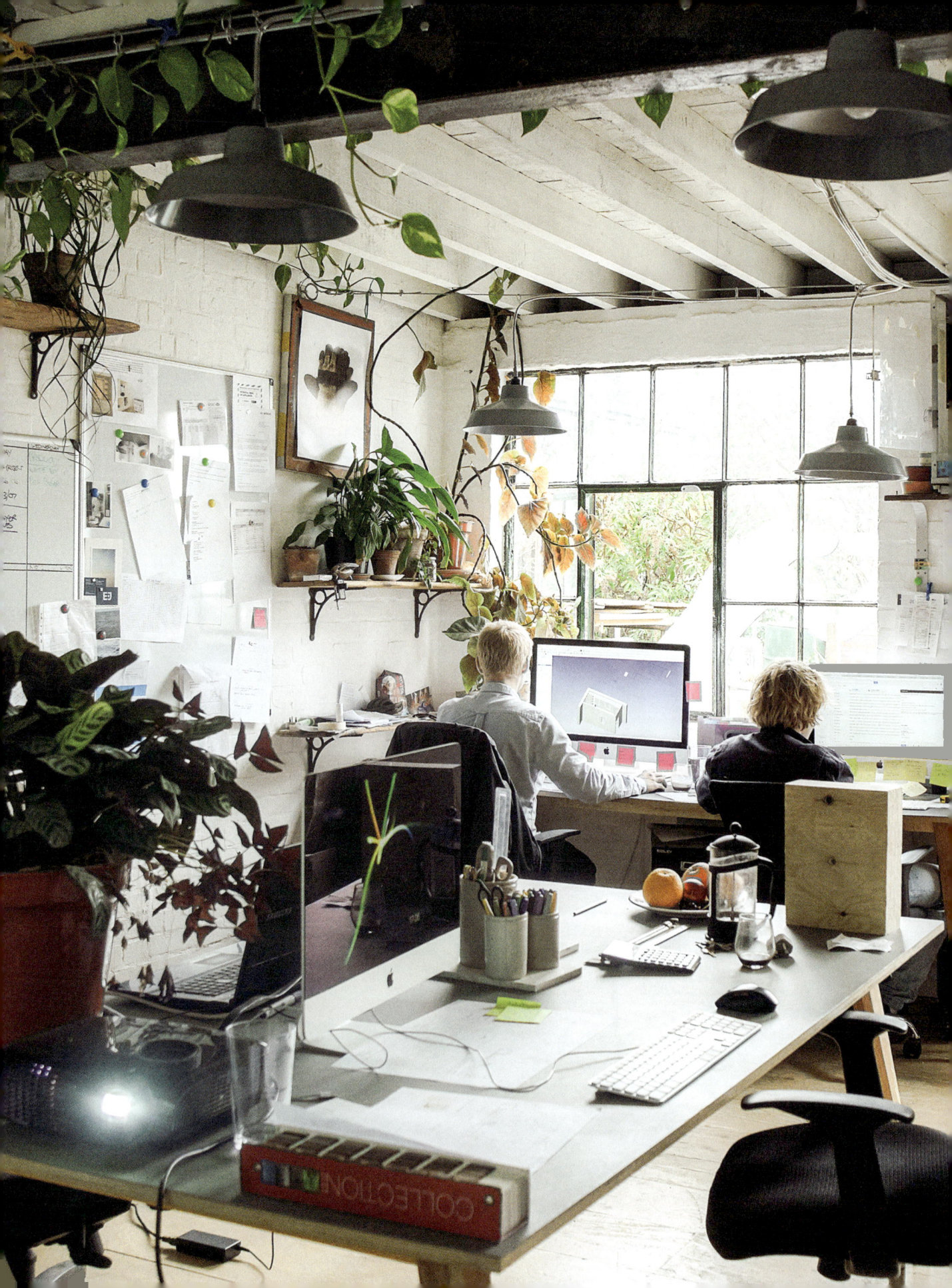

EJ Ryder's offices were falling down when they took over the lease in 2015 but they've fixed and filled them with their own know-how and furniture.

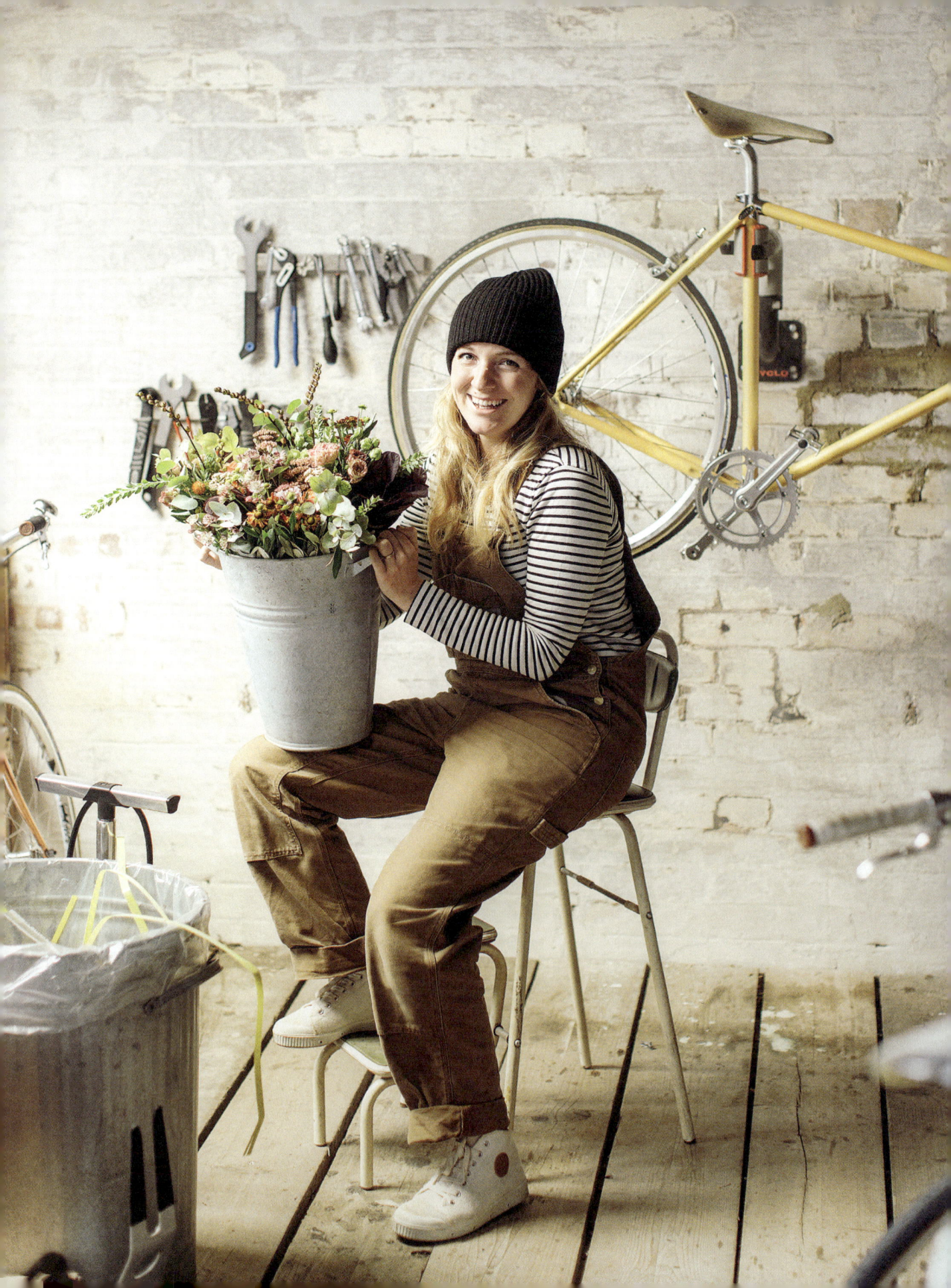

Petalon

How to make London lovelier with affordable flowers delivered by bicycle

Who
Florence Kennedy

What
Flower delivery service

Website
petalon.co.uk

Follow
@petalon_flowers

Florence's business, combining as it does flowers and bicycles, is the ultimate photogenic startup. To add to the petals and pedals, her Clapton workshop also features her bicycle-making husband James, their tiny baby Clover and a huge Great Dane. As James self-mockingly puts it, the whole thing is 'Insta-gold', while Florence laughs that if only she liked kittens, they could break the internet.

Her studies and past jobs didn't suggest that she'd become either a florist or an entrepreneur. After a degree in architecture, she worked at a 'Sloaney' interior designers, a concierge service and in sales at Contagious Communications, a trend forecasting agency.

James was key in prompting her decision to give up her well-paid sales job and start Petalon. In 2013, he started Kennedy City Bicycles, making perfect urban bikes from their kitchen. 'It was really hard working in the Contagious office,' remembers Florence, 'knowing that he was following his dream and getting to play with our new puppy.'

He even, inadvertently, gave her the idea for Petalon. 'James wanted to thank my boss for helping him to organise a surprise birthday trip to Paris for me. He sent

'It's easy to bash Instagram, but I owe it my business – people like to show off when they get a bunch of flowers.'

her some flowers, but I saw them on her desk and they were disappointing.'

He couldn't afford the £60 needed for a high-end bunch and Florence felt there must be a way of creating and delivering cheaper, yet still beautiful, flowers. Getting a man and a van, alongside parking and congestion charges, was something that made delivery expensive. After investigating both New Spitalfields and New Covent Garden flower markets, Florence worked out that a good bunch could be made and delivered by bike for far less.

From the start, she has only offered a choice of two bunches, to help customers avoid decision paralysis but also for practical, economic reasons. 'I couldn't afford to have wastage so we do a bunch in softer colours and one vibrant, or one without pink in order to make sure that there's one to appeal to all tastes.'

All she had to do was to create a bike trailer with dividers to protect the flowers and business could begin. 'The setup costs were so minimal that I felt if it didn't work, I'd just get another job. I saved up three months of living expenses to start me off.'

So it was that, without any formal floristry training, Florence rented a stall at East London's Netil Market to promote the business and Petalon began. She'd get up at 3:30am to get to the market, make the bunches and borrowed one of James' bicycles to deliver to her early customers.

'After three months, I'd made a profit of £400 and it wasn't enough for me to live on. It was disheartening that James was selling more bikes in a week than I was bunches of flowers. I should have saved more money before I started, and I was in tears thinking I'd have to give up.'

At that point, her father-in-law stepped in and insisted on lending her a further three-month fund. This was just at the point that sales began to increase.

'I hate being in debt so I didn't want a bank loan, while the lovely people who started Innocent offered us investment but advised that if we didn't need it, not to take it.'

One of Petalon's cycle couriers loads up his deliveries – the hessian wraps and leather dividers keep the flowers safe.

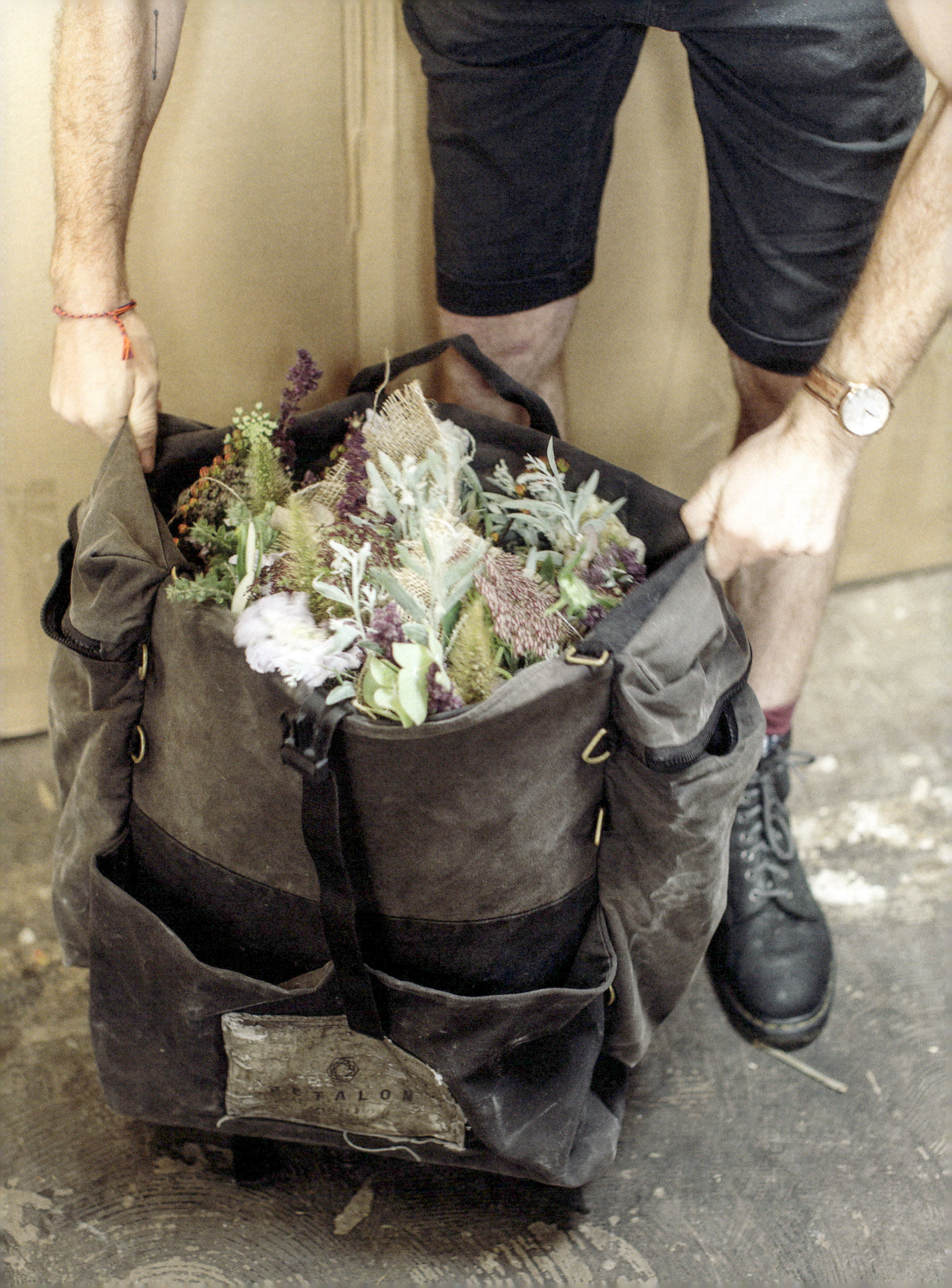

Florence offers two bunches each week based on what's in season, making sure there's a choice between softer or more vibrant colours.

A second crisis hit the business in 2016 in the shape of Brexit when Florence was pregnant with Clover. Overnight the cost of imported flowers rose dramatically. She was also wondering how she'd get to the market at dawn with a newborn. Then a cold call from a Dutch wholesale flower distributor came at just the right moment. He offered to deliver anything from his website at far lower costs. 'We went on his website and saw that a flower I'd paid £1.30 a stem for was selling for 90p. I really miss the market, but he saved my business.'

Ordering via a website rather than at the market has also helped Florence streamline her accounts, something she confesses to finding challenging. Now one glance at the Excel spreadsheet tells her which are her busiest periods: 'People are much more likely to buy flowers straight after payday, while August is quiet because people are on holiday.'

She has opened new revenue streams by providing wedding flowers and holding workshops. These pay her salary, while the delivery service funds her employees – two cyclists, two freelance florists and an office manager.

Marketing is an area that she's struggled with. She can laugh now, but her grand plan of putting single stems and a business card onto all the Santander bikes around Old Street backfired when the pupils from a local boys' secondary got to them first, leaving nothing for the 'techy people who might tweet pictures of them'.

The photogenic nature of flowers has so far proved to be Florence's best advertisement. 'It's easy to bash Instagram, but I owe it my business – people like to show off when they get a bunch of flowers. Though I still miss the excitement of seeing people blushing in an office when they receive flowers.'

The combination of improved accounts and the Dutch wholesaler mean that Petalon is looking to the next stage. 'We're putting money aside to hire a strategist to help us. What are the options? There's chains, franchises, going international, opening up another workshop . . . I feel we've winged it so far, but our next step needs to be thought through.'

Standout Advice

'Everyone should do a stint in sales – we did a lot of learning around the psychology of persuasion. Trying to sell a product without being "salesy" is something I already knew how to do when I started my business.'

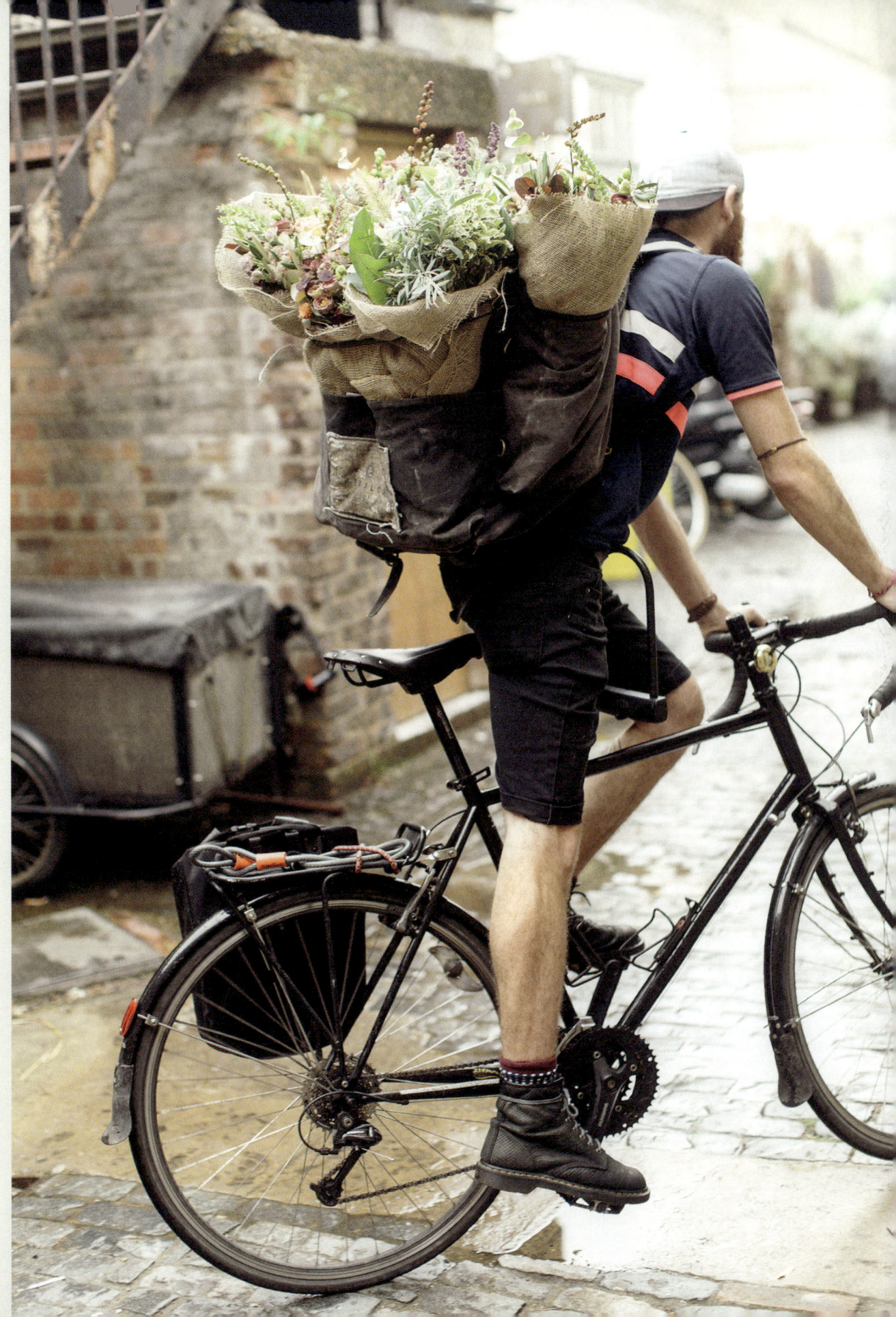

Yardarm

How to start a wine business and a family in the same month

Who
Dan O'Connor and
Eliza Parkes

What
Deli and wine shop

Website
yardarm.london

Follow
@yardarm_leyton

Of all startup dreams, opening a deli is perhaps the most prevalent. I can't be the only one who has passed an empty shop for rent and wondered what it would be like to serve flat whites and specialist salami to an eclectic but loyal group of customers.

Looking at London's streets, it seems as though in certain areas every new outlet is selling food, often with the word 'artisan' attached. Statistics back this up: in 2013, food stores were the most popular independent outlets to open, while in 2014 it was coffee shops. Between 2010 and 2014 the sector grew by 100 per cent.

A concurrent trend has been London's gentrifying spread to the east. London Fields, Hoxton and Shoreditch have long since ceased to be affordable places for creative types; Walthamstow is going that way, so the smart move is to identify the freshest district.

Dan O'Connor and Eliza Parkes certainly capitalised on the growth in specialist food shops and the spread

'I gave up hosting the wine tastings at eight months pregnant – it was starting to look bad!'

eastwards, but they bring far more than just enthusiasm to Yardarm, their Leyton-based shop specialising in wine. With a decade of experience in both restaurants and the wine trade, they're a reminder that eating and drinking, while joyful, makes for a serious job and is not for dilettantes with a passing interest in cheese. As Eliza admits of starting the business: 'It's not all bunny rabbits and rainbows; it's tough.'

While Yardarm sells some food and serves coffee, their primary focus is alcohol, reflected in the lovingly hand-written labels taking customers through the shelves of wine and the growing section for beers.

They met in 2010 when Eliza, originally from Cornwall, was hired as the manager of the Walthamstow restaurant Eat17 (also the makers of the world's most moreish relish, their famous bacon jam) that Dan ran with his stepfather, two brothers and sister-in-law.

Three years later, their professional relationship ended while a personal one began and the idea of opening their own place was hatched. Eliza passed her wine exams and worked as a sommelier, adding an additional level of expertise to solid experience.

Dan grew up in Leyton, and recognised the changes happening there that marked it out as a prime spot in London's drift eastwards. 'It feels like Walthamstow did a few years ago with a buzz about it . . . something seemed to be happening.'

Eliza agrees. 'We had a few friends living here and they told us that it was crying out for somewhere like this. Plus there's an energy to East London – when I was selling wines in West London they wanted something they were used to, here they want something new.'

Securing the freehold of their property not only gave them a shop, but somewhere to live, as it came with a flat upstairs. They bought it with money that Dan made by selling his stake in Eat17 and a bank loan. 'We had to come up with a business plan in order to get this,' says Dan, 'but the combination of our experiences in restaurants and the wine trade helped make that straightforward.'

They got the keys in September 2015, the very same month that they found out that they were pregnant with their first child – Finn, the utterly cherubic baby who is now as much a part of the shop as they are. 'Looking back, maybe we should have staggered it!' laughs Dan.

As well as a smart choice of location, they've created a sharp look for Yardarm. Eliza was inspired by a series of graphic novels about wine, *The Drops of God*, which meant that they could provide a very specific brief to a designer, which in turn saved them money.

Experience once again told in their decision to hire shop fitters rather than builders to do the refurbishments. 'They come at a premium,' says Dan, 'but it would have been a false economy to have got someone cheaper, as them working so fast meant we could open earlier.'

Which they duly did, welcoming customers to the front section of the shop a mere three months after completing on the freehold. Then the back section opened the following April and baby Finn arrived in May. 'I worked up until the day before he was born,' says Eliza, 'but I gave up hosting the wine tastings at eight months pregnant – it was starting to look bad!'

Their confidence has allowed them to respond to customer demand. The back part of the shop, where drinks and coffees are served, was originally lots of small tables with no shelves. They soon realised that it was being used more informally and that a communal table would work better – 'plus the sales of beers were nuts' so they needed more space for that. They've also recognised that the footfall in the area won't allow them to expand into stocking more perishable goods, such as fruit and veg, and besides, 'We like being booze dominant, because that's our thing.'

As if opening a new business and having a baby weren't enough of a challenge, they've now taken out the lease on the next-door property in order to open a bistro. 'Financially and in terms of our energy levels, we've pushed it,' admits Dan.

As Finn crawls happily across the floor, they make it all look like child's play, though they've worked hard and Eliza had almost no time off after his birth. But the experience of having worked in restaurants, where you solve problems yourself and the 9-to-5 doesn't exist, means that they now thrive on being fully independent.

Standout Advice

'Be flexible and constantly revisit earlier decisions in order to respond to changes – we might have to up our stock of English wines if the pound falls further.'

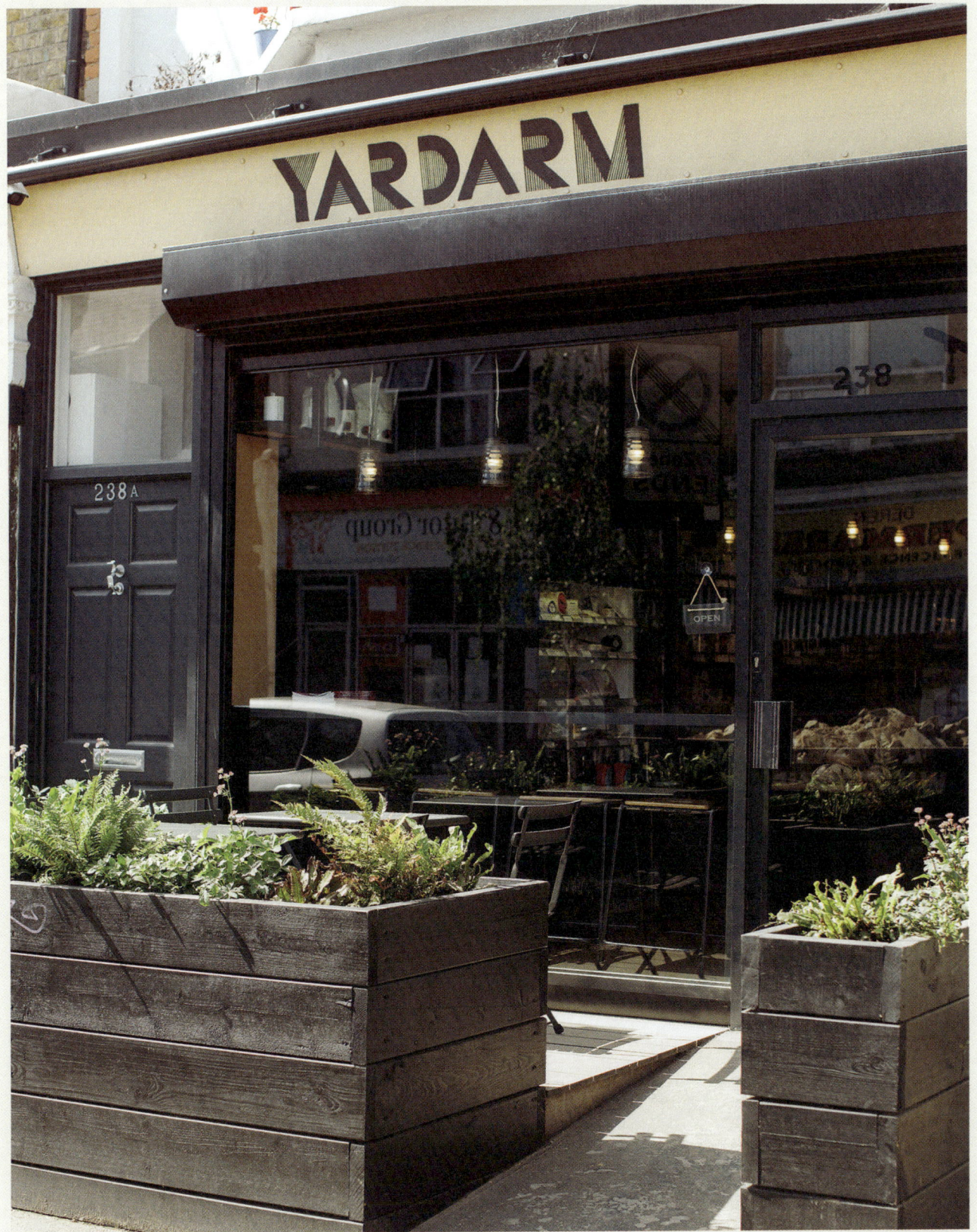

Second Home
How to build shared workspaces aimed at the startup community

Who
Sam Aldenton and Rohan Silva

What
Workspace and cultural venues

Website
secondhome.io

Follow
@secondhome_io

Sam and Rohan, the pair behind Second Home, the members-club style workspace in East London, are the embodiment of the adage that there's no decision as bad as not making a decision at all. Their meteoric growth is predicated on the belief that instinct is good, inaction is bad.

Their own business marriage is testament to this, since Second Home was born after a whirlwind courtship – having only met in 2012, they decided to go into partnership in 2013 and opened at the end of 2014. All this having never previously worked together.

'Sam was helping one of my closest friends as well as advising my wife on a not-for-profit arts festival,' says Rohan. This told him all he needed to know about Sam – that he was collaborative, knowledgeable and generous: three key traits in the Second Home philosophy. Also, Rohan says, 'Sam has, a great social conscience but is also an entrepreneur.' This is another Second Home theme: that capitalism and charity can harmonise.

Rohan's professional background was almost entirely public sector, having worked in government since the age of

> '**It's about peeling back those layers so that you're clear about which bits of your intuition you can rely on.**'

23, advising first Gordon Brown, then David Cameron, most notably in the development of Old Street's Tech City (the government programme to accelerate the growth of East London as a rival to Silicon Valley). Sam had worked at Bootstrap, which supplied offices to entrepreneurs, as well as setting up London's first co-working space in 2005 and the Dalston Roof Park, and brought 'concrete' experience in the world of property.

So Sam and Rohan hatched the idea for a new kind of workspace over lunch one Saturday in 2013. It would offer businesses flexible space, but, just as importantly, networks of other businesses. Sam recalls, 'Then I went online and filled out a company form. By the Monday afternoon we were incorporated, working on an investment deck and had a name. In 48 hours we'd gone from lunch to this reality.'

The next challenge was to find a building to accommodate these businesses and ideas. It was always going to be in East London, says Sam: 'It's where I've always operated and it's where I'm from, as well as being near Rohan's work in Tech City.'

When Sam saw an estate agent's board outside the old carpet factory on Hanbury Street near Brick Lane in January 2014, he knew it would be perfect for them. One problem, though, it was already under offer. Which brings us to another running theme in the Second Home story – the ability to charm and persuade others of your vision before it is fully realised. 'We met the landlord,' says Sam, 'with an amazing booklet that showed what we planned, which presented the idea as far more fully formed that it probably was.'

'And we talked to him,' adds Rohan, 'about what we'd do with the building and he was impressed with the fact that we cared and that if the building ended up being halfway as beautiful as this little book then he'd end up with a more valuable asset. Which he did.'

Sam and Rohan also worked their magic on a disparate group of investors, including an ex-Goldman Sachs chief economist and TV producer Peter

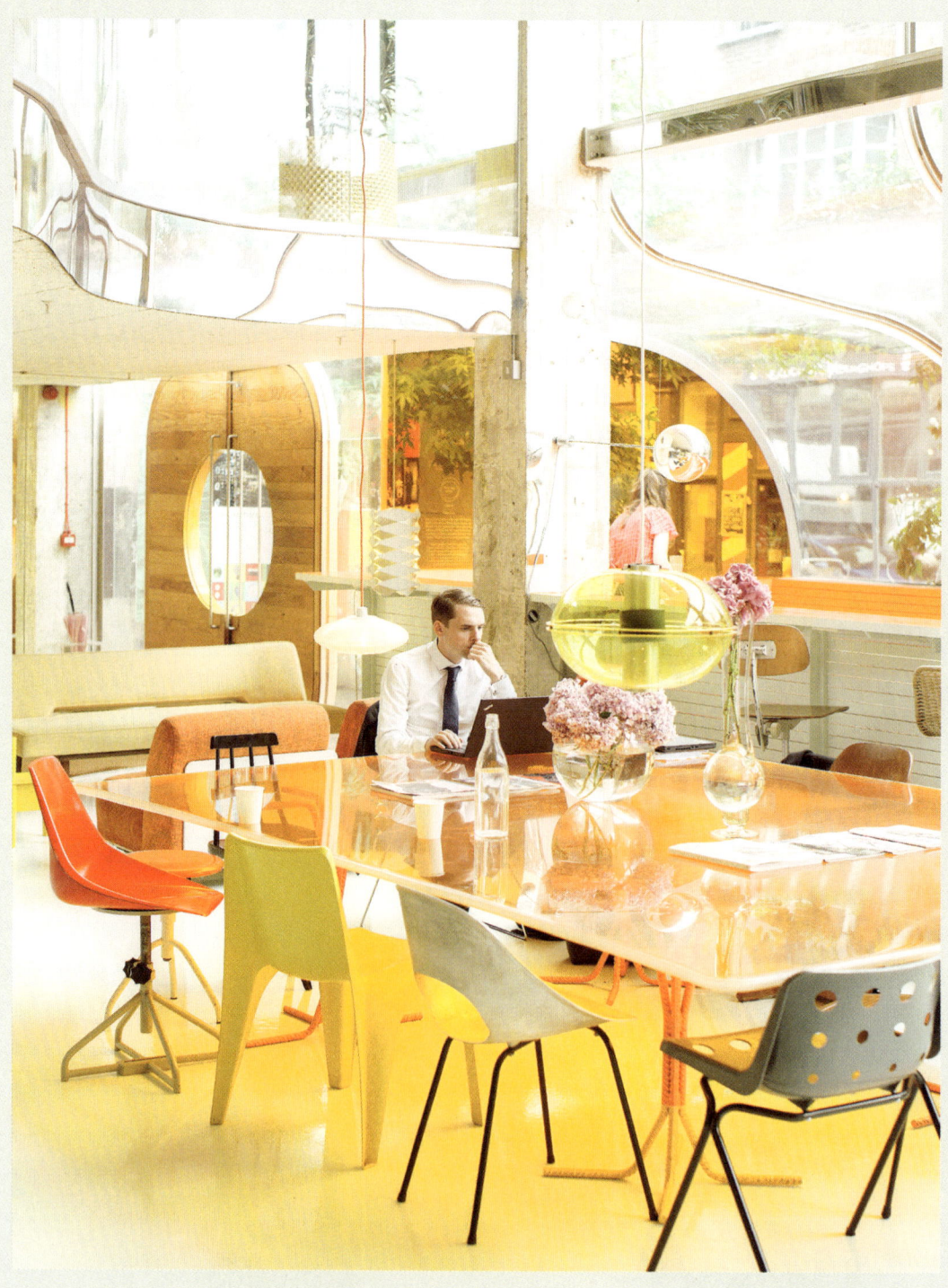

Large communal spaces such as the café allow those working for the myriad businesses to meet and share ideas.

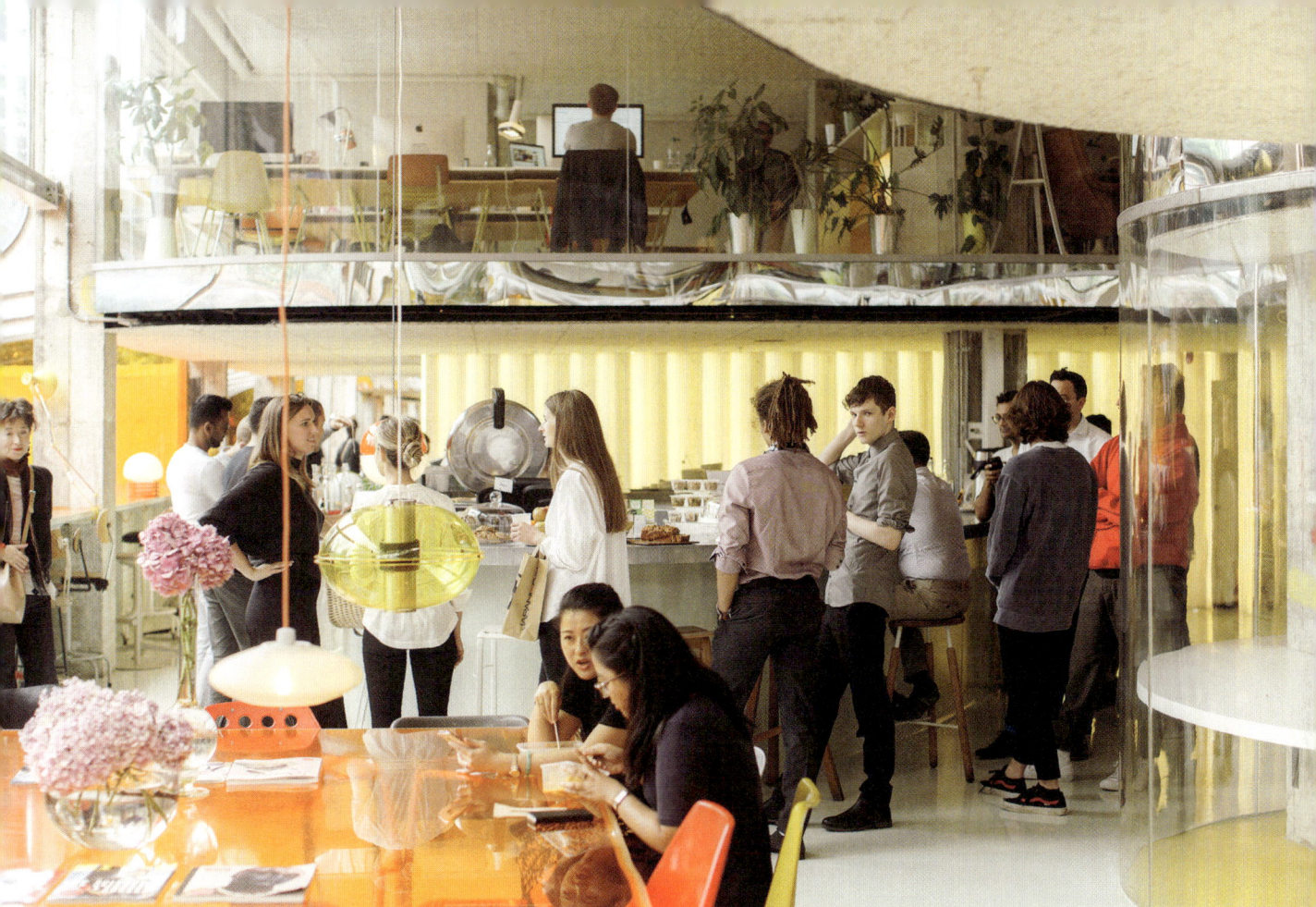

Bazalgette, to raise an initial £4 million. Not bad for what was really a shell of building and two untested founders.

By November of that same year the factory had been transformed by a thousand pot plants and swathes of yellow and orange Perspex, and opened as a home to 35 companies. Many of us have builders in for longer than that just to redo our bathrooms.

All Sam and Rohan's interests and enthusiasm collide perfectly in the concept of Second Home. As entrepreneurs themselves, they knew exactly what startups need, from accountancy to branding. 'We work on an 80:20 ratio,' stresses Rohan. 'Twenty per cent of the teams here do things that if you're starting something you'll probably need – investors, recruiters, lawyers, branding people, PR.'

The other 80 per cent of tenants are curated to provide as much diversity as possible. 'Background, gender, age, industry, stage and size,' says Rohan. 'Help Refugees are here, but they're next to Zegna, the luxury menswear designer . . . virtual reality film makers are next to a charity creating jobs for girls in Africa.'

Talking to them less than three years after they opened Second Home and they make it sound so easy, but they admit that they've made almost a deliberate policy to remember only the positive. 'Starting this business,' laughs Rohan, 'is

as near as I'll ever come to giving birth. You almost have to anaesthetise yourself to forget how painful it was. I used to think to myself, "Oh it was so easy to raise the money", but then I look at our spreadsheet and see that we met with 150 investors. If you keep thinking how hard it is you'll never steel yourself to do it again.'

'You forget,' agrees Sam, 'that time at five in the morning when you were crawling under desks trying to make the lights work for the 400 people who were going to turn up in two hours.'

However, they have since re-examined decisions that they made in a haze of forward propulsion as they rapidly expand with a Second Home in Lisbon, as well as ones in Holland Park and London Fields. Starting a business, they say, was about finding their strengths, but evolving it involves examining their weaknesses. 'Now it's about peeling back those layers so that you're clear about which bits of your intuition you can rely on and which bits you've really got to get other people involved with,' says Sam.

London Fields, complete with crèche, is a natural extension – it's only two miles away from their original home and, as a greener, more family-friendly location, reflects the way that their own lives are evolving. But, in our tribal city, moving to West London almost feels like more of a departure than opening in central Lisbon. But this westwards journey is deliberate. 'Creative people definitely cluster in East London, but the pendulum has swung too far and the city's becoming unbalanced. Cultural venues and cinemas in West London are closing, but there are so many creative people there and we're so excited about it. Fashion, TV, the music industry . . . there's lots there if you scratch the surface,' says Rohan.

With the two new London spaces, as well as Lisbon and Hanbury Street to maintain, and plans for a further Second Home in Los Angeles, the pair have got plenty to keep them busy and they laugh when I ask them what other plans they might have. Then I discover later that Rohan's whipping up a book in his spare time, and I read that they're already eyeing up residential housing as an area that needs shaking up, just as they did with old ideas of what makes an office.

Going on past form, I wouldn't bet against them doing just that.

Standout Advice

'At the beginning, it's important to suspend a lot of your critical faculties and, weirdly, not think too strategically.'

NOTES

NOTES

NOTES